Amalyah's Search for Love

ISBN 978-1-936208-83-8
Cover design: Christian Aid Ministries
Text layout design: Felicia Kern
Printed in the USA
Printed July 2012
For more information about Christian Aid Ministries, see page 235.

Published by:
TGS International
P.O. Box 355
Berlin, Ohio 44610 USA
Phone: 330·893·4828
Fax: 330·893·2305
www.tgsinternational.com

TGS000520

Amalyah's Search for Love

HARVEY YODER

Table of Contents

1

I LAY AMONG THE TALL MALLOW PLANTS, HOLDING MYSELF AS STILL AS POSSIBLE. IT was springtime, and I could feel the dampness from the last rain through my clothes. At any other time, the fresh green seeds of the mallow plant would have tempted me as a delicious snack, but not on this particular morning in 1974. This time I lay very still, for I was hiding.

"Amalyah! Amalyah!" I could faintly hear the cries from my playmates down the slope from my hiding place. I grinned triumphantly as I pictured them busily scouring the eucalyptus grove for those of us who still weren't found. *There is no way they can find me,* I thought. *They would have to step right over my head. Even if I start singing, no one will know where my voice is coming from* . . .

Our group of twelve was named *Katzir,*[1] the Hebrew word for harvest, to distinguish us from the other groups on the kibbutz, our Israeli communal farm. We had already graduated from our earlier title of *Gozalim,* or the nestlings' kindergarten, and had been together for as long as I could remember. These hikes around the kibbutz were part of our regular school curriculum. For me, the seven-year-old girl hidden in the grass, this group-oriented life was the only existence I had ever known.

There was something special here today. Spring was in the air, the tall grass

[1] See pronunciation key for foreign words on page 231.

was waving all around me in the fresh breeze, and the sun was caressing my face with its warmth, holding me motionless. I lay there peacefully, and warm pictures floated through my mind like the clouds that drifted overhead.

I thought about the times when I got to spend a night with my parents and how special it always was when Mom pulled up the sheet around my neck and kissed me goodnight. I thought about Dad and how his eyes would twinkle as he pretended to be a bear or other fierce wild animal.

I am eight years younger than my closest sibling, Rafael, and even more distant from my two older sisters, Deborah and Hannah. Since all the children in the kibbutz lived in the children's houses away from their parents, my siblings did not play an important part in my childhood. Still, there was something that made me realize they meant more to me than other teenagers in our community.

My thoughts drifted to the world where I lived. I knew that not everyone in Israel lived in a community village as we did. I knew from my studies in school that there were big cities in our country, and that there were many more countries in the world.

The deep blue of the sky above me was so close and yet so far away. The intensity of the blue was broken by the white cumulus clouds that sailed along like fluffy white pillows, and I began to imagine how lovely it would be to lie on one of them, looking down on the world beneath me.

I even imagined that I could see myself lying perfectly still in the grass, hiding from my classmates. I saw a brown-skinned girl with dark, fly-away curls that never could be brushed down smoothly. She was dressed in a plaid flannel shirt, her skinny legs encased in bell-bottom jeans and ending in sturdy brown shoes.

I giggled as my fanciful thoughts floated through my mind. How was it possible that I could be on a cloud and yet see myself in the grass?

How did those clouds form? I knew vaguely about the water cycle that brought rain to earth and water back to the clouds, but right now, there was a probing for deeper answers to the thoughts running through my mind.

What was the sky? I stared up and tried to see what lay beyond the blue. How could thin air be blue? How could nothing be blue? How had this enormous world come into being?

Suddenly, I felt small. Not only small, but tiny. The vastness of the sky above me, the huge floating pillows drifting by in leisurely succession, and the waving green grass all around me somehow transported me into a world full of questions on how all this came to be.

"Who made you? How did you come to be? What is up there and down here and all around me?" My voice was small and quiet, but as I spoke, vast caverns of thought opened inside me, and I felt as though my questions echoed and re-echoed in my mind. *Who? What? How?* The fragments grew into a roar of thoughts.

I sat up, not worrying now whether anyone would find me, and groped in my backpack for a pencil and paper. Smoothing the paper out on my knee, I began to write the thoughts that had begun to crystallize deep within me.

> *Here I lie in the grass*
> *Looking all around me.*
> *I look up into the blue, blue sky,*
> *I watch the clouds go sailing by,*
> *I feel something, I know not why.*
>
> *Beyond the blue of the sky,*
> *What lies there?*
> *Beyond the white of the clouds,*
> *What lies there?*
>
> *How did the sky appear?*
> *Who made it?*
> *What made the clouds?*
> *Who made the earth?*
> *Who made me?*
>
> *I know that there is*
> *Something somewhere.*
> *It is somewhere,*
> *But I am here.*

Suddenly I had to move. I could not bear the stillness any longer.

"Here I am!" I cried, jumping up and waving my arms wildly above my head. I sprang away from my flattened grass bed and ran swiftly down the slope toward my playmates. Cries of delight burst out of my mouth, and I felt energy and vitality course through my veins. With a bound, I left my dream world behind and entered the familiar world of my childhood.

<p style="text-align:center">❂ ❂ ❂</p>

"We are taking off for Greece!" Roni yelled. "Everyone who wants to go, get in!"

I hastily wiped my hands on my blouse and bolted toward the car where Roni was sitting in the driver's seat, spinning the steering wheel in his hands.

The other *Katzir* children came running from our play yard and piled into the junk car that was sitting under a spreading shade tree.

"Tickets!" Efrat yelled, holding out her hand from the seat beside Roni. I scowled momentarily at her, for I resented her self-appointed leadership of our group, but in the excitement of the moment, I hastily thrust out the required tree leaf and scrambled inside with the others.

We all helped Roni with the needed noises to get our "aircraft" off the ground, and then our imaginations took over.

"Oh!" one of my seatmates squealed, looking out of the hole left by a missing door and pretending to be scared, "it is so far down to the ground! I see my mother in her yard!"

The rest of us joined right in with the make-believe. "There is Jerusalem!" someone called, pointing out a side window.

"Not that way, silly! Jerusalem is over on this side," Roni yelled, deftly turning the steering wheel. "That must be Tel Aviv you're seeing."

"My mom used to live near Tel Aviv," Yoni shouted. He jumped up from his seat to see better, and as he did so, he slipped and fell out of the car onto the ground.

"Man overboard!" someone yelled, and we shrieked with laughter as he jumped back inside.

"I see the ocean!" Efrat exclaimed, cleaning the inside of the dusty windshield with her hand and peering out.

"You mean the sea," I yelled back, remembering our geography lesson. "It's the Mediterranean Sea."

"Whatever," Efrat said with an airy wave of her hand. "Sea or ocean, I see water."

"Water!" A chorus of cries rose up. "We're thirsty!"

Indeed, it was sweltering inside the car, even with all four doors removed. In Israel, the summers are hot and dry. My throat felt parched.

"Captain, land this plane," I commanded. "The passengers need water."

Roni looked at me in the rearview mirror. "Aye, aye, sir!" he laughed.

"That is how they talk on a boat, not an airplane," one of the other boys corrected.

"Never mind, it works," I said with a laugh.

With the appropriate noises and plenty of swaying from the passengers, we "landed."

Tumbling out of the car, we raced to the children's house, which also contained our classroom, and drank deeply before heading back outdoors.

The play yard might have looked like a junkyard at first glance to an undiscerning eye, but it was the center of our lives whenever we had free time. We gravitated toward it as soon as class was over, and the educators even used it to teach us quite often during classes.

The rectangular area was ringed with defunct stoves and refrigerators whose doors, like the car doors, had been removed to minimize smashed fingers. All sorts of tables and chairs were set out to make the play yard a space where our imaginations could take flight.

A large bin held the expected assortment of balls, bats, and other toys, but the main attractions were the discarded items. We could set up factories and manufacture bowls and cups out of mud. We could set them out to dry while we "fixed" the car engine or "repaired" the stove that no longer baked bread properly. Great was our delight whenever we could actually take food from the kitchen and eat outside, all seated around one table.

We hardly ever thought of ourselves as playing. In our world, we were living, not playing.

❁ ❁ ❁

I raced through the front door of my parents' house, dashed across the large single room, and climbed onto my parents' bed. I snatched a clear plastic ball off the shelf and dashed back outside to the warm sidewalk.

"How . . . are my . . . pets . . . today?" I was gasping for breath as a result of my sprint from school. I unscrewed the top half of the ball and looked down into the mound of shredded leaves I had put inside.

This was my daily routine: open the ball, pour the contents onto the sidewalk, and rake the leaf bits apart with my fingers to find the bugs that had expired since the previous day. Then I would put the surviving insects back inside the ball. I would offer them crumbs and droplets of water, and I always grieved briefly for the dead ones before tossing them away.

But this time, there were no wriggling live ones. I saw only two dead bugs, lying on their backs with their crooked thread-like legs folded on their chests like tiny mummies.

"Where are my bugs?" I wailed.

Mom had been outside somewhere, but she must have heard me, for she now appeared in the doorway. "Oh, Amalyah," she exclaimed, seeming to frown and smile at the same time. "Your time of keeping bugs inside our house has come to an end."

"But where are they?" I insisted.

"Let me tell you what happened," Mom said, sitting on the doorstep. "Last night, as we were falling asleep, Dad began scratching. Then I began scratching too. We got up and turned on the lamp. When we looked in our bed, Amalyah, there were bugs all over the sheets!"

I patted the plastic ball. "My bugs escaped!" I cried in dismay.

Mom nodded. "Yes, your bugs somehow escaped from the ball and climbed into our bed. Dad said that from now on your pets have to live outside."

"Did you save the bugs?" I asked.

Mom shook her head. "No. Dad gathered up the sheets, and we took them outside and shook them into the grass. You know that Dad needs his sleep. He has to get up early to go to work."

My lower lip began to protrude and I pouted for my bugs. Mom tried to comfort me as I cried, but I continued to mourn the loss of my little pets.

"The bugs are no help to the kibbutz," Mom said, apparently trying to distract my thoughts. "Some insects are harmful to the crops or even carry diseases. It's more important to take good care of our kibbutz than it is to protect every little bug. Do you know," she continued, "that when we first moved here, there were no trees at all? All this space," Mom waved her hand toward the surrounding area, "was just fields and meadows."

I sniffed, and Mom handed me a handkerchief. "Even before the Israeli War of Independence, settlers were coming from all over the world to form these communities."

I am not sure how much of this information actually sank into my mind at the age of seven. In any event, it was intriguing to me that our apartment, or "room" as we called it, had been built on an open field along with the other rooms in this four-apartment unit. I tried to imagine no trees, no houses, and no buildings where our complex now stood.

"You see," Mom continued, "before the war, the British were in control of the land of Palestine, as it was called then. However, the Zionist movement was already underway and building momentum. Settlers would arrive, usually by boat, and would move into an area overnight and quickly put up a wooden fence and a rickety watchtower. It had to be done quickly, because if the British soldiers would catch them building the fence and the tower, they would order them to stop or destroy the settlement. The law did not permit the building of new settlements.

"However, the law also forbade the British soldiers to destroy an existing settlement. If the tower and fence could be secretly built during the night, by morning the settlers could claim it was an existing kibbutz. All over the land, many kibbutzim were springing up overnight. So many Jews were arriving and staking out claims that the British soldiers could not keep watch over everyone."

"Did you help build our kibbutz?" I asked, forgetting about the missing bugs.

"No," Mom replied, "I was still living in America at that time. I came after the war was over."

"And the people lived in the old houses at first," I said, referring to the simple wooden structures that stood close to the livestock barns.

"Yes," Mom laughed. "When I first arrived, that is where I stayed. Since

those houses had already been built by the time I came, I lived there while I helped work in the fields and in the kitchen."

"Then you and Daddy got married and had Deborah and Hannah and Rafael."

"Something like that," Mom chuckled. "And then later we had you, a surprise baby. I thought I was too old to have any more children."

I looked up into my mother's face. "What if I hadn't been born?" I inquired. "Where would I be?"

Mom laughed and put her hand on my head. "Child, you have such deep questions. I don't think you would be anywhere. We either are or we aren't."

I lifted my hand and watched as I gently waved it in the space between us. "But I am," I said in wonderment.

"I am glad you are," Mom smiled.

I liked to hear that. It comforted me.

"Amalyah, come help me with a project," Dad said, interrupting my thoughts as he came around the side of our house.

"See, right between our window and Roni's parents' room, I am building a set of shelves," Dad told me as I followed him.

"What are the shelves for?" I asked, hopping on one foot.

"For you." Dad smiled his brief smile.

"For me?" I echoed, stopping in mid-hop.

"What is that for?" another voice inquired. Roni must have seen us outside and had joined us.

"Shelves," I told him, and then turned to Dad. "What am I to do with the shelves?"

"It is for your collection," he told me.

I stood stock still and my eyes widened. "For my collection," I breathed. "For my pets."

Roni laughed. "For your bugs and toads and beetles and anything else that breathes and moves." He was my constant playmate and knew my fascination with all things living.

I squealed with delight and ran to the house. "Mommy! Daddy is building shelves for me to store my collection!"

Mom smiled and allowed me to tug her outside. The sun was already

setting, and the trees to the west cast long, thin shadows on the grass.

"Amalyah!"

I looked around to spot Roni. His voice sounded quite close, but I could not see him anywhere until a piece of bark fell in front of me and I looked up into the pine tree in our front yard.

With a shrill cry of glee, I sprinted to the trunk of the young pine and jumped up to reach the first branch. As skillfully as a cat, I climbed up to where Roni was clinging to the trunk and laughing at me.

That evening, I collected all my jars with specimens, cocoons, and various oddments from the tiny front entrance hall and placed them on the new shelves. I breathed a deep sigh and pried some pine pitch from between my fingers.

It was dark by now, and I tried to put off the inevitable daily parting with my parents. How I wished I could just stay and sleep in our own home. Never mind that ever since I was six weeks old and had been moved to the baby house, I had never slept here except when I was sick. I still wanted more than anything else to sleep in my parents' house.

The familiar melancholy feeling stole over me and stilled my liveliness. Mom came outside and stood beside me on the front step.

"Look!" she exclaimed, pointing to the sky. "It's the evening star!"

Venus sparkled just above a treetop, and as our eyes adjusted to the darkness we could gradually see other stars.

"Mommy, who made everything?" I asked curiously. "Who made the sky and the earth and everything?"

"It all just came about with a big bang," Mom said smoothly. "Millions of years ago. From nothing."

"Well," I persisted. "Who made nothing?"

"No one made nothing," Mom laughed.

I shook my head. "That can't be," I insisted. "Someone made everything and nothing."

The darkness crept over the sky.

"I wrote a poem today," I told Mom. I could always tell her everything, for I knew she was interested in my life.

I recited it to her from memory and promised, "I will bring it home tomorrow for you."

"The sky looks like a dark bowl turned upside down," Mom said musingly.

"With little holes where the light shines through," I said dreamily. "We call them stars."

We sat silently for a minute. Then I asked, "Are we on this side or on the other side?"

Mom did not answer, for just then Roni came bounding out of his parents' house. "We're going up to the dining room; let's run ahead!" he yelled and began running toward the community dining hall.

I did not want to be left behind, so I jumped up and raced after him, leaving my contemplative moments behind and entering once more into the daily routine of life on our kibbutz. Roni's parents, together with Mom and Dad, strolled behind us until we all arrived for dinner. Our main meal had been in the middle of the day, as usual, so we ate bread and cheese and drank milk until it was time to go back to the children's house. Parents with children, including some babies in strollers, were all heading toward the children's houses, each child according to his age group. Mom and I walked slowly.

Soon we will reach the house, and Mom will tuck me in, kiss me goodnight and leave, I thought. Oh, how I wished she could stay.

2

"AMALYAH! COME OVER HERE!"

It was Roni, and he was standing on top of the magnificently high slide in the playground, his arms spread wide.

"I am the watchman, looking for the enemy and waiting to sound the alarm at first sight!" he shouted.

I ran over to join in the fun. "Esther! Can you see any enemy soldiers?" I yelled to my friend.

Esther stood up and peered intently through the trees. Suddenly she became very excited. "Yes! Yes! They're approaching!" she shrieked.

So real was her excitement, I could almost imagine a troop of soldiers marching toward the kibbutz. "Where? Where?" I questioned, straining to see what she was seeing.

"Right there." She pointed up at the sky. "A group of seven—no, eight! Oh, they are terrible enemies, all dressed in black!" She covered her face and shuddered.

The flock of crows that flew overhead skimmed away on rapid wings, never realizing what a wonderful sensation they were causing for us down below.

"Watchman shift is over," Roni shouted, and came feet first down the slide.

I climbed up the ladder and sailed down the slide after him. Esther followed me, and we whizzed down one after another.

As I hit the ground and turned to climb the ladder again, I spied a stick

lying on the grass. I grabbed it and pushed it between the middle supports of the slide. It lay across the top of the metal sides, just high enough for us to slide underneath as we shot down the slippery slope.

"Look at this!" I shouted. "I made an obstacle course!"

Heedless of my new venture, Esther had already launched herself down the slide. Obviously she did not see the stick, for instead of bending down to slide underneath it, she slammed into it at high speed.

With a yell of pain and surprise, Esther was stopped with a thud in mid-slide. The slide was long and steep, so the poor girl had already picked up speed even in the middle of her journey, and the impact almost knocked the breath out of her.

In the melee of screaming children, Yaffa, our school caregiver, came running and helped the sobbing Esther off the slide.

"Amalyah did it! Amalyah did it!" The accusing cries of the *Katzir* children gave me no chance for explanations.

"Shame on you!" Yaffa yelled angrily. She glared at me with a look of disgust. "You were utterly heartless. Why would you do such a dreadful thing?"

I was already hurting deeply for what I had accidentally done, feeling very sorry for Esther, but I had no idea how to show my contrition. When the cries of my playmates assaulted my ears, and the scolding and shame came harshly from my caregiver, I turned and ran as fast as I could away from the playground.

Tears were streaming down my face, and I wanted desperately to hide somewhere. I had not consciously thought where I would run, and yet my legs knew where my heart wanted to go. Almost before I knew it, I was rapidly climbing the pine tree in front of our house.

I climbed high enough that I could not see anyone on the path below me. Then I hugged the trunk with both arms. My breath came in rapid gasps, and I kept replaying in my mind the sight of Esther crashing into the stick.

I clung to my lonely perch for a long time. Eventually news of the incident must have reached my mother, who was working in the laundry that month.

"Amalyah!"

I heard the soft tones of my mother's gentle voice reaching through the pine branches. I said nothing.

"Amalyah, come down now." She knew where I liked to hide.

Still I did not move. I could hear that Mom was not angry at me, and yet I did not want to leave the comfort of the tree.

"Amalyah, I am not blaming you for what happened. Esther is a little sore, but she will be all right. You can come down."

Slowly I began my descent to the ground. The warm weather had caused the pine sap to ooze profusely, and by the time I reached the ground, I was a sticky mess.

"Come," Mom said calmly, "let me help you clean up."

As she applied turpentine to my legs and arms to scrub off the pine pitch, Mom spoke to me. "It was not a wise thing to do to put that stick there on the slide, but I do not believe you meant to hurt anyone. There is nothing for you to be worried about."

I could still hear Yaffa's voice. "But the children all yelled that it was my fault, and Yaffa scolded me!" I sobbed.

My mother shook her head. "When there is an accident, people immediately think they have to blame someone. Yaffa, without thinking, immediately assumed that you meant to hurt your friend. In our frustration, we often look around for someone to blame. I believe that by now Yaffa realizes that you did not mean to do it. It was only when she heard the screams of Esther and the accusing voices of the other children that she did what comes naturally."

Mom was like that. She could explain things to me in a way that helped me look at things from a different perspective. However, I did not feel better this time.

"We need to go back to the children's house now," continued Mom.

"But I don't want to!" I cried.

"You must be with them, and I need to go back to work," Mom stated.

"Pick me up and carry me!" I demanded.

"But Amalyah, you are so big already, and too heavy for me," remonstrated Mom.

I sat down defiantly. "Pick me up, or I'm not going," I insisted.

With a weary sigh, Mom picked me up and carried me all the way back to the children's house. Although many Israelis viewed kibbutz life as an ideal

way of raising children, we children selfishly thought life revolved around us. Even though the adults occasionally disciplined us, we had become little tyrants, expecting the adults to cater to all our whims and wishes.

◌ ◌ ◌

Yom Ha'atzmaut! May 14, Israel's Independence Day, had arrived. Celebrations were in full swing at our kibbutz, where everyone loved a party. The hardworking adults were glad for a day off from their usual hard work of running the community. We children loved the extra food and the festivities.

The celebrations were often held west of the community buildings in the rolling meadow which was now crowded with people. Blankets were spread on the grass, and small children and toddlers tumbled about, under the care of their own parents for the day.

"There is a big plastic pool with live fish," someone told me gleefully. The news passed from one person to the other. Families were all sitting under the trees, preparing for the picnic. "Each family gets to choose one fish for their barbecue."

"Go get us our fish," commanded my brother Rafael.

"And take this," added Hannah, handing me an orange bowl.

In my excitement at the prospect of having another pet, I chose not to hear the part about cooking the fish for a barbecue. I eagerly raced the short distance from my family's blanket to the fish pool, swinging the bowl in anticipation. A cluster of people had already gathered eagerly around the pool.

"I want to see!" I yelled. I pushed and wormed my way through the crowd until I could see the plastic pool full of fish—large fish! There seemed to be more fish than water as they thrashed around in agitated circles.

Everyone was laughing and jostling to get in position for their catch. "Do you want to get your family's fish?" someone asked me.

"Yes! Yes!" I danced up and down with excitement.

"Just reach in and grab one. I'll help you!"

I shook my head. I didn't want to grab just any old fish. Mine was going to be special! I watched as other people began pulling fish out of the water

and tried hard to figure out which one I wanted.

"I want that one! He looks sad." I pointed to a big fish swimming in circles.

"Amalyah wants the sad one!" The shout went up, and helpful bystanders pushed my choice into my waiting hands.

The fish was too big to even fit in my bowl. His tail hung limply over the side.

I struggled to carry my heavy prize as I turned and walked away from the pool. "Poor fishy!" I whispered, stumbling across the meadow.

"Amalyah, come here! Bring it over here!" I dimly heard Dad's voice calling me, but I just walked on past my family and continued on my journey.

"Amalyah! Where are you going with that fish?" Hannah demanded.

But I didn't answer. I ignored the questions and kept going, determined to accomplish my mission. I imagine they suddenly realized that my love for all things living had made a pet of our lunch, so they said no more.

I walked back to my parents' house, filled the kitchen sink with water, and dumped my prize into his new home. "There, fishy, you have more room now," I panted, slightly out of breath.

My fish was still crowded in the sink, but he did have more space than in my bowl or in the crowded fish tank.

"You are so big!" I said softly to him, reaching in to stroke his back. The fish recoiled in fear, retreating as far as the sink would let him.

I'll train him, I thought. *Then he will let me touch him.* I looked at my fish and marveled again at my good fortune. "You're so much bigger than the goldfish in school," I told him proudly.

One of my favorite activities in school was spending time beside the fish bowl, watching the goldfish swim about. I already knew it could be deadly to feed them too much, so mostly I watched as they darted about.

"He went to the bathroom!" I would shout excitedly to my classmates if I was able to catch that memorable moment. For some reason, that always brought the whole class running. They, too, liked to witness this exciting phenomenon.

Now I patted my fish once more and returned to the meadow to rejoin my family.

"Look, we got another fish, and it's been cooked," my siblings told me. "Do you want some?"

I had no qualms about eating the other fish. The flaky, moist meat had no direct connection with my pet at home.

My parents dutifully admired my new pet when we went home that evening. I fed him bits of bread, and was delighted when the fish opened his big mouth and gulped down the tidbits.

"We'll move him into the laundry tub where he will have more room," Mom said. "I really do need my sink."

I danced around with excitement. When it was time to return to the children's house that night, it was hard for me to leave my new catch. More than ever, I wished I could stay and sleep at my parents' house.

The next day I dashed breathlessly into our house and ran over to the laundry tub. There he was! I fed him again.

In my excitement, I must not have sensed that my parents were not reconciled to my new pet. I simply ignored their gentle comments about fish being intended for food, not for pets. But I certainly found out the next day when I came running in from school and found the tub empty. No big fish. No water.

"Mommy!" I wailed. "Where is my fish?"

"You know, Amalyah," she replied evasively, "Rayah really knows how to make those tasty fish patties we all love. You can go to the fridge and get some right now if you like . . ."

My piercing wail rent our house as I realized what she was saying. *No, no! She didn't! Surely they didn't kill my pet for food!*

I refused to eat any fish that evening. All I could think of was those big round eyes, looking at me gratefully, as I had imagined, for saving him. Now he was gone. I mourned brokenheartedly.

◊ ◊ ◊

"Psst!"

I heard the whispered hiss from one of the girls and cautiously lifted my head from under the blanket where I was reading by the rather feeble beam of a flashlight.

"Blankets!" the girl whispered.

There were four single beds in our room, and from every bed a blanket was now thrown onto the floor. The only light in the building was shining dimly from the hallway that connected all the sleeping rooms.

We all knew the game, one of many we had invented to play after lights out. The game we called "Blankets" was one of our favorites.

"Amalyah, you go first."

"Okay, hide your eyes," I said excitedly, hardly remembering to keep my voice down to avoid alarming the night guard.

The mattresses rustled as the other three girls hid their faces. I scampered out of bed and noiselessly tiptoed to the rumpled blankets. First I stuffed my pillow under one of them, trying to make it look like I was hiding under there. Then I burrowed beneath another blanket until I was completely covered, my legs partially hidden underneath Esther's bed.

Then the fun began. The three girls all scurried onto one bed.

"I think the blanket closest to the door is hiding the animal," I heard Lilly say.

"No," Efrat said boldly, "it is under the blanket at the foot of this bed."

I had a choice. I could either hold perfectly still, or I could jump up and try to scare them while they inspected the rumpled blankets.

Since it was dark, it was easy for me to decide which I wanted to do. I leaped up with a fierce growl and sprang toward them.

The scream that came from my three bunkmates was not quiet. But they covered their mouths hastily and fled from me as I pursued them with my blanket flowing out behind me.

"Let's play hide and seek," suggested Esther after several rounds of the blanket game.

It might seem there are not many places to hide in a small room with only four single beds, but we were quite innovative. One of the rules we made for this game was that we could not go outside the room to hide.

Lilly sat on her bed and we covered her with a blanket. Then we scattered to find hiding places.

I had wanted to try a new hiding place, and I decided tonight was the perfect time to carry out my plan. I climbed up on the windowsill and pushed myself through the gap between the sliding shutters. I stood hidden behind the shutters, balancing on the narrow windowsill and clinging to

the window frame for support.

Inside, I heard Lilly begin her search for us. There were muffled squeals and thumps as she found Esther and Efrat.

"I can't find Amalyah," Lilly said after a while. "Help me find her."

I giggled softly.

"She left the room," Efrat said in disgust. "That is not allowed."

My hands were still clenching the window frame, but I did not move.

"If she is in the hall, I will tell the watchman," Efrat threatened after more fruitless searching.

When a tousled head was thrust through the window and appeared right beside my foot, I couldn't resist. I scraped the shutters loudly.

The scream that pierced the night was not in the least bit muffled. It was loud and frantic.

"Shh!" I gasped as I scrambled back inside. "Oh, now you got us into trouble!"

"You are the one who got us in trouble," Efrat scolded. "You left the room!"

"I didn't leave the room! I was on the windowsill the whole time!" I reasoned.

We had no more time to argue, for the main door opened, and the night guard was in our room before we could jump back into bed and pretend we were asleep.

"All right, you know what this means," he said. "I'll have to record this in the night log for your group. You girls will get in trouble!"

All of our complaining, arguing, and trying to blame each other were to no avail. The guard was firm, and finally we gave up and crawled into our bunks.

I lay quietly in bed, feeling lonely and desolate. I resented having Efrat blame me for the disturbance.

Our children's group was known to be noisy. Most evenings, our rambunctious pillow fights or gymnastics on the beds were tolerated, but occasionally the residents of a particular room crossed the line, as we had tonight, and could expect a punishment of some sort.

Although all the children's groups had supervisors, the night guard often complained that our group was so noisy he could not even hear if the toddlers in the other house were crying.

I lay still, my eyes wide open, staring at a patch of dim light shining in from the hall. Suddenly I saw something black moving across the floor.

"Help!" My terrified cry brought instant echoes from the other three girls. I snapped on the light and pointed. "A cockroach! A giant, nasty roach!" We looked at each other and screamed.

No one had to make the suggestion. We all jumped out of bed simultaneously and dashed out into the hall. Running swiftly in our bare feet, we raced through the hall, out the front door, over the stoop, and into the night.

My feet knew just where to go as did the other girls' feet. We all headed for our parents' rooms. No one had ever actually told us that if there were emergencies we were allowed to spend nights with our parents, but somehow we knew. And this . . . this was certainly an emergency!

On the occasions when I was sick, I was allowed to sleep in my parents' tiny house. I did not mind sleeping on the couch, if tucked in by my own mother. I did not mind at all that my parents were just across the small room at the other end. And tonight I did not care about anything except staying out of reach of the giant cockroach.

Through the night I fled, past the dining hall and down the hill, underneath the trees that made the darkness shadowy and mysterious. Past Roni's parents' house, and then I was home!

"Mommy!" I gasped as I flung myself against the door and scrambled to find the latch.

"Amalyah! What is the matter? What happened?" My mother was at the door.

"A roach was in our room! A really, really big one!" I gasped, and for effect, held my hands far apart and opened my eyes as wide as possible.

"A cockroach?" I heard my father's voice from the bed.

"Yes! A gigantic, scary one. It was awful!" I headed for the couch.

I think that deep inside, my parents were just as happy to have me with them for the night as I was to be there. I felt the warm, comforting blanket around my chin and squirmed with delight. Ah! This was where I wanted to be. This was where I belonged.

"A roach," I heard my father say sarcastically when Mom returned to bed. "So Amalyah is terrified of a roach."

The irony was lost on me, but I am sure that both my parents were thinking of the endless collection of bugs and creatures that I kept on the shelves on the side of the house. But on this night, I did not care. I was at

home. No one was going to make me go back and sleep in the children's house tonight. There was a roach there!

3

I KNELT IN MY LITTLE GARDEN PATCH AND FONDLY PATTED THE SOIL AROUND THE carrots. The tiny green fronds reaching toward the sky pleased me immensely. I was so glad we had been given a space all our own in the garden.

"Let them have a small plot," Yaffa had told the gardeners. "They will learn more about germination and horticulture out here than if they read about it in textbooks."

It was true. Each of us were given our own patch of soil, and we did learn far more than we could have from textbooks. We were instructed on how to prepare the soil, how deep to sow the tiny seeds, and how to carefully cover the seeds with good soil. We checked the gardens daily to see if our seeds had sprouted, and we worked to keep the soil damp, but not too soggy.

"My lettuce is up!"

"I've got radishes!"

Our exultant cries rang out excitedly day after day.

"Your carrots are big enough to pull," said a voice behind me. "I've already pulled a lot of mine."

I didn't even turn around. I knew Efrat's voice.

"No," I said. "I want them to grow bigger. See, I already thinned them out so they can grow without being crowded."

It had been hard for me to pull out healthy young plants, because I found it hard to believe that the remaining carrots would actually grow big

enough to need all that space. But Yaffa had told me it would be so, and I had obeyed. Now my obedience was being rewarded.

"See how big they are," I marveled.

I should have known that Efrat would not tolerate being upstaged. With a quick movement, she bent over and jerked up two of my biggest carrots, dangling them mockingly in front of my face.

The bitter pain of an action that cannot be reversed pierced me with frustration. Efrat's taunting face was thrust forward, daring me to do anything to her. I was not as tall as she was, and she knew that I couldn't run as fast as she could either.

She took off running, turning her head and chanting, "Can't catch me, Amalyah! Can't catch me, little Amalyah!"

"I don't fight, I get even," I muttered to myself. I was nine years old by this time, and I knew I had to outsmart my bigger friends.

Before naptime that afternoon I went to the sink in the hallway and took my time washing my hands. Sure enough, Efrat soon showed up, still dangling the carrots in front of my face. "You couldn't catch me, little Amalyah!" she sneered, while chewing noisily on my carrots. Calmly I took the glass I had prepared ahead of time and dashed the cold water right into her face. Then I sped down the hall and ran into our room.

The angry girl came storming right behind me, armed with a glass of water of her own. But I was prepared for that too. I jumped up onto her bed and said, "Go ahead and dump it on me if you dare. Your bed will get wet, and you'll have to sleep on it!"

Breathing threats at me, Efrat circled her bed. I kept turning to face her.

"Get off my bed!" she ordered. "Get off my bed this minute."

Esther and Lilly watched our conflict. "You girls better quit," said Lilly, the peacemaker of our room. "If the caregiver catches you, you won't be allowed to go outside after naptime."

"Get off my bed," Efrat kept demanding.

"I will get off your bed when you dump your water out the window," I replied serenely.

Knowing she was defeated, Efrat grudgingly dumped the water out the window, and we went to bed for our daily nap, the conflict smoothed over

but not forgotten.

That night I lay awake in bed for a long time. Even though I knew I had defeated Efrat in our little spat, it did not bring me the thrill I expected. I felt restless and unhappy, tossing on my bed and yanking at the sheets as they seemed to wrap themselves around me.

My life seemed normal enough. I had food, clothes, shelter, and friends. From the outside, it would have appeared I had everything a child could want. Our instructors did everything they could to make our education interesting, and there was scope for our imaginations to soar. In spite of all this, I still wished I could be at home with my parents. Even though I had no memories of sleeping regularly in my parents' house, I knew that was what I wanted. I hardly knew any children who lived with their parents, but I knew from the many books I read that for most of the world that was considered normal. Children were a part of the family and lived with their parents in that world.

0 0 0

I sat upright on my horse, holding the reins in my right hand and the Israeli flag in my left. Behind me, the band was playing, followed by more riders on horses.

Our entire kibbutz was assembled in the meadow where the Feast of Harvest, or *Shavu'ot,* was being celebrated by the kibbutz members.

Oh, how we loved our festivals! Now the first harvest celebrations were in full swing. The children wore crowns made of flowers, and the teenagers from the kibbutz carried baskets of lettuce, radishes, and spring onions. A few carried lambs or led young calves tied to decorated ropes. We all waved wildly and cheered lustily. Another day of feasting and celebrations meant another day without work, except for those delegated to feed the animals or prepare the food in the community dining hall.

We gathered our mounts into a semicircle and the teens gathered in the middle. Cheering, they lifted their baskets and chanted, "Our baskets on our shoulders, our heads crowned, we came from all over, we brought the first fruit."

It was June, and the early summer sun was shining joyfully on the golden fields. The harvest was abundant this year! I did not know then that the Orthodox Jews celebrated this holiday as the day when God gave the Pentateuch, or the Old Testament laws, to Moses on Mt. Sinai.

"Don't talk about God. We are modern Jews!" That was the sentiment of most of the kibbutz members. In fact, even mentioning God was considered unlucky, and any reference to Him was to be avoided. So even though we were keeping an ancient feast, celebrated by Jews everywhere, we definitely were not observing it as a religious holiday. We were secular Jews, and we were proud of it!

There were foot races, sack races, and competitions of all kinds on that day. After the sumptuous feast of freshly baked homemade bread and all kinds of cheeses, there was dancing and music and revelry.

"Let's go to the far tree," I suggested to the rest of the *Katzir* members.

"No, let's go to the rocks!" Roni yelled. "The far tree is not even far anymore. It's for the little children."

"The wadi! The wadi!" We children jumped up and down with glee at the thought of playing in the dry creek bed.

I don't remember that we bothered to ask for permission. The kibbutz and its environs were ours to explore. School was out for the day, and the regular schedule had been abandoned. We were free!

A huge group of children ran across the newly harvested wheat field to the lone eucalyptus tree that we had known as the "far tree" for as long as we could remember.

That tree had been the scene of many of our escapades and games. We had dangled from its branches, danced around its trunk, and eaten our picnic lunches in its shade.

"On to the rocks!" Roni shouted as we streamed past the far tree. "On to the wadi!"

The rocks were a jumble of large boulders, and we loved to play among them. It was amazing how many different shapes they took in our imagination. They could be huge sea turtles as well as ships. They could be forts or bridges from one island to another. Nooks and crannies provided secret places to hide from imaginary predators.

"Look!" Roni pointed. "Water!"

"The wadi is still flowing," I yelled.

In a flash, we were down in the water, feeling the tug of the murky current as the rain-swollen river flowed through the wadi. During the long summer, the wadi was dry, and grass even grew in the bottom of it.

We were not the only ones there. The two older groups of children had already discovered the swollen creek. Someone had brought pieces of Styrofoam that had once encased large appliances, and had tied the pieces together to make a boat.

What a wonderful afternoon we had! We took turns riding down the wadi on the boat. No matter that we got thoroughly drenched and dirty. No one was there to scold us, and I don't suppose anyone really cared. We splashed and dunked and enjoyed every kind of water activity we could think of.

"Hang on!" One of the teenage girls yelled at me as we took our turn riding downstream. I looked into her laughing face and suddenly felt strange. Right there in all that activity, I realized that I was growing up. One day soon I would be a teenager like her. It gave me a strange feeling.

My brief moment of reflection pushed aside, I immersed myself again in the *Shavu'ot* activities around me.

❁ ❁ ❁

"Did you feed the geese yet?" Esther asked me.

I shook my head and replied, "No. Why don't you feed them this time?"

"Are you scared?" Esther asked.

I shrugged my shoulders. Actually, I was scared, because the old gander seemed to pick on me.

"Take a stick to that old gander," Esther said bravely, guessing the reason for my hesitation. "He will run then."

"Show me how," I said slyly. "I need to see how it's done."

"I am scared too," she admitted.

"Girls, have you fed the geese?" asked Moshe, the director of the petting zoo, walking up to us at that moment.

We shook our heads. "The gander attacks us if we do," I explained.

Moshe tipped his head back and laughed at us. "He knows you are scared of him," he explained. "You have to learn to boss him. He just wants to protect all his wives."

"He is married to all of those geese?" This intrigued me.

"Oh yes! He is their husband, and he constantly needs to show off in front of them so they are impressed by his power. He is the king!" Moshe teased.

I looked into the pen where the geese were kept. The gander turned his head majestically and then lowered it, straightening his neck and hissing.

"He doesn't look like a king to me," I said, scowling back at the beady eyes. "Looks more like a tyrant or a dictator."

"Whoa!" Moshe said with a note of respect in his voice. "You girls are getting educated. Tyrant, dictator. What big words for small girls!"

We giggled, knowing that Moshe, like many of the kibbutz founders, had emigrated from Eastern Europe. As young children, they'd had to quit school and flee the Nazis, so now they were proud to see us learning and using Hebrew fluently.

"Here, take this stick in with you, and hit him on the head if he tries to bite you," Moshe directed.

Right then I did not care how educated Moshe thought I was. He was braver than I was, and I needed his support.

All the elementary school children took turns working at the petting zoo. It was preparation for high school when we would actually join the various work areas of the kibbutz as a team several times a week.

I grabbed the stick in my right hand and took the pail of feed in my left hand. Gingerly, I pushed the wire gate open with my foot.

Immediately the geese all stretched out their necks, hissing and honking as they rushed toward the feeder. The gander led the charge, headed straight toward me.

"Beat him!" Esther yelled from her side of the fence. "Hit him on the head!"

"Wait until he gets close enough," Moshe told me. "If you swing too soon, he will get to you before you can aim again."

I had learned earlier what it felt like to get the worst of an encounter with the gander, so I forced myself to hold my ground until he was so close I could almost feel his hiss.

With a loud honk he took another step toward me, his wives encouraging him on with their own sinister hissing. I suppose there were only about a dozen geese in the entire flock, but to me it was a veritable army. I clutched my stick, holding tightly to the feed pail.

The gander seemed to swell even larger. I don't know if he hoped to make me abandon the pail so they could overturn it and gorge themselves, but he took another step toward me, honking his terrifying honk.

I swung that stick as fast and as powerfully as I could. Somehow, I hit him. Not his head, for he was too quick at dodging, but his long neck couldn't move as quickly, and my stick thwacked solidly against that white serpentine neck.

He stumbled and swayed sideways, his honk dying away feebly. The rest of the flock made up for his silence, honking frantically as they saw their leader attacked. At first I thought they were going to make a rush for me, but then the gander shook himself and led them in a rapid retreat, blinking his eyes in bewilderment.

The sight of all their feathered backsides marching off in undignified waddles was too much for my tense nerves, and I began to laugh hysterically.

Esther and Moshe were already laughing, and I joined them in whoops and cries of merriment at the expense of the defeated flock.

"Wow! You really taught him!" Esther said when she could finally talk. "You gave that old gander a lesson he won't forget."

"Watch him tomorrow," Moshe warned, wiping his eyes with his handkerchief. "He will be more cautious, but he might try to attack you again. With more respect," he added, slapping his knee and bursting into laughter again. "You certainly showed that guy who was boss! For a little girl, you can pack a mean punch."

I dumped the feed into the hopper, but not until I had left the pen did the geese dare to venture closer, complaining bitterly the whole time.

"Next are the turkeys," I told Esther. "You get to feed them."

"Oh, those old things don't bother me," she scoffed. "They are much dumber even than the geese."

"Remember when we were in kindergarten and we took our daily walk past the turkey pen?" I asked my friend as a vivid memory swept over me.

"One Friday the workers were butchering turkeys as we came by and . . ."

"Yes," Esther interrupted. "We stopped to watch, and saw someone chop off a head."

"And we didn't eat turkey for that Sabbath meal or for two weeks afterward," we finished in unison, laughing as we mimicked our caregiver's voice. We had heard her tell that story many, many times.

I remembered when I was younger and collected all kinds of living things. Now I was older, and even though I still liked animals and birds and amphibians, I no longer tried to keep a huge collection on the shelves outside my parents' house.

I realized I was growing up, and I wasn't sure I liked it. There were times when I was greatly pleased by all that I could do now. At other times, I was dismayed by some of the strange things that seemed to be happening inside me. Life seemed somehow more fragile and complicated.

"Come on! We still have to feed the goats!" Esther's voice brought me back to the task at hand, and I followed her to the barns.

4

"HE'S SO WEIRD," LILLY SAID SCORNFULLY. "HE DRESSES STRANGELY AND KEEPS telling those weird jokes. They don't even make sense."

We were in sixth grade and felt we could adequately judge the character of any current resident or newcomer.

"I don't know why anyone considers Mr. Theo, as he wants us to call him, a teacher," Yoni said, kicking gravel in the path. " 'Good morning, I am Theo, but you may call me Mr. Theo, as I am older than you are,' " Yoni imitated mockingly.

We all laughed.

"You know what?" I said. My classmates looked at me questioningly. "He might be a spy!" I breathed.

"A spy?" Efrat repeated skeptically. "Why would he be a spy?"

"Don't you remember?" I reminded them. "In that book from the library that we all took turns reading? It was about that Russian spy who was sent to America as a scientist. Soon he began to infiltrate government circles and send information back to Russia."

"I remember," Roni said. "You know what? I think Amalyah is right! He does act like a spy."

"No wonder he is so secretive," Esther said, her eyes growing wide with the thought. "After school he disappears into his room in the immigrant dwellings, and we don't see him until supper. Even then, he eats rapidly

and disappears again. He probably has a contact he connects with to pass on information."

"Let's question him today and find out," Yoni suggested.

<p style="text-align:center">◊ ◊ ◊</p>

"Mr. Theo, we are curious to know why you came to Israel," Efrat said after we settled into our classroom seats.

Mr. Theo raised his bushy eyebrows and looked through his black-rimmed glasses. "What makes you ask that?" he inquired.

Efrat shrugged her shoulders.

"It is interesting for us to learn about the people who come here to work," I said as nonchalantly as I could.

"Well, I thought it would be an opportunity for me to try my wings," Mr. Theo replied, looking at us expectantly as though he hoped we would understand his jest. When no one laughed, he opened his book. "Now everyone turn to page 231, and we will begin."

"You haven't told us yet." Esther went straight to the point after looking at us with an I-told-you-so look. "We really want you to tell us."

"That is not the topic of the lesson," Mr. Theo snapped, exasperated. "Please turn to . . ."

"It is our right to know," Roni insisted, and he sounded authoritative. His voice was already changing, and he was almost as tall as our teacher. "We want you to tell us."

"I . . . I . . ." Mr. Theo stammered, raising his hands and waving them nervously. "I wanted to know what life is like on a kibbutz. I wanted to experience something new."

"But you are not an Israeli," Efrat said bluntly. "You have a strange accent."

Mr. Theo frowned at us and tried again. "Could we continue with the lesson now? Open . . ."

"Mr. Theo," Yoni said bluntly, "we will continue with the lesson once you give us the information we want. We," he waved his hand grandly at our class, "feel it is important to know about the people working on our kibbutz. Would you be so kind as to answer our questions?"

Mr. Theo's shoulders slumped in weary resignation. "Okay!" he blurted. "I came here from Romania because I wanted to know more about my mother's heritage. My father is not a Jew, but my mother always kept all the traditions and observed *Shabbat* (Jewish Sabbath) and went to the synagogue every week. Sometimes I went with her, and sometimes I stayed at home with my dad. After I finished school and got my teacher's certificate, I applied to come here to Israel to teach on a kibbutz, and here I am." He folded his hands as though that were all there was to tell.

"Mr. Theo, did you work for your government before you came here?" I asked.

He looked startled; then dropping his eyes, he toyed with his pen briefly. "Why do you ask that?" he queried. "Of course I didn't work for the government. I came here right after I finished school." His eyes darted from one face to the next. "I . . . we . . . we must go on with class."

Exchanging furtive glances, we nodded knowingly. For the moment, we would question him no more. But we were more convinced than ever that there was some ulterior motive behind his presence in Israel.

"I believe he is studying our kibbutz methods and telling his Romanian bosses how best to conquer us," Roni declared after school. "You know there are many countries in the world that hate Israel."

"But Romania is not an Arab country," Lilly objected. "It is a communist country, and it's mainly the Arabs who are fighting against us."

We were silent for awhile as we digested this information. We all knew that the countries along our borders were continually agitated that Israel was even recognized as a country. There were constant skirmishes with hostile Arabs, not only on our borders, but even among those living in Israel and the disputed territories.

"Maybe Mr. Theo has a connection to the Arab carpenters who come to the kibbutz whenever we are building anything," Yoni finally suggested. "You know we just finished the new barn, and for the last three months the Arabs came and went every day."

We draped ourselves over the wooden fence outside the dining hall and considered the mystery we fancied ourselves to be solving. "Remember that tall Arab who always watched everything we did whenever we went close to

where they were building?" Efrat asked, swinging her long straight hair over her shoulder. "Maybe there's a connection with him."

The boys watched her, and I was once again keenly aware of my own black, frizzy hair, but I jerked my mind back to the issue at hand. "I don't think so," I said. "He was really nice to us. But, if our country is in danger of being spied on, it is our patriotic duty to watch Mr. Theo, assuming that is even his real name."

"You know what I just remembered? I read that if someone is under stress, and suddenly something extraordinary happens, they usually buckle and spill the information," Esther said excitedly. "Amalyah said it is our patriotic duty, so let's plan on doing something."

The boys jumped on the idea right away, enthusiastically making plans for an ambush. "I don't know about this," Lilly said dubiously, but her misgivings were ignored.

That afternoon we waited until Mr. Theo left the children's house. Then, instead of going directly to our parents' homes, we quickly exited through the kitchen and took a shortcut as we ran quietly to the immigrant lodgings. Roni carried a bag.

It was easy for the three boys to position themselves in the bushy garden next to Mr. Theo's front door, for he was conveniently staying in the end room. The rest of us hid behind a shed facing the house.

The crunching sound of footsteps came closer as Mr. Theo walked over the gravel path. He had almost reached his door when the three boys jumped out and threw clouds of cattail fluff all over the unsuspecting man.

"Tell us where you are from!" they demanded. "Tell us the truth! You are a spy for your country!"

The startled yells of surprise and shock that came from our teacher were not coherent to those of us who were hiding, so we boldly advanced to where the confrontation was happening.

The boys kept on asking the prescribed questions, and Mr. Theo kept on sputtering and spitting fluff out of his mouth while bellowing with rage. "You are going to get in trouble for this! What are you asking? This makes no sense. I know you think I am weird because I don't speak your language fluently, but I don't deserve this!"

Realizing that our primitive methods of trying to elicit information from our teacher were to no avail, we left the poor man alone.

◊ ◊ ◊

"You thought Mr. Theo was a spy?" the main director of the kibbutz's education system asked us incredulously. "Whatever made you come to that conclusion?"

Our parents had joined us for the meeting that had been called. We tried to appear nonchalant, but I, for one, was a little worried.

"He is so mysterious about his past," Efrat sniffed. "We asked him why he came to Israel, and he said that he wanted to fly with his wings or something."

"Fly with his wings?" Mr. Stein was puzzled.

"See!" Roni inserted, "he keeps saying these weird things all the time. We don't trust him."

Mr. Stein looked at us and then at our parents. "Mr. Theo is not a spy," he said patiently. "We checked his qualifications carefully before we accepted him, and his résumé was solid. Maybe he has different customs, but don't we all? We who live here in the kibbutz have come from a variety of cultures and backgrounds, but we believe that everyone should be given an equal chance in life. We have learned how to live with each other and make community living work. I hope the children who grow up here are not becoming closed-minded and rejecting others who seem different." He paused to let this sink in.

"We want absolutely no more of this kind of behavior," he continued, and I saw my parents nod their heads in agreement. "We are known for our openness and acceptance of diverse ideas. Let it never be said of us that we drive people away by our behavior. Remember that. To reinforce this lesson, you will take turns cleaning the bathrooms, and there will be no recess for a week."

In spite of his stern voice, Mr. Stein couldn't hide a slightly amused smile. "I know you meant well," he said, "but in the future, you need to let us adults make the important decisions. Do not take action without consultation."

We had largely tuned out the director's voice as soon as he pronounced

our sentence, and we were only vaguely aware of his final words.

"No going outside for a week! That stinks," Yoni muttered sullenly under his breath.

As sixth graders, we were old enough to form our own ideas. As undisciplined as we were, we were fast becoming insolent and self-willed. We had early realized that the lax child-training methods of the kibbutz gave us a certain kind of power. We learned to stick together and push our ideas through, whether the adults liked them or not, and we were arrogant enough to think we could live our lives without adult "interference."

◊ ◊ ◊

I paused before crossing the threshold of my parents' house. I could tell by the light in the kitchenette and the sound of low voices that my parents had already gotten up from their nap.

I loved it when they were awake before I came home. Mom was always up in the afternoon, but Dad needed more rest, and when he rested, I had to be very quiet. Today they were both awake, but the tone of their voices told me they were arguing . . . again. It was not the first time that I had noticed the growing friction between my parents.

"It's getting worse," my brother Rafael had told me recently. "When I was younger, I remember hearing them fight a few times, but now it happens all the time."

As I reached for the doorknob, I heard my dad's stern, authoritative voice. "You always take other people's side and make excuses for them. They will step on you and take advantage of you if you show this kind of weakness."

As I rattled the doorknob, I saw Mom clench her teeth and stamp her foot in frustration. I knew as well as she did that it was no use talking or trying to explain a different point of view. Dad had his opinion, and as far as he was concerned, that was the end of the story.

"Amalyah, are you home already?" Mom exclaimed, but her suddenly cheerful tone could not entirely mask the anger she was feeling.

Dad got up with a sigh, lit a cigarette, and went to the porch with the newspaper.

The tension in the atmosphere did not dissipate. Like a heavy but invisible cloud, it hung in the air. I hated it and wished I could reach out and brush it away, but it crept into my heart. I could feel Mom's pain and resented the way Dad disregarded her opinions. I wished in vain that I could do something to fix this mess.

"Mommy, look what I found." I opened my hands and held out my offering, hoping she would get distracted from the argument.

"Oh, Amalyah!" Suddenly she covered her mouth and began to laugh. "Mice! Ugly little pink mice!"

"They're not ugly," I protested. "Look, they are hungry. See how they keep opening their mouths, trying to find something to eat?"

"Where did you find them?" Mom was trying to sound interested, but I could tell her mind was still on the interrupted argument.

"In the petting zoo, under the turkeys' water dish," I told her. "I went to see the new baby goats after school and noticed the turkeys didn't have water. When I lifted the dish, there was a nest with these cute little creatures. Oh, Mommy, if Moshe would have found them, he would have drowned them for sure!"

"So you saved them." I knew the bitterness in Mom's voice had more to do with her recent quarrel than with the mice.

"Yes," I told her eagerly, hoping to somehow clear the air. "I'm going to feed them with that little dropper. I need to warm some milk for them."

"Here, take this," Mom said resignedly, handing me a small saucer. "Watch that you don't overheat the milk."

"Mommy," I asked as I watched the pot carefully, "what kind of childhood did you have?"

"Child! Why do you ask such a question?"

I poured a little milk into the saucer and put it on the stove. My babies were safely tucked into a shoebox.

"Just because I want to know," I replied, stirring the milk with my finger.

"Well, you know I grew up in the United States," Mom began. "I just had a normal childhood. Well, kind of normal, I guess, but we were poor. I saw how people treated each other very differently depending on how many possessions they had, as if your wealth determined your worth.

Somehow I always believed there was more to be had from life than what capitalism offered. I went to school and got a good education, hoping that would be the key to improving my situation. There I got involved with the youth movement called *Hashomer Hatzair,* or the Young Guard. In that movement we were all friends and equals. It didn't matter how much you had or how you looked. We were united in our Jewish identity and in the dream of one day helping to build the nation of Israel. We wanted Israel to become a place that all Jews could call home, where everyone would have an equal opportunity in life and no one would feel left out. When I heard I could emigrate from the States to Israel, I came here and met Shlomo, your dad, and well . . . that is all." She shrugged her shoulders, filled a glass with water, and took a drink.

"What kind of life did Dad have?" I asked. "He never talks about his childhood." I drew some milk up into the dropper and dribbled a little on the snout of one little mouse. I was immensely pleased when a tiny tongue slipped out and licked the milk droplet. "It's drinking!" I shrieked triumphantly.

But Mom didn't seem to notice my ecstasy over the mice. "Your father grew up with unloving parents," she said tonelessly. "His mother often let him know he wasn't wanted. 'I wish I had died instead of giving birth to you,' she told him once. So he left home at a very young age. He had to fight his way through life, and that is why he still has such a stubborn streak in him and a need to always be right. He had to prove to himself and to me and the rest of the world that he was someone. He has always been searching for acceptance."

"Hunting for love," I said bemusedly, feeding the next little mouse.

"Amalyah, sometimes you scare me," Mom said. "Your words are greater than your years. You feel too deeply."

I said nothing but fed the third mouse. I admired my dad for what he had achieved in life all on his own. *I wish I could be like him,* I thought. Little did I realize how much I too needed to feel approval and love from my father. Nor did I realize how incapable he was of showing such love to Mom or me, simply because he had never experienced it himself.

"Maybe that is why you are always rescuing living things," Mom suggested, looking with some distaste at the little pink mouse I was holding. "Maybe

you are hunting for something to love."

"Did you want me?" There, the question was out.

Mom's face softened and brightened with a smile. "Sweetheart, the doctors told me that at 43, I was too old to have a child. They wanted me to abort you. They said you would have health issues, and that I could die from complications during the birth."

"I told the doctor that I would not go through an abortion. 'This child is God's gift to me,' I told him, 'and someday she will bring me joy when I am old.' "

I pulled some soft nesting material carefully over the baby mice. "Do you believe in God?" I asked Mom.

She made a dismissive gesture with her right hand. "Not really," she replied.

"Why don't you believe in God?" I persisted.

Throwing up her hands, Mom exclaimed, "Child, I thought you would be the joy of my old age, but with your endless questions, you will bring on my old age prematurely!" Chuckling, she continued, "Why do you ask?"

"Because every time anyone in my group talks about God, everyone else acts as though He is nothing but a bad word, like a swear word. I have often wondered if He exists."

"Let me tell you," Mom said, her voice bearing tinges of bitterness, "if He exists, He doesn't really care about the details of our lives."

My mind had latched onto the idea of God. "But our history is filled with stories about God, and in the Bible lessons at school we learned stories about God speaking to people. How come He doesn't speak to us today?"

"Listen, dear," said Mom, "the Bible is a great literature book. Some of the stories in there are probably historically correct, but as for God, He is just a man-made idea. Once when I was about seven years old, I lost my favorite red ball, so I asked God to find it for me. He didn't, so I don't believe in Him."

"I'm going to take the mice outside and put the box into that old fish bowl so nothing can get them," I said, bringing my mind back to the present. "I want to raise them until they're grown." My mind shut out the mysteriousness of the subject at hand, and I firmly pushed away the questions that I had.

A few days later the mice opened their eyes. A day later they disappeared.

Mom and Dad told me not to talk about them, because one of the neighbors had complained to Mom that her house was overrun with the little rodents. "I have no idea why we suddenly have so many mice," she had complained bitterly. Mom, Dad, and I laughed at our secret, and I felt the warm glow of sharing a rare tender moment with my family.

5

I STEPPED OUT OF OUR COMMON BATHROOM AND HEADED FOR MY ROOM. NOW that we were in junior high school, we girls all stayed in one house. Even though we were still together, there were now only two girls to a room. Each room had a private entrance, and we were permitted to decorate the room to our taste. I loved the new arrangement even though there was room for only two single beds and one small closet.

I heard muffled giggles come from Lilly's room as I passed the open door. Lilly and Efrat were sitting on Esther's bed, their heads close together. I could hear their excited voices and giggles but couldn't make out what they were saying. My heart lurched inside me as I made my way to my empty room. I felt left out and wondered what the girls were talking about. Why wasn't I included in their secrets?

I took my hairbrush and fiercely tackled my tangled curls. The reflection in my little mirror was not one that I liked. That small, rather narrow face, those big brown eyes, and that wild mop of hair . . . I brushed the snarls so vigorously that the resulting pain brought tears to my eyes, but I didn't care. The pain in my heart was much greater.

I felt that I was different. Even as a young girl, I often felt that the others in my group somehow knew things that I was not privy to. I got along with Esther and Lilly and some of the other girls, but for the most part, I felt that I didn't fit in.

"They are all Anglo," I told myself in the mirror. The other girls almost all had straight hair, or if they had curls, they were nice curls, the kind that fell gently on the shoulders and decorated the face with a cute frame.

"No one else has curls sticking straight out from the scalp!" I said out loud. They were all fair-skinned, and there were even several girls who had blue eyes. Now that we were growing up and noticing such things, I was often aware of the boys watching my companions. Every time I saw it, a pang went through my heart, for I never detected them looking at me in that way.

"I'm ugly," I groaned, trying to straighten my wet hair. I took a scarf and wrapped it tightly around my head, hoping to hide some of the kinky locks.

"You like Lilly, don't you?" I had asked Roni one time. "You think she is pretty."

Roni had laughed. "Of course I like her," he had agreed genially. "I like all pretty girls."

I wanted to ask him if I was pretty, but I could not speak. I was so certain he would confirm the terror in my heart by telling me what I already knew.

"Come on," Roni had interrupted my thoughts, "we want to do the lab experiment we studied about this morning. I want you to help me." He headed toward our science lab.

That's the way it always was. I was just Amalyah, the girl who was ready to help the boys. I was not Amalyah, a girl whom the boys liked. I was just one of their friends, always ready to go on a jaunt with them or join them in their school assignments.

"I should have been a boy," I scowled at my reflection. "Then I wouldn't have to worry whether the boys like me or not." I climbed into my lonely bed, still hearing the girls in the next room chatter and giggle.

◊ ◊ ◊

"Come on over! Join us around the campfire!"

I was on my way back from the stables when I heard the voice of a young man outside the volunteer house hailing me.

Without hesitation, I joined him. He was with a lively bunch of young people who had just arrived at the kibbutz the day before.

"Hi, I'm Robert," the slight, blond-haired boy introduced himself to me.

"My name is Amalyah," I replied, smiling at him and wishing I had straight, perfect teeth like the other girls.

He didn't seem to mind my teeth, but scooted over and made room for me beside him on the log. Sparks from the campfire flew upward into the darkening sky.

I could see Roni and Yoni across the fire, laughing at a joke from one of the new fellows. A tall, dark-haired boy was playing a guitar and singing a love song.

"Have some cheese," Robert offered, and I took several pieces. "Help yourself to the drinks," he urged.

It was all so free and easy, and the volunteers were friendly and full of life. The slight breeze of the summer evening felt fresh compared to the warmth of the fire. Some candles were burning, dripping their wax on a rock in mystical decorations. A pair of shoes hung from the tree just above me. I felt accepted and welcomed.

Volunteers had started coming to our kibbutz around the time I was born, in 1967, and they came from all over the world. Israel was a magnet for youth who were hungry for adventure. Many of them were intrigued with the young nation of Israel and admired the military victories it had achieved in its many wars. As part of a generation that birthed the hippie movement, many of these young people still faced a stigma in their own countries. This motivated them to go abroad, donating their time to help with farm work or kitchen and laundry duty. Our leaders were eager to have them, for they helped with the many tasks of running a community farm and cost us only whatever it took to feed them. All over our country, foreign volunteers continued to apply to work with the Israelis.

Some stayed up to a year or even longer, but most of them stayed only a few months before moving on. They were like a constantly migrating flock of birds, and we accepted them as a part of our life.

"You look beautiful in the firelight," Robert said, setting his bottle down. He looked boldly at me.

"Maybe so, but have you seen me in the daylight?" My voice sounded brassy even to my own ears as I tried to cover up my insecurity with a witty reply.

"I am sure you look beautiful in the sunlight," Robert said smoothly, "as

well as in the cloudy light." He began laughing at his own joke.

We spoke in English, for many of the volunteers used the common language of drifters and travelers. We young people were fluent in both Hebrew and English because of this constant exposure to the volunteers.

I shrugged and turned back to the fire. Lilly and Efrat shrieked from the other side of the campfire. They were giggling wildly at some joke from the boys.

Robert followed my glance and then turned back to me. "Show offs," he said shortly. "I like people who are genuine, like you. Isn't the fire beautiful?" he continued softly. "You know, I like girls who can appreciate this kind of beauty."

Something inside me was beginning to blossom. I was not used to having someone accept me just for who I was. Not only did Robert accept me, he even seemed to like me. Maybe he even loved me! I liked these new feelings, and I found myself liking him too. That night, I didn't care that none of the girls came into my room and shared tidbits of gossip with me. All that suddenly seemed superficial.

0 0 0

"I don't care if every other girl in Israel dresses this way!" My father was furious. "The way you dressed last evening was totally disgraceful."

"You have been saying that for weeks," I retorted, trying to defend myself. "You single me out and say I don't dress right. What is wrong with me? Why should I dress like an old woman when all the other girls wear the same kind of clothes I like?"

It seemed that every time I was at home lately, my father would follow me around and scold me about my clothes. Or rather, my lack of clothes, as he would so succinctly point out to me.

"Look!" he exclaimed in frustration now. "Little tiny straps, no sleeves, and these shorts—they cover nothing at all!"

"Shlomo, stop it," Mom said pleadingly.

"Oh, so you want her to walk around like that?" Dad turned on her. "You encourage her to dress like a tramp?"

"Times change," Mom tried to reason weakly. "No, I don't like how the

girls dress, either. But . . ."

"That's just it," Dad continued, "we don't stand up for what is right anymore."

"Just what is right?" I shouted at him. "Whatever you decide?"

"Don't you ever yell at me," Dad hissed. "What goes on in this house stays in this house. We don't want to be heard by someone outside!

"I'm warning you," he continued in a low voice, "when you dress like this and get attention from boys, it's not because they actually care about you. Their only thought is how they can get a chance to take advantage of you. You don't owe them anything!"

"I have to go to the bathroom," I said abruptly, my emotions shattered. I rushed in and shut the door before sinking down on the floor of the tiny bathroom and bursting into tears.

I didn't know why I was crying. Sure, I felt threatened and attacked by my father, but there was something else. Something seemed to grab my heart and squeeze my throat tightly. I knew my dad was telling me the truth. I knew all too well, far more than he even realized, but I didn't think it was as horrible as he made it sound. It was just the way life flowed, and I was carried along with it, reluctantly doing what I believed was expected. How could I possibly explain this to him? I was afraid he would be angry and disappointed if he knew some of the things I had experienced. In addition, I was starting to feel something else, a desire to be in charge, to have my own way, and to shape my own identity without his interference.

"I will not give in," I told myself fiercely when my tears abated. "I am finally winning approval from someone. The volunteers like me just the way I am."

I dabbed cold water on my eyes and looked in the mirror. There was the same narrow face and the same frizzy hair, but I was getting past the stage of caring so much how I looked. Of course, if I could have gotten straight hair by wishing for it, my tangles and curls would have immediately turned smooth and sleek, but the desire no longer consumed me. I shrugged my shoulders and left the bathroom.

Before my father could resume his lecture as he normally did, Mom asked brightly, "Amalyah, why don't we go for a walk?"

I nodded. I was all too ready to get away from the house. "Let me get a water bottle to take along, and we can walk toward the cemetery," Mom said.

After such arguments with my father, I could have chosen not to go home anymore, for my life was busy with school, work, and being around the volunteers. I saw my parents in the dining hall at mealtimes, and yet there was still something that drew me back to my parents' house. Even though I thought I no longer needed them, I kept coming back.

"I love it when the sun casts these long, golden shadows across the land," Mom now said as we walked westward. "All the colors are more vibrant. Look at the green fields, stretching as far as the eye can see, and the orchards with the bright orange fruit. See how the shining white walls of the village houses over there contrast with the red roofs? It is so much more beautiful at this time of day."

I could smell the sea, as the Mediterranean was only several kilometers across the flat land. "Yes, it is beautiful, and just look how tall I am!" We laughed at my shadow stretched long on the ground. These rare times with Mom were a special treat.

That night, I lay in bed wide awake. My thoughts kept returning to the argument with my father. What had happened to the father-daughter relationship we once had?

I cannot understand him, I thought. *He has always taken great interest in me.* I found myself remembering how he had taught me to drive a tractor when I was very young. I smiled as I recalled how I used to ride in the truck with him to the reservoir to check the water supply, and how he taught me to shoot a gun. He never showed real affection or told me that he loved me, but I hadn't questioned his love when I was younger.

I reflected on the time when I was about six years old and Mom and I went for a walk by the wadi. Dad said he was too tired to come. As we walked, I suddenly stopped when I heard a faint cry that sounded like a bird.

"I have never heard a bird call like that before!" I whispered. I loved birds and always tried to identify any that I saw or heard on the kibbutz. Once more I heard a whistling call coming from a small patch of bushes ahead of us.

"Shh!" I put my finger to my lips and silently crept forward, careful not to kick any small stones that would scare the bird away.

Before I could actually peer into the shadowy bushes for a glimpse of the

bird, a large figure suddenly stood up and said, "Boo!"

"Daddy!" I gasped. "You scared me!"

We had all laughed together as he joined us for the rest of our walk. But now that fun and companionship were all gone. He didn't understand me, and I didn't understand him. He suddenly didn't like the way I dressed or anything else about me, it seemed.

I felt bewildered, but didn't really know why. I wanted something more from him, and he probably wanted to give it, but neither of us knew how to put it into words. I resented his criticism of how I dressed, and yet I did want him to be interested in me and my life. I desperately needed his guidance and protection. I needed him to teach me how to guard my heart, but he didn't know how. Instead, he tried to enforce rules that made no sense to me since no one else I knew lived by them.

"Anyway, Robert likes the way I dress," I whispered to myself, and felt the familiar warm glow spread over my heart when I thought of his admiring eyes looking deeply into mine. I thumped my pillow and buried my tousled head in it. It was time to sleep.

6

I HUMMED A LIVELY TUNE UNDER MY BREATH. DANCING A FEW STEPS ON THE PATH to my parents' house, I flung my head back and smiled gleefully. I was in love!

No, it wasn't Robert. He had left several months ago. At first I had been heartbroken, mourning him for days. He had been my first boyfriend, and he always could make me feel special. We had spent so many hours together, and I thought I had finally found a resting place for my heart.

"I'm leaving," he had told me one evening as we sat around the campfire with the others.

My heart had lurched. "No!" I gasped.

Smiling gently, he said, "We both knew from the start that it couldn't last. I have to go back home to Norway and get on with my life. You are still in school and have to finish your education."

Of course I had known that, but somehow I thought . . . I hoped . . . that maybe this was the kind of lasting love that would keep him with me forever. It was like that in the love stories I used to read.

Tears streamed down my face. "I love you, Robert," I told him.

"I know. I love you too," he replied, but nonetheless, he left.

Then Andre arrived. Short and dark like me, he and I hit it off immediately. He was so much fun! We often took off evenings and hiked for hours in the countryside. Occasionally, we rode the bus to the beach and walked along the golden seashore at sunset. As darkness fell, we would find a little café

and laugh over our special jokes as we got something to eat. The happiness that I had lost when Robert left seemed to be restored to me.

"Hi Mommy!" I now greeted my mother as I entered the tiny house.

"Amalyah!" I heard my father's voice from outside, around the corner of the house.

"Hi Daddy," I greeted him cheerfully. Nothing could dampen my spirits today. I skipped several more steps, but when Dad followed me into the house, I sensed something was wrong. Of course, that was nothing new, since our conflicts were as constant and predictable as shadows on a sunny day.

"I saw your balance sheet. Your account is in the red," Dad said, his heavy eyebrows coming together with concern.

The kibbutz system of those days worked somewhat like a commune. Everyone worked at least eight hours a day, and everyone, including the teenagers, got a monthly allowance. No one had to pay for food, utilities, or anything else on the premises, so the allowance was used to buy small personal items. The kibbutz had a small general store where we could get snacks and toiletries, but since no one actually used money, our expenses were simply recorded on a chart and deducted from our allowance. At the end of every month we would get the balance sheet.

I glanced at the sheet, and my heart sank. It was in the red indeed. Not too much, but I had spent more than my allowance would cover.

"Daddy, there were some things I really wanted to get. I'll just have less available next month," I reasoned.

"I want to explain something to you," Dad said, not unkindly. "There are some very basic principles that everyone should learn. The very first one is, don't spend money you don't have. Never think that you will pay it back next month. That is the fastest way to financial ruin."

For some strange reason, I listened. Perhaps I detected the genuine concern in his voice and knew that what he said really was a fundamental truth.

"You see, my daughter, when we begin accumulating debt, we start down a slippery slope. Even though we think we can pay it back, there always seem to be other things we 'need' to have, and we delude ourselves into thinking eventually we'll catch up."

I was surprised at my dad's insight. I knew he was not a foolish spender,

but I had never really known this side of his character.

"It was only forty shekels," I protested feebly.

Shaking his head and smiling ruefully, he countered, " 'It was only.' Those three words are extremely dangerous. People say, 'I can afford this or that because it is only . . .' Those exceptions add up to be much more than 'only.' They become huge. Amalyah, if you owe someone money, you become their slave."

I had to admit that what my father was saying made a lot of sense. This I could understand much better than the reasoning he used about my dress. I looked at him with new respect.

"I'm sorry," I said simply, and I really was. The practical side of me intuitively acknowledged his wisdom.

"You know that when you really need something, we will provide it for you. But you are not one to collect trinkets and useless junk, and I do appreciate that," Dad continued.

"I don't want to be like the other girls." I rolled my eyes. "Efrat has more silly things in her room than the whole flea market," I exaggerated. "You are right, Daddy. I remember when I told you I wanted a boombox; you bought one for me because you knew how much I like music. But you always said no when I wanted silly, cheap trinkets." I smiled, delighted to be on the same side as my dad for a change. It made me feel close to him.

Mom chimed in, "The only presents your father ever bought me were things for the house. He knows I would make him take it back if it were some useless junk."

I looked around my parents' small house. It was simply furnished with all the necessary furniture, but it was not crowded with stuff. I had often marveled at some of the other families who lived on the kibbutz, and how their small dwellings were so crammed with junk that they felt suffocating.

"I need to feed the horses, so I will see you at dinner," I said as I got up. "And I will not spend money I don't have," I promised with a laugh.

◊ ◊ ◊

I buried my head in my pillow and tried to stop my thoughts from piling

up in my brain. I felt drained, washed out, and in despair. At only seventeen years old, my life no longer seemed worth living. I could see no glimmer of hope for the future.

I knew it was late. All was quiet, but the rising turmoil inside me was growing into an all consuming roar. Finally I could stand it no longer. I jumped out of bed, grabbed my clothes, and silently left our group home.

Into the night I ran, not caring where my feet were taking me. Even as I ran, I realized I was instinctively heading toward the volunteers' housing. When I reached the path that led up the hill to where the volunteers lived, I forced myself to make a left and go down the hill to the stables.

I made my way through the dark barn, where I knew my way by heart, and opened the door to Chestnut's stall. The mare inside moved toward me as I whispered her name. I flung my arms around her neck and began weeping into her coarse mane.

"Chestnut, you have such an easy life," I murmured through my tears. "People give you good pasture and hay in the winter, and you don't have your heart broken over and over again. Why can't my life be simple like yours?"

Chestnut nudged at my chest with her head and neighed softly. "Oh, Chestnut!" My cry went out into the darkness, and I felt a storm of emotions unleashed in a string of words.

"First I met Robert, and when he left, I thought my world had ended," I murmured aloud. "Then Andre came, and I realized that I had met someone even better. He healed my broken heart with his wit and charm and bravado. We shared so much together, and for six months I lived in what seemed like heaven. I felt cared for, loved, and cherished. I knew that life was worth living again. Now look what has happened." I did not know I even had any tears left, but another wave swept down my cheeks.

"I have to go, Amalyah." That's what Andre told me. "I have to go back to Switzerland and go on with my life. It was nice to have met you."

"Why? Why?" My anguished cries were muffled as I buried my face in the horse's mane.

Will no one ever really, really care for me? I wondered. *Will all the people who steal my heart just throw it away again? Even though they say they feel my hurt, will all of them just walk away from me and leave me alone to cope with the pieces?*

My thoughts tumbled into a downward spiral. *My dad constantly gets mad at me for how I dress, my mom has no encouragement to offer other than the usual, "You'll feel better eventually, sweetheart," and all my friends think I'm weird. Efrat, Lilly, and Esther are all crazy about boys, and our boys from the kibbutz like to spend time with them. That leaves me alone, so I go make friends with the volunteers. I get along great with them, but now my heart is broken again. Oh, I want someone to love me!* The age-old cry from my heart rose up in the dark barn, and I tried to get as much comfort from Chestnut as I could.

The darkness outside matched the darkness in my heart. When my sobs finally died away, Chestnut held still and let me bury my nose in her mane again. Her horsey smell was pungent, but she offered companionship and I loved her. At last suppressed weariness swept over me, and I stumbled back through the night and fell across my bed.

From that time on I threw myself into a rigorous cycle of working hard, partying hard, and trying to make myself tough. School was not going well for me, as I could no longer concentrate, and my grades fell.

"I'm quitting," I told my parents. "I want to work in the kibbutz instead of toiling away inside the walls of school." My group was attending high school in a neighboring kibbutz, but I had lost all interest in academics.

Mom and Dad thought I should continue but did not press much. I think they both realized that I was way beyond their control by that time. Much had changed since my childhood. My sister Deborah had married a non-Jew and moved to Holland. Hannah was married and lived close by, while Rafael had finished his military service and had moved into Jerusalem. My parents were getting older, and I could not understand why they even bothered trying to direct my life.

I don't know how much they knew about my relationships with boys. With all the modern philosophy about life and love that prevailed in our secular community, there were hardly any eyebrows raised at the immoral lifestyle of the young people. As long as the general system of community kept on functioning, most people were well satisfied.

Now that I knew that the volunteers usually came for only a few months at a time, I steeled myself every time a new group came. I quickly chose which one of them I wanted as my new boyfriend, and convinced myself

that this was the way things were done everywhere. I tried to believe that this was actually what I wanted. Deep in my heart I was longing for more than I got from each new relationship, but I didn't even know anymore what I wanted. I kept telling myself that this life was okay and perfectly normal. What other choice did I have? What if love only lasted for a short time and then faded away? What if life really had very little meaning, and disappointment and emptiness were my constant companions? Was there anything else? Did anyone else have a solution?

7

"IT'S LOVE, IT'S LOVE! THAT'S WHAT LIFE IS ALL ABOUT." THE SHAGGY-HAIRED BOY sitting near me on the beach strummed his guitar and sang above the splash of the waves on the rocks. Three other young men were stretched out on the sand. I wasn't sure if they were sleeping, but whatever their condition, they did not move. A girl poked idly at the campfire, and in the darkness of the night, I could see several other figures milling around on the beach.

It was 1985, a time when thousands of young people were continually trying to "find" themselves. Temporary hippie camps like this one were not unusual.

"Welcome," they had smiled when my friend Abbie and I had hesitantly approached this group just outside the city of Eilat.

"No," they had said in answer to our questions, "we haven't seen William or Richard, but they will probably come here sometime. Meanwhile, just make yourselves at home. Do you want something to eat? Marcie just cooked a huge pot of rice. Help yourselves."

That had been our welcome. No fanfare, no questions, and no resentment that there were now two more hungry teenagers to feed.

> Yeah, it's all about love!
> Come and love with us.
> Join us and love us.
> Do not fight, do not quarrel, just love.

The soloist continued in his melancholy voice, singing his improvised version of a popular song.

I listened idly to his song as I reflected on the events that had brought me here. The education committee of the kibbutz had recently decided that I should attend an experimental school in Netanya. I had been at the school for only three days when I met Abbie, and we had struck up a friendship of sorts. She was quiet and moody, and I guess we both felt as though we didn't fit in with the rest of the girls. We became friends by default.

One day after school Abbie had said rather abruptly, "I wish I could get away from all these obligations. I want to experience real living."

"I'll go with you," I had said impulsively. It had been easy. Abby and I had gone to her house to grab some of her belongings before collecting a few of my own at the kibbutz. We hitched a ride to the main road with the produce truck, and a few hours and a bus ride later we arrived in Eilat.

"We're going to the hippie community at the Eilat seashore," William and Richard, the two American volunteers, had told me the day they left the kibbutz. "We worked hard enough on the farm that we deserve a chance to take it easy for awhile before Mom and Pop send money to bring us home."

Even though they were brothers, the two were not at all alike. William had been my boyfriend of only two weeks before they left. After missing him for several days, I had been quick to accept Abbie's suggestion that we run away to the hippie community ourselves.

The city of Eilat had seemed busy, modern, and exciting compared to our community life. It was fun to walk the sidewalks and look into the storefront windows. We had bought some fruit at an outdoor market, and the first night we slept on a strip of grass next to an abandoned building.

"It's like camping," I had told Abbie as we pulled our blankets from our backpacks. She had said nothing.

I had lain on my back, staring up at the sky. I had always loved camping trips and spending time in the open countryside. This was different from those excursions, for the city noises were all around us. The sound of the traffic, the beep of the car horns, and the constant buzz of noise kept me awake for a while. I wondered what my parents would say when they found out I was missing. At last I had fallen asleep.

Three days later Dad had arrived in Eilat. How he knew where to find me, I don't know to this day.

"Amalyah," he had said quietly, "if this is where you want to be, then so be it. Just know that I'm available. If you ever need me to come take you home, just call."

"What you thinkin'?" My reverie was interrupted by a stranger who plunked himself next to me on the sand.

I shrugged. "Not much," I said vaguely.

"Missing your family?" he asked.

Though my heart was aching to go home, I shook my head. "No," I told him, "I never lived with my family anyway. I was raised on a kibbutz."

"Oh-h-h." His reply was slow and drawn out. "You are one of those girls who is hunting for her identity. You want to know why you exist and what your purpose in life is."

I looked more closely at his profile in the dark. "Yes, that kind of describes me," I admitted, wondering how he knew.

"Meet them all the time," he said with a nod. "I know the type. They feel they never fit into the regular group. Keep questioning why they are so different, and wishing they could find someone who understands what they are going through. There are lots of people like that out there."

"Are you one yourself?" I asked a little sharply, for he had hit a tender nerve. "I guess it takes one to know one."

He laughed loudly and stuck out his hand. "My name is Tower. What's yours?"

"Seasport," I said, taking his hand and matching his teasing mood with a name I invented on the spot.

Another laugh came from my companion, and he jumped up. "Then come and let's dash into the water. I will be the Tower for you, Seasport. I'll watch out for you."

Life seemed so easy and simple with the group at first. "Love" was in the air. We slept whenever and wherever we wanted. Food seemed to appear almost miraculously, and we all shared. During the daytime, we either slept or explored the seashore. Evenings were for singing, eating, laughing, and doing drugs. I tried the drugs, but they only seemed to deepen the sadness

in me. Alcohol was much more effective, and I enjoyed feeling tipsy. As for cigarettes, they made me feel sick, but I took one here and there because I really wanted to fit in.

Eventually petty bickering and arguments broke out among the group. Discarded lovers grew spiteful and had malicious things to say about their former partners. Money issues became a recurring reason for quarrels, and when the supply of drugs and alcohol was depleted, all the fun was gone. Abbie kept herself aloof from most of the disputes, but I had not fared so well. More than once I found myself the brunt of someone's sharp tongue or barbed look.

"There is no such thing as real love. It's all the same illusion everywhere," I muttered one day. I watched as Tower leaned over a newly arrived blonde beauty. It seemed she had just washed up on the seashore like a starfish from the mysterious depths of the water.

"I want to go back," I told Abbie on the tenth day of our new life. "This is really no better than life on the kibbutz. All this so-called love is just a fake. They're just like a bunch of spoiled brats."

"You chose to join them," Abbie reminded me bluntly.

I got up from the beach, dusted the sand from my hands, and picked up my backpack. "I thought that at seventeen I was old enough to take life into my own hands. I was wrong," I admitted, and went to look for a phone.

My father answered the phone. When he realized who it was, he immediately asked, "Are you all right?"

"I want to come home," I wept. "My money is gone. Will you come get me?" The long sigh of relief that I heard on the other end of the line made me realize just how concerned Dad had been about my endeavor.

"Stay right there," he said abruptly. "I'm leaving immediately to come get you."

On the way home, he did not question me about what I had been doing, and I did not volunteer any information. Mom didn't ask any questions either, but I knew from the way they both looked at me that they were very relieved to have me back.

My sister Hannah was not so forgiving. "You crazy girl!" she hissed. "You need to wait until you're older before you take off. Besides, you never even

finished high school. You won't even be able to find a decent job when you do leave. And what were you thinking to make Dad drive five hours to bring you home? Use your head, little Amalyush!"

I merely shook my head without replying. It seemed strange that my sister, twelve years older than me, should be so concerned about my life now when she had ignored me throughout my childhood.

After this there was no more talk about going back to school. I settled back into life at the kibbutz, chalking up the hippie experience as one more disappointment on the chart of my life. I threw myself into my work on the farm and in the kitchen. When I worked hard, it was easier to forget the empty feeling that never seemed to quite go away.

<p style="text-align:center">◊ ◊ ◊</p>

It only takes a spark
To get a fire going,
And soon all those around,
Can warm up in its glowing.

I sat next to my new boyfriend, listening to the song that a young volunteer couple was singing. The night was balmy, and the glowing embers and mild pinewood smoke created a peaceful ambiance as the soft melody continued.

That's how it is with God's love;
Once you've experienced it,
You spread His love to everyone,
You want to pass it on.

"I like the part about love spreading to everyone," said a curly-haired girl from Austria. "That is the biggest need of this world."

"It must come from God," inserted a young man from Germany in a thickly accented voice. "God is love. What is love is God."

Opinions and comments were tossed around, but I noticed that the couple who sang the song did not say much. The man was short and

unassuming, but he sang with a quiet intensity you couldn't miss. His wife wore a modest skirt and blouse. I didn't consider her stylish, but she seemed perfectly content. I liked that about her.

> *What a wondrous time is spring,*
> *When all the trees are budding;*
> *The birds begin to sing,*
> *The flowers start their blooming.*
> *That's how it is with God's love;*
> *Once you've experienced it,*
> *You want to sing,*
> *It's fresh like spring,*
> *You want to pass it on.*

"I love to hear you sing," I told the couple. "There is something so special about the words of that song."

Anne's eyes sparkled in the firelight. "It's because the words are true for us. Listen to the next lines."

> *I wish for you my friend*
> *This happiness that I've found;*
> *You can depend on God,*
> *It matters not where you're bound.*
> *I'll shout it from the mountain top,*
> *Praise God!*
> *I want the world to know*
> *The Lord of love has come to me,*
> *I want to pass it on.*

I felt a rush of emotions that I had no idea what to do with. I sat lost in thought until I heard someone say, "Well, it's not very smart to sing that song here. You Christians should know you are not entirely welcome in a Jewish community."

These people were Christians! I looked at them curiously.

"Christians are the ones who drove the Jews into seeking their own country," someone else said. "They somehow blame us for killing Jesus. I

remember Christian children mocking me and calling me a 'Christ killer' all my grade school years."

A look of deep sadness crossed the couple's faces. "We are so sorry," Fred murmured. "I know that those things hurt, and they are completely unfair."

"I know the Jewish leaders condemned Jesus to death," I said. "But anyway, that is something that happened two thousand years ago, so don't blame me for it. I wasn't even born yet."

"Jesus could have escaped," Fred said with feeling. "So it was not the Jews or the Romans who were ultimately responsible for His death. Our sins brought about His death. He gave His life so we can all be set free from sin and Satan. We are not trying to blame the Jews. In fact . . ."

"Then why do you come here?" interrupted a heavyset fellow. He picked up his guitar and began plucking a popular tune. "Leave us Jews alone," he spat.

To my surprise, the couple did not try to defend themselves or argue in the face of all that hostility.

I think Anne sensed what was going on inside me. A while later when the rest were singing, she told me gently, "You don't have to be caught up in this type of lifestyle, you know. There is a better way of life."

I did not have to ask what type of lifestyle she meant. I knew she had seen me team up with a boy from the new group. She knew the kind of life we lived.

"I don't know any other life," I said simply. "I ran away and joined a group of hippies on the beach, but they are worse than we are here."

Anne shook her head slowly. "I am talking about a change of heart," she said softly. "God really wants to come and give you peace through Jesus. Right now you are wasting your love. I'm not condemning you, because you don't know any better. But, dear friend, if you continue in this lifestyle, you will destroy your life. Only God can give you the satisfaction and love you are craving." I could not mistake the sincerity of her words.

A great magnetic pull drew me toward the truth of what she was saying. While I could not completely understand it, I felt there must be something there that I needed to know. But for the moment I couldn't completely grasp it, let alone imagine how I would apply it to my life.

"Let's dance!" My boyfriend pulled me up, and I tried to forget my longings as we joined the lively steps of the melody.

I wasn't thinking of the seeds of truth that were sown in my heart that night, but I did feel I had finally met some sincere, authentic people. Anne and Fred did not join in the usual carousing, but were pleasant and friendly with everyone the whole time they were in our community.

8

THERE WAS A YELL FROM THE FARM WORKERS, SO I TURNED THE KEY IN THE ignition, and the tractor roared to life. I put the machine into low gear and drove slowly between the banana rows.

The men around me were working in teams of two. One would skillfully swing his machete and cut a hanger of green bananas from the plant, dropping them onto the waiting shoulders of his partner. The teams loved to compete with each other. Sometimes the bunches were so large they would make the catcher grunt as the weight came down on his shoulders, but that only added to the macho display.

I loved working outside. Even though the work looked elementary, there was a lot of skill and timing involved in perfecting the harvesting system we used. Bananas grew well in this part of Israel, and I had joined the group of workers and volunteers to gather the fruit. Besides selling bananas in our own country, exporting them was a lucrative business.

I was twenty-three years old now and had finished my mandatory two years in the army. From the military, I had drifted to first one kibbutz and then another. Eventually I ended up here on this banana plantation, where I threw myself into the physical work as hard as I could.

Not much had changed in my life except that now I was living with Yaron, an Israeli. Yaron and I had been together for over four years, and everyone assumed that this would be a long-term relationship. Earlier, I had

planned to marry one of the volunteers who came to our kibbutz, but I was too young to get a license without my parents' consent, so that marriage never happened. Then Yaron came into the picture, and we had moved together to this kibbutz in northern Israel.

<p style="text-align:center">☉ ☉ ☉</p>

I sat bolt upright in my bed and turned the light on. "Yaron!" I yelled. "I hear sirens, and they just said 'Poisonous snake' on the radio!"

We had been told to prepare for an attack, and gas masks had been issued to every Israeli resident. It was January 1991, and the United States and its allies had initiated Operation Desert Storm after Iraq invaded Kuwait in a bid to seize Kuwait's oil wealth and expand Iraqi power in the region. Saddam Hussein, the Iraqi dictator, had threatened that if the allies attacked Iraq, he would retaliate with Scud missile strikes on Israel. Knowing the animosity that existed between most Arab states and Israel, he shrewdly calculated that an attack on Israel might enhance his support in the region. He hoped that the neighboring Arab nations would cheer his attacks on their mutual enemy. Now he was carrying out those threats. We were being attacked!

"Go back to sleep," Yaron mumbled. "You're dreaming about snakes."

"No, Yaron!" I insisted, "This is it! The war has begun!"

Suddenly awake, Yaron leaped out of bed. "The procedure!" he gasped. We had reviewed many times what was to be done should there be an attack.

The shrill wail of sirens pierced the night, and several loud explosions confirmed that we were indeed under attack.

"Get the windows!" Yaron yelled. "I'll do the door."

"Wait!" I gasped. "You have to wait until I bring Clara over." The procedure called for the old lady next door to join us.

"Run!" Yaron was already putting up the thick plastic over the windows. He was taping all the edges in an effort to seal the house in case the incoming Scud missiles were carrying chemical or biological warheads.

"Just relax, my dear," Clara said when I dashed into her room next door.

"Relax?!" I screamed. "We are being attacked! Come with me quickly!"

The old woman came willingly enough and seated herself in a chair in

our apartment. "No," she said firmly when I brought her a gas mask, "no mask for me." She waved me away dismissively.

"But you must wear one!" I protested. "There could be a chemical attack!"

Yaron was busily taping the front door shut when suddenly Clara cried, "The cat! I must get the cat!"

The air raid siren kept shrieking into the night, and I felt panic clutching my throat. "Don't worry about the cat!" I began, but Clara was already headed for the door with grim determination. Yaron looked aghast as she ripped the plastic away.

"I'll go!" I yelled, and sprinted out the door, calling, "Here kitty, kitty, kitty!"

I guess the cat was perturbed enough by the siren that he must have been seeking shelter, for he was waiting right outside. I scooped up the big bundle of fur, dashed back inside, and plopped him onto Clara's lap.

Once more Yaron began taping up the door, only to be interrupted by a quivering voice outside.

"I'm scared!" Our young neighbor, Miriam, was knocking at the door.

Yaron looked at me with weary resignation and opened the heavy plastic again. "Come in, quickly!" he ordered.

The terrified woman peered at Yaron and asked pointlessly, "What shall I wear? I didn't have time to get dressed or put on my makeup."

She plucked nervously at her robe. Yaron wasted no time trying to explain that her appearance did not matter in a life and death situation, but simply grabbed her arm and pulled her inside.

He had just finished sealing the door when there was another knock on the door. "Are you there, Granny?" called a voice.

"Oh, it's Shmuel!" Clara cried. "He came looking for me!"

Once more the plastic was opened and Shmuel came in. "I just wanted to make sure you were being cared for, Grandma," he said.

"I'm fine, I'm fine," the old lady assured him. "Now go home to your wife and children." Once more Yaron took the plastic sheet off the door to let Shmuel out. He re-entered the room and once again began taping the door.

"Hey!" A shout and a loud knock on the door interrupted him. "What's going on?" our friend Danny asked as he entered through the door that yet again had to be unsealed.

I giggled nervously. A lot of good the sealing would have done if we had been hit during our preparations.

"Wow," Danny said. "I was just finishing my night guard duty at the gate when I heard those sirens and saw flashes from the area around the bay. There were some loud explosions too. Do you have any idea what's going on?"

"Are you serious?" I asked him. "Don't you realize the war with Iraq has started? We are being hit by Scud missiles!"

"Put on your mask, Danny," ordered Yaron. "You too, Clara, please."

"I'm not going to wear any old mask," Clara insisted stubbornly. "I fought in the War of Independence, I cooked for the soldiers during the Six Day War, and I survived the Yom Kippur War in 1973 without any silly mask. I will not wear such a ridiculous thing in my old age."

I looked at her and said loudly through my own mask, "But if we get hit, you could die from the poisonous gases!"

Almost majestically, Clara raised her hand. "You may call my doctor and tell him that I said it is hard for me to breathe with the mask! Tell him that I said I am not doing it!"

I looked to Yaron for support, but he just rolled his eyes in resignation.

We huddled in our room, eagerly listening for any bit of information from the broadcasts on the radio. The reports were a bit confused in the beginning, but everyone was instructed to stay in sealed rooms. Then more details started coming in. "Scud missiles have fallen on Tel Aviv, and some as far north as Haifa," the announcer said.

"Those must have been the streaks you saw, Danny, and the explosions we heard. Anyway, we aren't too close to either of those cities," Yaron said, trying to keep our spirits up.

By morning, the sirens were shut off, and we wearily escorted the two ladies back to their rooms.

Our kibbutz never took a direct hit. From the radio, we kept abreast of the news about the Gulf War, as it was called, and lived for a time under stress and uncertainty.

During the daytime life was fairly normal, but as soon as the sun set, the air raids began. We quickly learned that the missiles were aimed at the more populated center of Israel, so we felt relatively safe in our rural

neighborhood. Whenever the siren would sound, we would run to the hilltop to watch. Many times we saw a bright streak of light like a huge falling star racing across the sky. If it disappeared from sight behind the mountains, we knew Tel Aviv had been its target. If it landed in front of the mountains, then it was the Haifa Bay. But at the end of the conflict, there were remarkably few casualties in Israel from these attacks, and life slowly returned to normal.

9

"YOU'RE GOING TO ANOTHER ONE OF THOSE HEALING WORKSHOPS?" YARON
asked with evident mockery in his voice.

"Yes, I'm going for the weekend," I replied. "Why don't you come too?"

I was deeply involved in the New Age movement, driven by a hunger of
the soul, trying to fill the underlying emptiness in my heart. Every time
I stumbled upon a new healing method, "spiritual" technique, or any
philosophy that had to do with the mystic and the supernatural, I took
to it with a passion. Our house was full of gemstones and crystals that I
treated like little gods. I learned several healing methods which I used here
and there, but nothing lasted, because nothing gave me the satisfaction and
peace I was looking for.

"No, I don't find anything to interest me in those workshops, although I
must admit the food is worth going for," Yaron said. "Besides, no one really
gets healed there. The only thing that benefits is the pocket of the guru."

Once again I went alone to a workshop, yearning in my heart for
someone who could share this quest with me. Yaron worked outside this
new kibbutz we had moved to on the Lebanese border, and though he was
doing something he really loved, I never bothered visiting his job. I really
took no interest in that part of his life. We had lived together for about
eight years now, but more and more we were just two individuals sharing a
house. Instead of drawing closer, we were gradually drifting further apart.

"Yaron," I said one day after my shift at the kindergarten, "it's a nightmare for the children having to be in the bomb shelter all day, so the kibbutz decided to evacuate them for a week. Since I'm on the kindergarten staff, they asked me to go along." Armed conflict had broken out again as Israel launched attacks against Hezbollah targets in Lebanon.

"If they want you to go along on an evacuation, they should pay you overtime. In fact, they should pay you 24/7!" Yaron declared.

I cringed. There had been unrest along the border, and we had been experiencing Katyusha missile attacks for the past two days. *How can I ask for extra money at a time like this?* I thought. *We all make sacrifices together in a time of war.*

"It's an emergency situation," I told Yaron. "Everyone gives what they can in such cases."

"If you will not agree to demand more pay, you are not going," Yaron said firmly. I decided to stay behind, but not very willingly. This was completely contradictory to who I was. I had been raised on the principle of giving what you can and getting what you need. Yaron had grown up in the city. He was trying to advance in the business world, and he looked for every possible opportunity to make a profit. I had thought for a while that we were two opposites who were meant to complement each other, but it certainly didn't seem that way now. When I was honest with myself, I realized I didn't even love him.

Yaron walked out the door of the apartment we shared. As I watched his back disappear, I crumpled on the bed. I was learning that life handed out disappointments much more frequently than I had ever imagined.

At first when Yaron had wanted to date me, I wasn't sure if I was interested, because he was an Israeli and I had always dated foreigners. There was something more exotic about them. The few Israeli boys I had liked never seemed to share my interest. However, Yaron kept pursuing me, and eventually I gave in. Early on, there were times when I tried to break off the relationship, but Yaron's emotional threats to kill himself were so strong that I didn't dare follow through. I didn't want to be responsible for his death, so we stayed together in spite of the constant conflict.

Conflict! I had grown up with it, faced it throughout my life, and yet I

still hated it. I found myself trying to avoid it at almost any cost.

I reminisced about my parents' conflicts. Dad would say something, and Mom, knowing it was no use to argue, showed that she didn't agree by clenching her fists, gritting her teeth and drowning herself in work around the house. They never argued in front of me, but I knew by the tension in the air that the conflict existed.

I had conflicts with my peers growing up, especially with Efrat. We were constantly at odds, and I tried to avoid her as much as possible. Even in the short-term relationships I had had with the succession of foreign boyfriends, conflicts had always arisen at some point.

I reflected unhappily on my life. What was I achieving? Growing up on the kibbutz, working on the banana plantation, and now working at the kindergarten just wasn't cutting it. I wanted more from life.

Yaron and I enjoyed a lot of things together, but in the long run our relationship was just about a good work team. Yes, there were some feelings too, but I was not ready for commitment. I missed the familiar thrill of falling in love and the excitement of a new relationship.

The ringing phone interrupted my thoughts, and I listlessly picked it up. "Amalyah!" It was my sister Deborah.

"Hello!" I said, my spirits lifting. Even though we were never close as children, we had become closer as adults, and it was good at that moment to hear her cheerful voice.

"I was sitting here eating lunch, and I decided to call you," Deborah said. I could hear the smile in her voice as she munched away. "I didn't know if you and Yaron were doing something tonight, but I decided to take the chance. Let's see, it's nine o'clock there in Israel, right?"

I glanced at my watch. "That's right, and I guess it's noon in Arizona?"

It was easy to talk to Deborah now that we were both adults. She, too, had a wandering spirit, and seemed to be on a continual search for something in her life. It was also good to just share with her my frustrations about the relationship with Yaron.

"Oh my," Deborah said, "I'm sorry to hear you are feeling this way. Yaron is a nice man, and I like him, but I never thought you two could really make it together. He is so settled in his ways and ideas, and you need more

freedom. Listen, why don't you come live with us? It would be so much fun!"

Go to the United States? That would indeed be fun. I had never been there, and I was ready for some adventure. It would be easy to do, for Mom had kept her U.S. citizenship, and she had gotten American passports for each of her children.

I wondered what Yaron would say, but suddenly I realized he probably wouldn't even care that much. Our relationship was losing momentum and slowly disintegrating. I suspected he was as ready to part ways as I was.

Although Yaron seemed to think our relationship could have continued, he was supportive when I told him of my plans to go to America. He gave me the name and address of an American couple he had met a few years before and assured me they would welcome me if I chose to visit them.

I moved my belongings back to my parents' kibbutz for storage and spent a few weeks with them before heading out on my journey. As my plane for America left the runway, a surge of excitement filled my heart. I was going to have a new life. I was on a quest for love and meaning!

<center>◊ ◊ ◊</center>

"Don't you care about what will happen to you after you die?" The woman looked intently into my eyes.

I shifted my eyes from Susan's penetrating gaze and shrugged. "Not really," I said honestly. "I don't even know if there is any kind of life after death."

"Oh, Amalyah, there can be! The 144,000 chosen ones will go to heaven, while those who have dedicated themselves to Jehovah will enjoy life forever on a restored earth! You want to be part of that, don't you?" I could hear the passion in Susan's voice. Her friend Mary sat quietly beside her.

I glanced through the doorway into my sister's kitchen. I was still new in America and was living with Deborah and her husband Jacob.

"You know, one day you will die." Susan would not give up. "You want to be resurrected after you die so that you can live on the new earth!"

"It is all so strange to me," I told her. "Once I met some Christians back in Israel. When they talked about God and Jesus, I felt in my heart that

what they were saying was truth. Later Deborah came back from Holland and told me I needed to be saved. I don't really remember what happened, but I repeated the prayer she told me to. Honestly, I rarely think about these things."

My mind drifted back to how this had all started.

"Susan and Mary are Jehovah's Witnesses. They come here every week to teach me about the Bible and their way of believing," Deborah had told me soon after my arrival in the United States.

"You need one-on-one time with us," Susan had said soon after I joined Deborah for a study with them. That was why they were here today.

"Amalyah, do you believe the Bible? Do you believe that Jehovah wants to show you the truth?" Susan's voice brought me back to the present.

"I don't know," I said. Her persistence was starting to irritate me. "One thing that puzzles me, though," I continued, "is that God kept talking to the people in the Old Testament. I mean, He talked to Moses and Abraham and those saints—I guess that's what you call them—as though He were right there. Why wouldn't He do that today?"

Susan closed her Bible and picked up her red book entitled *You Can Live Forever on Paradise Earth*. She searched the index, flipped through pages, skimmed a few paragraphs, and then frowned. Finally she closed the book and re-opened the Bible. "Amalyah, let's just focus on one thing. Someday you are going to die. Don't you want to experience the marvels of the new earth that Jehovah is preparing for those are who His followers? Don't you want to dedicate yourself to Jehovah so that you can live on the new earth?"

I cocked my head and asked, "What does that have to do with my question?"

The middle-aged woman cleared her throat and glanced at the clock. I followed her glance and realized it would soon be time for me to leave for work. The mobile home was empty except for Susan, Mary, and me. Deborah and Jacob were both at their jobs.

"Once you believe the truth, then these other things will eventually make sense," Susan told me. "Maybe if you go to the neighborhood Bible study, you will understand this more. Hearing from the others will be beneficial to you."

A confusing jumble of thoughts went through my head. I remembered how I had once repeated a prayer at Deborah's insistence. I didn't really

believe all this, but it did intrigue me. Besides, I hoped to get Susan off my back if I complied.

"Okay, when is it?" I asked.

"Every Tuesday evening we have classes. You will want to come," Susan said as she gathered her books. "You will gain necessary knowledge about the Bible. This knowledge will prepare you to dedicate your life to Jehovah and witness for Him. And once you have done that, you can be baptized."

I nodded. "Well, I'd better get ready for my job. I have to be at work in a half hour."

The mobile home park in Arizona sat right in the hot sun, and as soon as I stepped outside, a blast of heat seared my face. I was used to warm weather back in Israel, but it was much warmer here in the Southwest.

My job at the gas station was not difficult, and I was learning much about Americans and their culture. It was exciting for me to finally be in the country of my mother's birth. I felt I had experienced everything that Israel had to offer, and now I was ready to experience America.

Furthermore, my quest for spirituality and meaning could continue through this new avenue Susan had introduced. Though my Jewish upbringing had taught me to be skeptical about Jesus and Christianity, I was far away from my Jewish peers, and I felt free to give this a try.

<center>◊ ◊ ◊</center>

"So when could Armageddon happen?" the brown-haired teacher asked us.

"At any time?" a young girl said hesitantly.

Just as our teacher, Mr. Youngers, smiled and nodded, Jack said, "I can't find that in the book."

"Try page 246," Mr. Youngers replied promptly, looking at his own copy of *You Can Live Forever on Paradise Earth.*

The handful of students opened their little red books and shuffled through the pages.

"Doesn't it say it in the Bible?" I asked.

"Not as directly as in the red book," Johanna said easily. "The Bible is hard to understand."

I was bewildered already. I had come to the class as Susan had suggested, but now as soon as a question came up, the class immediately turned to the red book for answers.

"What is Armegedion?" I asked.

The rest of the class laughed as I mangled the pronunciation. "Armageddon," Mr. Youngers corrected kindly.

"Well, what is it?"

"Jason, why don't you answer Amal . . . Emily's question?"

Now it was my turn. "Amalyah," I corrected. "My name is Amalyah."

"Oh yes, Amalyah. Okay, Jason."

The confident young man spoke up. "It is when the earth as we know it will end in a terrific battle and a new and peaceful earth will become the home of the righteous."

"Well said," Mr. Youngers praised, nodding his head. "It is very important to practice righteousness so we can live on the new earth."

Later that evening I told Deborah, "I don't understand it. Susan told me that I needed to dedicate my life to Jehovah so I could be baptized, but she didn't really answer my questions. In the group meeting they keep talking about the coming nightmare of worldwide destruction and chaos. They say you need to be among the righteous or something like that. It really doesn't make sense to me."

Deborah set a basket of rolls on the table. "Well, that's why you go to the classes, I guess. To learn."

"It all sounds too complicated for me," Jacob said. "Basically, I think we just need to be good people, not hurt anybody, and then we are okay."

"Every time there is a question, they all refer to their little red book. It's as though the Bible doesn't contain the answers. That really irritates me," I continued.

"You always thought for yourself," Deborah said. "So now, think for yourself."

That night before I went to bed I prayed, "God, I really want to know the truth. Please show me."

That prayer was genuine, coming from deep inside me. It was more sincere than the prayer I had prayed with Deborah a while ago. It was the real prayer of my heart.

I kept going to the classes for a while, but then my interest dwindled. The lessons were mostly about setting the stage for the coming of the war they called Armageddon and how the elect were going to rule.

Besides, this whole idea of death and life after death and a new earth didn't really matter to me. What I wanted was something that would impact my life. There were longings inside me that I didn't know how to express, and I wanted something to fill them. I needed something real. My New Age ideas and philosophies had taught me to accept new ideas easily. If they subsequently didn't make sense, I had been taught not to get too distressed about it, so eventually I stopped going to the classes. Yet my heart wanted more, and I continued to pray sincerely, "I want to know the truth, God."

10

"WE'VE ALREADY LOST THE CALF," I TOLD MY CO-WORKERS, "AND I'M AFRAID THE cow isn't going to make it either."

"Do you think we should call the boss?" Shay asked her husband Darmon.

He shrugged wearily, exhausted and frustrated after ten minutes of trying to revive the newborn calf with CPR. "I guess I'll call and ask for permission to get a vet out here," he said, "but knowing the kind of man Mr. Turner is, I don't have much hope he'll care enough about this cow to spend any money to save her life." He trudged wearily toward the house.

I had answered a newspaper ad the previous month for a farm worker. When I found out that the farm was located in the cooler elevations close to Flagstaff, I had applied and gotten the job, joining the newly hired couple, Shay and Darmon.

We had been on the farm less than a month when Astra calved. By then we had already realized the kind of man we worked for, and were deeply frustrated with his lack of concern for his livestock.

Shay and I waited impatiently, trying to comfort the distressed animal. The prolapsed uterus was a gory sight, covered with blood, dust, and straw.

"Mr. Turner is totally without feeling for his animals," Darmon spat as he came back into the barn. "He says it is too expensive to call a vet, and that Astra will probably die anyway." With an oath, Darmon kicked the side of the wooden partition. "Why does he even have animals? He raises the dogs

for profit and has this big farm so he can bring his cronies out from the city to impress them with his wealth. But he doesn't care for his animals.

"You know what else he said?" Darmon continued darkly. "He said, 'Take the gun and kill the cow. Shoot it right between its eyes.' "

"Shoot Astra?" Shay and I chorused. "No way!"

"Let's just call the vet anyway," Shay said decisively. "I'm willing to pay to save this poor creature's life."

"Me too!" I exclaimed.

"I'm with you," said Darmon as he started back to the house to summon the vet.

When the vet arrived, we waited anxiously for his verdict. "I could have saved the calf if you had called me in time," he told us as he pushed Astra's uterus back in and stitched the area. "Apparently the calf drank some embryonic fluids that swelled it up so it couldn't come out. One injection would have caused it to throw up, and it would have glided out easily."

We had labored for hours trying to pull the calf out. We had called Mr. Turner several times, and each time he had insisted we shouldn't call the vet even though we knew something was seriously wrong. Finally, in desperation, I stuck my arm into the cow and tried to reach the calf's hind legs to pull it from there while Darmon and Shay each pulled on a front leg.

When the calf suddenly came out and dropped to the ground, its belly was enormously swollen. It was dead. And now the vet was telling us that one simple injection would have saved its life? Our boss' heartlessness made me so angry!

"That's it. I'm leaving," Darmon said bitterly, voicing what I was thinking. "I will not stay and work for such a beast of a man." His anger was growing.

Shay looked at me and shrugged. I could tell she was fed up as well.

"What about the dogs?" I asked.

"We'll feed them tonight, and then we're leaving," Darmon stated. "I'm going to call Mr. Turner and tell him that he is responsible for everything from now on. He won't let the dogs die. They are too valuable to him."

"No way I'm staying here by myself," I told the couple. "I'm leaving with you."

We fed the dogs and gave Astra her antibiotics. Then Darmon made the

call to Mr. Turner, eventually hanging up on the angry shouts of the owner. We packed our few belongings, and they offered me a ride out to the city.

I never found out what happened to Astra, but I was pretty sure she died. I just hoped someone came and put her out of her misery before she suffered from too much pain.

As I left the farm, I just wished I could be rid of my own pain. America was not giving me any more real answers than I had found in Israel.

I thought about my experience with the Jehovah's Witnesses, but God seemed far away and remote, merely an abstract figure somewhere, removed from my real world.

<p style="text-align:center">◊ ◊ ◊</p>

"Wow, you have made quite a home in here." Jacob joined Deborah and me in the van.

"See, I can store my clothes here under the sleeping platform, and over here I keep the cooler for food," I told them gleefully.

"I like the little curtains," Deborah said, fingering the attached fabric. "It really looks homey."

"Now don't you run off and become a modern hippie too," Jacob teased Deborah. "Not that I wouldn't be tempted myself sometimes," he admitted. "I'd like to leave everything and start over somewhere where no one knows us."

"Amalyah, are you sure you should be doing this?" Deborah questioned with the concern of a big sister. "I mean, going off and being a drifter all by yourself could be quite dangerous. You are not very big, you know."

I put my hands on my hips and faced my sister. "How many times have we gone over this?" I demanded wearily. "I will be okay. No one needs to watch over me. I want to be free. I want to see America. Grand Canyon, here I come!" I hugged my sister, jumped into the driver's seat, and waving merrily, I headed for the highway.

After leaving the farm job, my work at a restaurant in Phoenix had been uninspiring, but I had worked hard and saved my money. Once more, I was thankful for the lessons my dad had taught me in living frugally and economically. Since I was living with Jacob and Deborah again after the

fiasco on Mr. Turner's farm, my expenses were few. Soon I was able to buy the old van and convert it into my new home—my home on the road!

◊ ◊ ◊

"I want to apply for a permit to hike the Grand Canyon." I spoke through the ticket booth's little window.

The man behind the window looked intently at me. "How many people want to go?"

"I am by myself. I am applying for one permit. Oh, I do have a dog. Harmony will go with me." I pointed to my van where the yellow mutt scratched impatiently against the closed window.

"I cannot issue a permit for the park," the attendant told me. "You can hike or ride to the bottom with a guide, but I cannot allow you to go by yourself. It is too dangerous."

"But I am experienced. In Israel I hiked through all kinds of terrain . . ." My voice trailed off as he waved me aside to let the next people come up.

I was exasperated. How was this possible? I had set my heart on spending two weeks by myself, away from other people. I couldn't imagine a better place to do it than along the Colorado River. I wanted to be deep in the earth and alone with nature. Just me and Harmony.

"Get over," I said to my dog as I entered the van. Harmony jumped up and down with glee and licked my face. "Sit!" I told her firmly.

That just made my hyperactive dog jump even more eagerly. I sighed and tried to push her into obedience. It was going to be quite a job training this rambunctious animal I had recently bought.

I didn't want to hike down the steep trail among a group of other tourists, but I had no other choice, so I went down. My love for nature was rewarded by the breathtaking views. At the bottom, I gazed at the swift current, swollen by melting snow from the mountains. I could sense the power and might of the river. Oh, how I wanted to lose myself among the boulders for weeks and see what lay beyond the curves of the canyons, but the group was returning to the rim and I had to follow them.

Back in the van, I shuffled through my papers and found the telephone

number Yaron had given me. I went to the pay phone.

"Hi, this is Amalyah, Yaron's friend," I said.

"Oh, yes, I am Michelle!" a voice responded warmly. "Yaron has talked about you."

I was relieved when she invited me to come and see her and her husband in Washington State. "Yes, come on up. We would love to meet you," Michelle assured me. Even over the telephone, I could hear the warmth in her voice. "It will take you a while to get here, but let us know when you are in the area."

So I headed north, driving mile after mile on the highways, marveling at the vastness of this country.

By the evening of the third day I had just entered Oregon. As I left the highway to find a place to camp for the night, I rounded a curve and saw a farm lane leading off the state highway. There was a metal gate, but it stood invitingly open, so I steered my van through the gate and followed the ribbon of gravel that wound through the hills until I saw a place that was ideal to set up camp for the night.

Harmony jumped out of the van and began running in dizzying circles, sniffing at all the smells dogs love.

"Harmony! Come here!" I yelled when she set off at a lope, head high. Although there were no signs of any cattle, I did not want my dog chasing any domestic animals.

I quickly got out her food pan and began drumming on it. It worked. Harmony loved to eat, and she ran back to me, whining and jumping up against my legs. "Just a minute," I laughed, trying to attach her leash. "I'll get your food in a minute."

I liked Oregon. The hills folded against each other, and the pastures reminded me of the fields back home, covered with dry weather grasses and small shrubs. I figured there was a small stream down in the ravine. After supper, I would go see.

I got out my little stove and made my supper. I loved being self-sufficient and preparing my own food. Just as I finished my pot of beans and sopped up the juice with coarse bread from a health food store, the sun set behind the hill. Almost immediately I heard a strange hum that grew louder and

louder. In no time at all, the air was filled with pesky mosquitoes that began attacking me in droves.

"Get out!" I yelled, waving my arms wildly as the lengthening shadows provided cover for the marauders. I could no longer see them, but I could certainly hear them. Even worse, I could feel them as they came in platoons to feast on me.

Finally I escaped to the van, hastily closing the door behind Harmony and me to keep the pesky insects out. Alas, a considerable crowd of "guests" was able to sneak in just before the doors closed.

Incense sticks! I had several with me, because several days earlier I had enjoyed the pungent smell of a shop I had been in, and the sales clerk had helped me track down the aromatic smell.

I switched on my flashlight, rummaged through my stuff until I found the slender sticks, and lit them with a match. I had an incense holder on the dashboard as any self-respecting New Ager would, and I lit three sticks.

They gave off a dim light and yes, pungent smoke. At first, the strong aroma was pleasant, but soon the van filled with smoke. I opened the window a crack to let the intruders out. The plan seemed to be working fine, because I stopped hearing the monotonous buzz. I soon realized that I did not need three incense sticks burning in the confines of the van and extinguished one of them. Soon I began coughing and extinguished the second one. Finally I closed the window, pinched out the last stick, and lay on my bed.

It was warm and stuffy inside the van, but I didn't dare open the windows. There were no screens, and I knew the mosquitoes would come back inside in an instant. Never had I seen so many mosquitoes at one time. I was glad I could get rid of them, and was more than ready to call it a night. Although the van was hot, and the smell of the incense hung heavily in the air, it was better than sharing my sleeping quarters with the hungry mosquitoes.

I passed a rather restless night, and was relieved to see daylight dawn the next morning so I could busy myself with cooking breakfast over an open fire.

"Hey!" An unfriendly voice startled me.

I straightened up hurriedly, trying to locate the person who was shouting.

"Get off my land! This is private land!" yelled a woman who was standing in front of a barn I had seen on the hilltop above me.

"Sorry!" I shouted back. "The gate was open!"

"This is private property," she repeated. "No camping allowed!"

"Okay! Okay!" I got up. "May I finish my breakfast?"

"Eat and go!" She seemed to relent a little. "Hurry!"

I nodded and finished my meal. I felt hot and sticky, and I desperately needed a shower, but I did not dare ask the landowner. Obviously, she considered me a tramp.

<p style="text-align:center">◊ ◊ ◊</p>

"Come on in! The water's fine!"

I waded into the cool lake and felt the refreshing water wash over me. Finally I was able to get clean again!

I reveled in the laid-back and friendly atmosphere as I relaxed in the water, delighting in the cool wetness after my long drive. It was so peaceful here, and I was glad to take a break in my trip to Washington State. The forest was beautiful, and there were little camps scattered about the park. There were colorful old vehicles parked near each campsite, including VW vans, converted vans like my own, and even a school bus that had been turned into a mobile apartment. It housed a group of youngsters who traveled all around the country together.

As usual, there was plenty of food and always some kind of music. Glazed eyes and incoherent phrases were indicative of the drug users among the crowd. We kept the environment clean, turning in our beer cans and bottles for cash at the nearby town. I thought I had truly found heaven.

Now I waded back into the shallow water before returning to my van. I got Harmony out of the van and put her on the leash, and we followed a trail into the woods.

"Hey!" a young man greeted me with a smile. "I'm Tom. We're going to the hot springs. Why don't you come with us?" He introduced me to the couple with him, and we walked through the forest together.

They asked where I was from and stroked the attention-loving Harmony as we walked together. They were so friendly, and I was so eager for human companionship, that when they invited me to their campsite, I gratefully

accepted. On the way back from the hot springs, Tom boldly took my hand as we walked toward the lake.

My first thought was, *Oh no, I don't want a boyfriend! Not again! I don't want this.* However, I had no strength to resist or say anything. I had been through this so many times, even here in America, one man after another. I stopped thinking about emotions and love. It was just the routine: alcohol, parties, men, no commitment, and no attachment. But deep inside I wanted something else. I wanted to change, and after traveling alone for a while, I felt I was succeeding. There was such a wonderful sense of freedom, but it had barely begun, and now here was Tom. I figured that if I played his game he would probably leave after a night or two to find another girl. I didn't want him, but I had no emotional strength to say no. Something stronger than myself was controlling me. I had lost control over my own life.

More than once in the next few nights as I was lying sleepless in the van, I imagined Satan laughing in my face. "You can't change. You will always be filthy, filthy. You can't escape from it! Ha, ha, ha!"

On one of those evenings we were coming back from town after dark. Tom said he had gotten a particularly good batch of LSD for me to try. He was praising the spiritual qualities of tripping on the drug, and was planning for me to take it that same evening. Then we saw her—a young girl beside the lake, sitting in her own excrement. She was singing strange words and chanting bizarre sounds.

"We have to help her!" Tom exclaimed. With the help of a few other campers, we took her into the lake and washed her. She was so limp and helpless that I know she would have slipped into the water and drowned without the supporting hands holding her. We covered her with a blanket and took her to camp, where she kept singing the weird chants and talking about a beautiful goddess she was seeing. The poor girl was totally oblivious to our presence.

"We'll need to watch her the whole night," Tom decided. "We have to make sure she doesn't stumble off into the lake." Other people joined us. As we sat there watching the girl and talking, somehow the conversation turned to the topic of the Bible and prayer. When the group heard that I was a Jew, they assumed I knew about these things, but Tom cut the conversation short.

"How dare you talk about God and things like that near this girl?" Tom raged. "Don't you know that even when she's spaced out she can hear what is said around her? She is not to be disturbed with such talk!"

Eventually I fell asleep, and when I awoke, the young girl was nowhere in sight. We went to a nearby camp where we had been invited for breakfast, and there she was, apparently back in her right mind, seemingly cheerful and normal. But as soon as she saw us, she started chanting, "You, you, you," in a voice that grew unnaturally deeper and deeper, and then she went right back to her strange singing.

If I take this drug, I thought, *I'm going to end up like her. I'm going to go on a trip and never come back.*

I never tried the LSD, and Tom didn't press the issue after that experience. The poor girl was only sixteen. She had come to visit her sister at the camp, and it was her first time taking this drug.

The days went on. Tom didn't leave, nor did he find another girl. I hated myself for being weak. I was frustrated with Tom for so easily assuming that I wanted him. I was determined to leave.

"Where are you going?" Tom asked the next day when I told him I was planning to drive away.

"Seattle," I told him curtly.

"How nice!" he said, leaning closer and grinning at me. "That is just where I am going. Sequoia and I were just talking yesterday about going to the city. We will go with you. You know, help you drive and show you the city."

Sequoia lifted lifeless eyes toward us and nodded. A quiet, introspective type, he seemed to be Tom's shadow.

My heart sank. I wanted to say, "No!" I wanted to protest and tell Tom he was the reason I was leaving, but again, I had no power to protest. I acquiesced meekly, letting them put their belongings into my van. When Tom took the driver's seat, I climbed into the passenger seat, and Sequoia sat on my bed in the back.

We headed north, and as the miles rolled beneath the van wheels, I felt trapped. Nothing was different.

"God, where are you?" My prayer was a desperate cry.

11

WALKING UP TO THE DOOR OF THE APARTMENT BUILDING, I GLANCED AGAIN at THE paper with the address Yaron had given me. Apartment C, number 122.

I wet my dry lips and rang the doorbell. Footsteps approached. The lock turned, and the door opened.

"You must be Amalyah! Welcome!" The man reached out a strong hand and grasped mine warmly. "Come inside and meet my wife.

"Michelle!" he called over his shoulder, "we have a visitor."

"Come in," he invited cordially, and motioned me to step inside. "As you know, my name is Wayne, and you don't know how excited we are to have you visit. We have so many questions to ask about Israel and about Jewish beliefs.

"Will you tell us about your life in Israel? Oh, here you are, Michelle. This is Amalyah. She can tell us all about Jewish customs. We have been doing a lot of studying and reading, but we don't know anyone who can answer our questions."

I raised my hand and said, "I am really not sure I can tell you much about the Jewish religion, because I was raised in a secular environment. And," I said hesitantly, "I am kind of . . . well, I might be a Christian." There, it was out.

"What?" Wayne literally jumped in excitement. "You are? So are we!"

He and Michelle laughed with joy. Michelle grabbed my hand. "Oh, do come in!" she urged. They showed me a chair, and I sat down.

"This is so amazing! Thank you, Jesus!" they both exclaimed. "We believe

that Jesus is the Son of God, the promised Messiah!"

"You see, Amalyah, we felt we should look more deeply into Jewish customs to understand some of the context that Jesus taught from," Wayne continued. "Can we pray right now and ask God to lead us into a deeper relationship with Him through your coming here?"

I sat in my chair and listened with wonder. Wayne walked back and forth through the living room as he prayed. Michelle's prayer was so simple and yet so direct, as though God were right there in the room with us.

"Stay with us for the weekend," my new friends urged me. "We don't have much space, but you are welcome to sleep in the office."

I stayed. It was an incredible weekend. It was the first time I had really had so much interaction with people who were serious about living the Christian life. I felt more than once as though heaven opened up and the glory of God came down to us. These were new experiences for me, but I could see that for this young couple, this was their way of life.

"Come back and live with us," they urged when I left on Monday morning. "We feel God is directing us to offer that to you, and we sincerely want it," Michelle told me, embracing me fondly.

Her words touched me, and part of me longed to accept her offer right away. When we had first reached Seattle, we had quickly found a camping place. Washington State was a haven for wanderers and people who were interested in living alternative lifestyles. But now I felt a stirring inside me that wanted something better, something more fulfilling.

I left and drove back to the park where I had been camping. "Where were you?" Tom asked when I drove in to my usual parking spot.

"I made some new friends," I told him. "They invited me to stay with them for the weekend, so I did."

"I was worried about you," he said, staring deeply into my eyes.

I shrugged and looked away. "I didn't think you would worry. You are gone sometimes too." I found myself getting defensive.

My relationship with Tom was a strange one. When I was away from him, I felt much lighter and freer. But when I was with him, I felt an invisible cord binding me to him. I was feeling bound and stifled with his control over me.

"I want the freedom to come and go as I wish," I told him frankly. "I give

you that freedom, so I want the same."

"Oh, yes, Amalyah, of course! I love you, so I was naturally worried about you."

"Sequoia, what about rustling up something to eat?" he asked, changing the subject. "I'm hungry."

I wanted to ask Tom why he didn't make some food for himself. I wanted to ask why he didn't seem to mind sponging off other people and freely eating their food, or why he never had any money to put gas in my van. But I said nothing. I hated conflict too much to bring up the issue. I already knew that many of the drifters we encountered felt totally comfortable living with others and "sharing" everything. Of course it wasn't real sharing since they didn't contribute anything. This lifestyle was all about peace and going with the flow. Don't rock the boat, don't get too excited about injustice, and just let love rule.

This might have sounded good in theory, but I saw many times how much it lacked in practical areas. The hangers-on and the lazy took daily advantage of those who held jobs and provided an income for themselves. Often parents didn't take responsibility for their children, so much so that children hardly knew who their parents were. Fathers were especially absent, for many times they had drifted somewhere else and were no longer in the picture.

Sequoia finished rummaging through my cooler and announced, "It's almost empty."

"There's still some rice in the bag under the bed," I told him.

"I'm tired of rice," Tom grumbled as he stood up and stretched. "I'm hungry for eggs and bacon. Yeah, good old bacon would satisfy about now. Doesn't fit into my vegan diet, but oh well, we can cheat every once in a while. Eat and repent—that's my philosophy."

Sequoia made a rare stand. "No! No bacon!" he said firmly. "We agreed that we would not eat any meat, Tom! We are making a statement against the cruelty of Christians toward animals and other living organisms. Just because they consider animals a lower form of life doesn't mean we can go along with the slaughter and destruction to feed our bellies. Would you eat Harmony?"

My dog jumped up eagerly at the sound of her name.

"Whoa!" Tom laughed at Sequoia. "What stirred you out of your usual lethargy?"

I knew. Sequoia had gotten some cocaine somewhere, and he was still high on that. He hardly ever talked unless some drug was coursing through his veins.

I didn't know why I put up with Tom's friend. No one invited him along anywhere, but he shadowed us wherever we went.

I sighed. The two men had begun to argue, each one so illogical it could have been funny under other circumstances. But to me, it was just another reminder of the pointlessness of the life I was living, the life in which I seemed to be trapped.

"They said I could live with them," I told Tom.

"Who said that?" he demanded, forgetting his argument with Sequoia.

"Wayne and Michelle, the couple I visited. I want to live with them and get a job and have a life." I was seething inside, and I knew that what I really wanted, what I desperately wanted, was to get away from my present life.

"No problem," Tom agreed. "You do what you want to do, darling."

Two days later I was once again at Wayne and Michelle's door, this time with Tom. Their welcoming smiles were like rays of sunshine in the damp evening air.

"Come in," they welcomed us.

"Tom, this is Wayne and his wife Michelle," I said. "This is my friend Tom."

"You are welcome," Wayne said instantly.

All evening I could sense Tom's uneasiness. When we sat around the dinner table, he visibly withdrew, and immediately after the meal he went outside.

"You two aren't married, are you?" Wayne asked, not unkindly.

I shook my head, "No. Tom is my boyfriend."

"We believe you are hungry to learn more about Jesus, but Amalyah, you cannot live in sin. We welcome you to live with us for a time because we recognize the hunger in you, but we don't see that same hunger in Tom. We want to witness to him, but we can't let you stay together in our house. We don't want to open our house to the evil that could come in because of this."

I stared at Wayne, bewildered. What was he saying? It didn't make sense to my logical brain. Evil could come into their house because Tom and I weren't married?

I think they discerned my bewilderment, because Michelle put an arm around me and said lovingly, "We have nothing against either of you. We love you. But we love God more, and we want to honor His definition of marriage. If we knowingly go against the truth of the Bible, we open ourselves to deception."

I wanted to ask questions. I wanted to know more. I wanted help. I looked blankly from one loving face to the other, but my throat felt tight. It felt as if something was gripping my voice box, and I could not speak.

"Amalyah! Come out here!"

Blindly, I turned and left, stumbling through my tears to the van.

"You are *my* girlfriend," Tom began. "Those people have nothing for you. They only want to brainwash you into thinking their way of life is better. I know Christians: you can't do this, you can't do that, and anything fun is wrong. No, Amalyah, don't listen to them. I am the one who loves you." He looked straight into my eyes.

I could not articulate what was happening inside me. I was being pulled in two directions. My head told me Tom was right, but my heart longed to have what Wayne and Michelle were experiencing. I hated my life.

But I heard myself dutifully saying, "Okay," and I climbed back into the van. I didn't dare look back. I couldn't bear the thought of seeing the couple I had learned to love standing by their door, watching me leave.

Even though I didn't say anything, I began to plan. I knew I could never leave Tom if I told him my plan. I would look for an opportunity to secretly flee back to the safe haven I had found. I was growing desperate.

12

"WE CAN'T GO. THE FERRY ISN'T HERE YET!" I SAT IN THE DRIVER'S SEAT OF THE van and stared straight out the window.

Tom was in the back with Sequoia. We had decided to go to one of the many islands off the coast of Washington, and as soon as we were on the way, I realized that this was not going to be a good day.

For two days I had looked for an opportunity to "lose" my passengers and return to Wayne and Michelle's house. But as though he were aware of my intentions, Tom made sure I was never alone.

"I don't understand why you didn't drive faster," Tom now whined. "You spent so much time back there at the gas station. We could have gotten here ten minutes ago and gotten the early ferry if you hadn't been so slow. Now how long will we be stranded here?"

"I don't know," I sighed. "But I couldn't help it that traffic was heavy today. I don't see why you are blaming me for not getting here earlier."

Like a wave of filthy water, Tom's words cascaded over me. "Amalyah! You are always defending yourself! If you want to be a real woman, then you must learn to do as I say! I am your man, and don't you ever value anyone else's opinion higher than mine! I try to tell you how you should have done something, and you always argue. You are one self-righteous person if I ever found one. Is that the way you have always been?"

"Hey!" I objected. "Who is riding with whom here? You are in my van,

and you decided to go along with me wherever I go! If you don't like it, you don't have to be with me."

With a roar of rage, Tom leaped forward and into the passenger's seat. He leaned toward me, screaming about what a horrible person I was. Then he yanked the door open, jumped outside, and began striding angrily back and forth beside the van.

Inside, I put my head on the steering wheel. "Why? Oh, God, why?" I murmured.

As I watched Tom pacing outside, I realized that he was getting more and more controlling and possessive of me. I really did need to remove him from my life.

Suddenly the door beside me opened and I tensed. "Amalyah, I am so sorry." He tried to smooth over his actions with repentant words. "I was so horrible to blow up at you. I guess I was just too impatient. I wanted to get to the island so we could enjoy the entire day, and I didn't like the delay. But it was mean of me to blow up at you." He slid his arm around my neck.

Even though I didn't want to acquiesce, I felt my anger subside, and the familiar tentacles wrapped themselves around my life again. My mind slipped into the old patterns once more. "It's okay," I mumbled. Just then the ferry came, and I started the motor.

0 0 0

"Tom, it says right here, 'God so loved the world' and you know what? That means all of us. It means you, it means Sequoia, and it means me. That is what Wayne and Michelle told me over and over, and that is what it says here in the book of John." I spoke over the whine of the van motor as we sped down the highway.

"We have been created by aliens," Tom replied as he drove. "There are other worlds out there, you know, worlds with beings much more sophisticated and modern than we are. We have no monopoly on intelligence at all."

I continued reading the New Testament Michelle had given me. " '. . . He gave His only begotten Son'—that would be Jesus—'that whosoever believes in Him should not perish.' That is really awesome! If we believe in Jesus, we won't

perish! That means we'll be able to live with Him in heaven when we die."

Tom interrupted coldly, "There are aliens that fly around in their spaceships, powered by renewable energy from the sun. They have been visiting the earth for years, although most of the time they are invisible to humans. Occasionally people do see their ships."

"Flying saucers, dude," Sequoia said cryptically from his seat in the back.

"Exactly," Tom nodded and laughed. "At one time they decided to populate the earth with humans, and created us as inferior beings. I actually think we are kind of like an experiment, and they laugh at our ridiculous notions about God and the creation."

"But," I interrupted, "do these aliens love us? Do they help us? Can they make a difference in our hearts?"

Lifting a hand, Tom assumed a superior air. "Amalyah, you are a Jew, and because of that you have an inherent belief system. It's not necessarily wrong, but not exactly right, either. The Judeo-Christian religion has dominated so much of Western culture for years, but is now being challenged by intelligent theologians everywhere. The aliens protected the earth from being burned by the sun. They also teach us how to exploit energy fields around us so that the elect will one day use that energy to travel from planet to planet like God does."

"I don't want ideas that will benefit only a few elect. I want something that works for me," I said. I was not giving up. "And I tell you, if God loves me, that works for me!"

"Oh, yes, of course," Tom agreed suavely. "It is God who made love. Love is important to sustain life. Mothers love their children. Men love women. It is imperative that love exists."

"Then," I continued, "what do we assume if love isn't seen in action? Where does love fit in when people kill, rape, and plunder other societies? Do your aliens come and make sense of that?"

"It is one thing to believe on a personal level, and another thing entirely to believe on a galactic level," Tom said.

I shrugged. I could see there would be no meeting of the minds between us. I felt trapped again. In fact, the only time I hadn't felt trapped for a long time was the weekend when I was at Wayne and Michelle's house, and Tom

was not with me.

For the last two months I had seesawed between two worlds. I wanted to escape to Michelle and Wayne and feel the security their home offered, but every time I tried, Tom would persuade me again with winning ways to stay with him.

Eventually he got all excited about some kind of meeting in Arizona, and his enthusiasm was contagious enough to make me agree to go with him. Tom had started paying for the gas, food, and other expenses, so I couldn't really say he was taking advantage of me financially. I groped for a good reason to end the relationship, to break free from him.

Tom was becoming more unpredictable, exploding suddenly in rage at something I had said or done days before. His voice was venomous as he attacked the way I looked or ate or walked, implying that I should know better.

Just as abruptly, he would shift back to the honeyed words and would treat me like a queen until the next outburst. I felt my life spiraling out of control, and I knew I had become a battered woman. Even though his violence was never physical, Tom was steadily crushing and breaking my spirit. He was using the cycles of verbal abuse and subsequent tenderness to control me and keep me from leaving him. I was always tense and nervous, afraid that something unexpected might send Tom into one of his fits of rage. My only times of peace came when I read the New Testament Michelle had given me. Those times of reading became my comfort and refuge.

0 0 0

"Do you like those?" Tom's voice was soft in my ear.

I fingered the earrings. The intricate design on the silver had fascinated me, but I shook my head and put them back on the display hanger. The proprietor of the shop was busy with another customer at the counter. I left the display and went to the cooler to get a bottle of juice. I stood in line, waiting to check out. Tom was still beside the earring display.

Tourists and travelers crowded the store. The West seemed to be filled with visitors, families on vacation, college students on break, and drifters like us, searching for meaning in life.

"Is that everything?" The clerk behind the register took my drink and scanned it. I paid for it, joined Tom and Sequoia in the van, and we resumed our journey. I pulled my New Testament from my bag and began reading in Hebrews. I was fascinated by this letter to the Jews. Something about this epistle resonated with me because I realized it was written to my people. More and more I was longing to know about God's interaction with the Jews. I realized there were huge gaps in my knowledge of my ancestry.

"Here." Tom extended his hand toward me. "I saw you liked these, so I got them for you."

The earrings! "Oh, thank you!" I took his proffered gift and inspected the intricate design. "I wish I could make something this beautiful."

Suddenly I realized there was something disturbing about the gift. "But I never saw you buy them!" I gasped. "I stood in line to get my juice and you were still examining the display. When . . ." my voice trailed off in disbelief.

"Don't worry!" Tom waved his hand airily. "They won't miss them. I mean, there were lots of pairs on the display. One missing pair will mean nothing to them. They figure the occasional loss into the price when they put them out."

"You stole them! You're a thief!" My voice came out loud and strong. I was shocked.

"Hey, wait a minute!" Tom immediately became defensive. "I got you what you wanted, didn't I? You see, I know how to take care of my girl." He turned his charming grin toward me.

"I don't want stolen property," I said, and tried to hand the earrings back to him.

Tom just laughed. "Do you know how many people do this? It's a way of life for them. Why shouldn't we help ourselves to what we want? Why should some people have things that other people don't? We should all be equal. Think of us as Robin Hoods, creating equality by taking from the rich to benefit the poor."

"Robin Hood?" I protested incredulously. "You aren't meeting the needs of the poor. These earrings are a luxury, not a necessity! Is that how you manage to pay for the gas and food—because you steal?" I felt a cold shiver of fear. What would my parents think if they knew my boyfriend was a criminal?

"I don't want these," I told him firmly. "I don't want you to ever steal again!"

"Amalyah," Tom said soothingly, "why do you take things so seriously? Relax. Life is what you make it. Let's live for today. Come on, enjoy the day. Enjoy the ride."

That was exactly what I was not doing. I was not enjoying the ride. The longer we traveled together, the more I realized what a trap I was in.

I thought of Wayne and Michelle with longing. Their home was so peaceful. I had felt like the depths of my soul were soothed just by being with them. What did they have that I didn't? Why couldn't I experience such peace in my own life?

My heart desperately longed for answers, but I felt so bound, like a fly trapped in a spider's web.

"The person who made those earrings was definitely a Bat," Tom said musingly. "I can feel the vibes from inanimate objects. The twelve tribes of aliens have all given us individual traits with which to identify us. When we rub our hands and fingers across objects and they pick up the sensations, then we are in communion with the aliens."

I held my hands over my ears and tried to concentrate on what I was reading. Suddenly waves of confusion and turmoil streamed over me, and unpleasant memories crowded my mind. I thought back to the young girl we had bathed in the lake in Oregon. It had taken more than a day for her to come back to consciousness. Even then, she had lapsed into more trances, only to return and begin talking about the demons that kept beckoning her back.

I remembered how I had gotten so desperate to help her that I had begun to pray. It might not have been the most appropriate prayer, but I had begun to pray loudly and earnestly the *Shema* that we Jews prayed in the face of death or trouble, "Hear, O Israel! The LORD our God is one LORD!" Over and over I had prayed it, hoping to drive away whatever demons were binding the girl.

Eventually I had begun to read the Bible out loud to her. There had been a wave of protest from the other campers.

"Don't do that! That will make it worse! She can still hear, and that's the worst thing you can do to her. Leave her alone!"

I had retreated, feeling helpless and defeated. I looked at the glassy-eyed girl and thought, *The poor thing. She just came here to visit her sister and got all caught up in this demonic drug.*

I remembered how I had vowed never to take any of the drugs Tom kept offering to me. But now, there was something in the way he was talking, the strange way he spilled out his words, that seemed to have the same dark power as those mind-altering drugs. It frightened me.

"Why don't we stop and take several days of rest?" I suggested. "I'm tired of traveling all the time. I need a break."

Tom didn't say anything but kept on driving.

I tried again. "Let's stop and set up camp close to the Pacific somewhere. There is no hurry to get to Arizona."

"Gotta keep moving," Tom said.

Once more, I felt used. "Tom, this is my van. I want to see the ocean, and I need to have some quiet time. I want to read the Bible and see what God has to tell me. I really need to hear His voice. Besides, this June weather is perfect for camping."

"No," Tom said firmly. "If we stay too long in one place, they might find us."

"Who might find us?" His answer puzzled me.

There was no immediate answer. "Tom, come on, I want to stop. Who might find us?"

"The FBI."

"The FBI?" I repeated, baffled. "Why would they want us?" I looked keenly at my companion. Who was this man? Was his name really Tom?

And then the story spilled out. He had been arrested for taking indecent liberties with a minor and had jumped bail. He was traveling under an assumed name and forged driver's license. Tom was indeed on the run.

That night, I could not sleep. I saw my situation getting more and more desperate. I was emotionally tied to Tom, who had demonstrated he was a thief, who was probably a felon, and who was definitely a wanted man. His ideas about God and the world were more than strange; they seemed to border on the demonic.

I tried to look objectively at myself. Here I was, running around the countryside, living off my small hoard of savings, hunting for meaning for

my life. I knew I wanted to know the God that Wayne and Michelle served, and I longed for the relationship they had with Him. I also knew that I wanted to detach myself from Tom and his shadow, Sequoia. I just didn't know how to do it.

I felt sorry for Tom. I wanted to leave him, but I thought I should do it in a kind way since I had started preaching the love of God to him. I didn't think I could just dump him at the side of the road with his luggage and tell him to hitchhike. I remembered how I had tried to get rid of him in Seattle so I could live with my Christian friends, but it had never worked. I felt utterly trapped.

"Lord," I prayed, "if there is a Christian way of getting rid of Tom, please help me to find it."

0 0 0

"Amalyah, take this calling card and call me every day while you are on the road," Deborah told me. "I'm concerned about you, and I don't have a good feeling about this Tom. Has he been taking your money?"

"No," I told her, "lately he's actually been paying for most of the gas and food."

"Well, girl, I still don't like your situation, and I want you to call me every day, okay?"

"Okay," I agreed, hugging my sister before I headed out on the road once more with Tom. He had only reluctantly agreed to stop and see my sister when we traveled through Arizona, as if he was afraid of losing his influence over me. Like Deborah, I knew too that something was wrong, but I still felt powerless to change the situation. In the few days we had spent with Jacob and Deborah, I felt uncomfortable and ill at ease around my sister. I couldn't look her straight in the eyes, and I didn't understand why. After all, Tom was the one who had been stealing. I wasn't the sinner, was I? It was all very confusing.

It had only been a few months since I had started my big trip with high hopes and grand dreams. Now I just wanted to get away from Tom and continue that interrupted trip as I had originally planned it. But things

were different now. I had even lost my dog. While we were at my sister's house, Tom had persuaded me to give Harmony away since she had become more aggressive and had even tried to attack other campers at the hippie camps where we sometimes stayed.

Tom said he knew some people in New Mexico, so we headed there together. As though an invisible cable bound me to this man, I followed his suggestions that often turned into demands. Every day I asked him to stop so I could call my sister, and every day he managed to delay until it was too late to call.

<center>0 0 0</center>

The coffee shop in the picturesque downtown of Santa Fe was full of young people, mostly students. Tom immediately struck up a friendship with Chris, who invited us to move into his apartment with him. This time Tom was not so lucky, though, as Chris was very firm that we would pay a hundred dollars a week to stay there.

"Here, Amalyah, take this laptop and sell it for as much as you can," Tom ordered. "It is worth at least two hundred dollars."

"I really want to look for a job, Tom," I told him.

"Fine," he replied curtly, "but no one will hire you without an address. Sell this computer, and then we'll be able to move in with Chris and have a local address before you start job hunting."

So I sat in the coffee shop with a little "For Sale" sign on the laptop. In the end, it was Tom who finally found a buyer, enabling us to stay with Chris for a while.

Every day I would go out looking for a job. I was eager to do something with my life, but nothing came up.

There was another thing that troubled me even more than being unemployed. By now I knew that my relationship with Tom was a sin, but I wasn't sure how to fix it.

"Tom," I said, "you know that if we want to keep on living together, we need to get married."

"Honey, we don't need marriage," he chuckled. "Why, that is something

only traditionalists need. We are fine just the way we are."

"Then we can no longer be together," I said firmly. "It is a sin to live the way we have been."

Tom agreed to separate, but I couldn't find a job, so I couldn't move out. We were in the city now, and I couldn't just live in the van or camp outdoors. I remembered Wayne and Michelle and longed for the peace I had sensed in their home. "God," I prayed, "please let me meet Messianic Jews, and please let me meet people who have what Wayne and Michelle have."

◊ ◊ ◊

"God," I said in despair as I scanned the columns of churches listed in the yellow pages, "how do I know which church to attend? How do I know they won't try to teach me something false? And Lord, you know I really need a job. Could you please help me find a good church and a good job?"

"I'm praying God will help me find a job," I told Tom that evening.

"You know," he said piously, "you really shouldn't pray."

"Yes I should," I protested. "God wants us to pray to Him."

"How do you know God is not a she?" Tom asked. I shrugged my shoulders wearily and dropped the subject.

"Hey, we're having a party here at the house tonight. You're welcome to join us," Chris said, coming in just then with a load of beer and snacks.

"No thanks," I said. "I'm going job hunting again. I'll see you when I get back."

I headed toward a small restaurant and bakery I had seen earlier. I hoped to find a job at a restaurant since I had been told that the workers often got one free meal a day, and I was interested in economizing any way I could.

"So you're from Israel?" Alfred, the jolly owner of the bakery, asked me with a broad smile. "My friend Joe spent time volunteering on a kibbutz in Israel a few years ago. Maybe you've heard of this kibbutz?"

My eyes widened as he told me where his friend had been. "Indeed I have heard of it," I told him eagerly. "That's the very kibbutz where I grew up!"

"Now what are the chances of that?" Alfred laughed good-naturedly. "Well, Joe told me that the kibbutz people are dependable, hard workers, and I do

need another worker in the bakery. The job is yours. Glad to have you."

Just like that, I found a job. God had answered my prayer, so now I could look for an apartment.

"Talk to Carlos. He has apartments," someone at the health food store told me in answer to my inquiry. "Here, take his number."

"You are an Israeli, a Jew?" Carlos was so excited when I contacted him. "You're going to have to tell me all about it. I love Israel! I love the Jews!"

"Okay, Carlos," I said, "so I'll see you Wednesday."

"Actually, my name is Ovadia," he told me. His pronunciation of the Hebrew name was just like an Israeli, and I was sure he was going to start speaking Hebrew to me.

"No, no," he laughed when I asked him about it. "I don't really speak Hebrew. I'll tell you all about it when we meet."

The party was already in full swing when I returned to Chris' apartment. I looked for Tom, eager to share with him how God had answered my prayers. At first I couldn't find him. When I finally located him, he was with another girl.

I was overcome by a strange mix of emotions at that moment. While I realized that I could finally be free of this horrible relationship, at the same time a wave of jealousy swept over me. Suddenly I exploded. Everything that I had held back in the four months since I met Tom came gushing out, and I screamed at him, lashing out without restraint. Tom said nothing in reply, but he gave me a wounded look as he took his new girl and left the house.

"God," I prayed as I sat alone in the tiny front yard, "I hate this life. It is always the same no matter where I go. The scenery changes, but things stay the same. There is no meaning, no purpose. I find only pain and heartache and loneliness and anger. I hate myself. I want to die. I don't even want to be here anymore. But if you still have a purpose for me in the world, please show me what it is. I need your help."

Feeling slightly more hopeful, I went the next day to inspect the apartment Carlos had available. While I waited for Carlos, curious to hear how he came to have a Hebrew name, I was pleased to note the beautiful shade trees in the courtyard.

"So, what do you think?" Carlos greeted me as he hurried up a few

minutes later. "Do you like it?"

The little apartment was perfect for my needs. Even though it had no furniture, anything with four walls and a roof seemed like a safe haven to me. Perhaps here I could break the final ties with Tom and begin my new life.

"So tell me," I said to Carlos, "how did you come by this name Ovadia?"

Carlos laughed. "I was born into a Catholic family, but eventually learned that my ancestors were Jews who fled Spain during the Inquisition. So sometimes I use my middle name, which is a Hebrew name.

"And you," he continued eagerly, "tell me about yourself. Tell me about Israel, and about Jewish customs."

Oh no, not again, I thought, remembering how Wayne had wanted to know the exact same things. Now I had a problem. If Carlos descended from the Jews who suffered so much during the Spanish Inquisition, I feared he would refuse to rent the apartment to me when he found out I wanted to follow Jesus.

I began rather hesitantly. "Well, I'm really not into politics, so I can't tell you too much about current conditions in Israel. As for religion, I was raised as a secular Israeli, and now, well, I kind of believe in Jesus, actually."

"Really!?" Carlos exclaimed with joy. "Me too! I'm a Messianic Jew! I believe in Jesus as my Messiah!"

I couldn't hide my excitement. "God has answered another prayer for me!" I exclaimed loudly. "God, you are so good!" A young girl who lived in the apartment across the yard shook her head and rolled her eyes as she walked by.

"Don't mind her," Carlos said joyfully. "What a miracle this is! I'll tell you what; you move in here the day after tomorrow since that will be the first of the month. Then on Sunday I'll take you to church, okay?"

13

SO GOD ANSWERED MY DESPERATE PRAYER, AND IN AUGUST OF 1996 I MOVED into my little apartment. For the first time in months, I felt as though I could breathe. And think.

I walked through the tiny apartment and looked out the second-story window onto the street below. The glass was cool to my touch, and I stood there for a long time, breathing slowly. A peace settled over me, and I found myself praying aloud.

"God, I really want something meaningful in my life. I want to experience for myself what I saw in Wayne and Michelle. I need more than I currently have. I need something that only you can give. Thank you that I am free from Tom. Thank you, thank you!"

I turned and faced the room. It was empty. I had known it was unfurnished, and I didn't have any furniture. But I didn't care. I had my sleeping bag, and that was enough for me right now. I had no idea how long I would be staying, and I didn't want to be cumbered with earthly possessions.

I felt lightheaded. It was as if I was going through some kind of withdrawal as my thoughts slowly began to clear. Even though I had never been on drugs, I began to realize that I had been bound by another kind of addiction that made me do things I really didn't want to. It was the addiction of co-dependency, of allowing people like Tom to dominate and control me. For too long I had been bound to him in a way that kept me

from thinking on my own. That dependent relationship had not allowed me to hear the voice of God.

"Where are you, God?" I asked, and then almost forgot my question in the pleasure of being able to speak out loud without anyone else hearing me. I felt free. I went into the tiny kitchen and marveled at the wonder of being alone.

That evening I lay on my sleeping bag and hugged my pillow to myself. My mind went back to my childhood home on the kibbutz. I saw myself as a little girl, always seeking comfort through living things, whether they were insects or frogs, worms or mice. I began to recognize the loneliness that I had experienced. For the first time I realized how many of my actions had been motivated by the desperate searching of my hungry heart.

I recalled how the other children and I had always hunted for some slight excuse to run home and spend the nights at our parents' homes. I now saw that hunger for companionship and acceptance from my parents as legitimate and unfulfilled.

I saw myself as a teenager, and I didn't like what I saw. I had been a young girl who wanted recognition, seeking for approval from my friends, but feeling rejected and different. I saw myself reaching out for love from the young men who came to volunteer on the kibbutz, trying to find security and acceptance from them.

"I'm so sorry, God!" I wept as I relived my life. The terrible things I had done in my desperate search for acceptance flashed in front of me. "I didn't know! No one told me. But I'm so sorry! I have sinned deeply against you."

Hot tears streamed down my cheeks, and I moaned in agony. "I want you to take control of my heart! I want you to take me and care for me. I can't do it by myself. Please help me!"

In my turmoil, I heard a small voice saying, "I will take you. I will love you." I knew it was from God, and that tender reassurance set off another round of weeping.

Scene after scene came rolling on the pages of my memory. I wept as I remembered the times I had intentionally taken other girls' boyfriends away in a power play to assuage the emptiness I had felt. I saw myself bar hopping, willing to give myself to any man who paid me a little attention. I

saw the sordidness and debauchery I had allowed myself to sink into.

My mind continued its journey back to those eight years with Yaron, seeking his approval and trying to live peaceably with him. I remembered the day we parted ways, and I realized that I had left a part of my life with him.

"God, will you please restore that which I gave away so carelessly?" I prayed. "Like the Christian couple said many years ago at the campfire on the kibbutz, I destroyed my ability to love properly by giving myself away so easily. I don't even understand true love. I trust you to teach me, and to restore what I have lost."

The night grew dark, and the street light shone through the bare window. Time stood still for me as I continued my mental journey.

"Did you put the hunger in me, God? Were you the one who kept me seeking? I know I really messed up time and again. Even my move to America was part of my quest to find a real reason for living. Did you lead me to come here?"

I thought back to the days of living with my sister and her husband, then becoming restless and moving on. I remembered the thrill of joy when I had finally purchased my van and prepared it for the road.

But traveling and living in my own vehicle had not brought me the lasting satisfaction I had been hoping to find. In fact, it had ended up accommodating passengers who had hindered rather than helped me on my journey.

"I am sorry for my life with Tom," I wept. "I am sorry for how I allowed him to control me. Even when I wanted to leave him, it felt as though an invisible force bound me to him. Somehow it seemed like I couldn't escape from him. But I didn't trust in your power, God. I wasn't asking for your help. I am sorry, God!"

I continued to weep. My eyes were red, and my nose was raw from continual wiping, and yet inner healing was taking place as I wept.

"Thank you for allowing me to meet Wayne and Michelle. Thank you for letting me find people who love you so deeply! Teach me, Lord, to know you like they do, or even better than they do!" My words and thoughts bubbled out effortlessly. I could say whatever came to my mind with only God to hear my outbursts.

"God, I repent. I repent of all my sins. I bring them to the cross of Jesus. I beg you to forgive me and accept me! Please take my weak faith and make it strong. I need you! I have to have you in my life. Please accept me!" I realized that the essence of my prayer was similar to what I had repeated before at my sister's urging, but this time I prayed with a sincerity born of desperation.

A lot of healing took place that night in my little apartment. Chapter by chapter, God allowed me to see another portion of my life, my sinful deeds, and my totally selfish actions and reactions. Each time I tearfully cried out, "God, I am sorry! I am so sorry!"

As I did, the peace in my heart reassured me that I was loved and cared for. Yes, I felt deep remorse, shame, and sorrow, but it was coupled with the realization that He was accepting me! I was being scrubbed clean from the inside out, and even though it was painful, I began to feel lighter and freer than I had ever imagined I could.

Sometime long after midnight, I finally fell asleep.

The next morning, I was immediately conscious of a difference inside me. I looked outside at the morning sky and was amazed at how brilliantly blue it was! "God, I thank you!" I exclaimed joyously. "Wow, the sky is so blue! Has it always been this blue?"

I jumped up and ran to the window. A small park across the road caught my eye, and as I looked at it with new vision, I almost gasped. The grass! It was so green, so alive!

I danced a few steps in my apartment. I felt light and free! I wondered if I could fly if I tried. I opened the windows and laughed out loud as some birds flew overhead. The sunlight streamed in on me, and I flexed my fingers, watching the play of light and shadow.

I sang and laughed, exhilarated! I prayed words of gladness. Snatches of songs filled my Spirit-filled mind. I was alive—alive and forgiven!

"God, I thank you that you reached out to me! I thank you that I don't have to face my future alone. Where would I be if you had not continued to seek after me and relentlessly pursue me? I thank you for your grace and mercy. Like a wounded deer, I was limping through life, and in your great love you came to rescue me!"

I had to tell someone what had happened, so I called my sister in Arizona.

"Deborah!" I shouted into the phone.

"Amalyah!" I could hear both reprimand and relief in Deborah's voice. "I've been worried sick about you!"

"I'm sorry," I said remorsefully, "Tom didn't let me call. Every time I wanted to call you he would find distractions and excuses, and I couldn't get to a phone until it was too late to call."

"Well, I'm glad you finally called now," said Deborah. "When I didn't hear from you for two weeks, I was terribly worried. I called my friends to join in prayer—"

"Deborah," I interrupted, unable to wait any longer, "I gave my life to Jesus last night! I really feel like I came from darkness into light. Everything has changed!"

"You do sound different," Deborah acknowledged. "You really do sound like you came out of your darkness at last. Tell me what happened."

As I launched into my story, I saw from the corner of my eye that Tom was approaching the front door. "Deborah, it's him," I breathed fearfully. "It's Tom. He's coming right now."

"Don't worry," Deborah urged me as I prepared to hang up the phone. "He has no power over you anymore."

A little nervously I opened the door in answer to Tom's knock.

"Hi, Amalyah," Tom said breezily, walking uninvited into the room, followed by a timid-looking girl. "You have a nice apartment here."

I shrugged. I loved the little apartment even though it had nothing in it except my sleeping bag. I knew Tom was just trying to gain some favor in case he might want to use the apartment himself.

"Leslie, would you like to live in a place like this?" Tom turned to the girl he had brought with him.

"Yes, I guess," Leslie answered hesitantly. "If this was what you wanted."

I detected the uneasiness in Leslie's voice. *She is trapped, just like I was,* I thought. I was relieved that Tom had found someone else and was out of my life, but my heart went out to Leslie.

"So you are going to stay here now?" Tom came quite close to me and tried to capture my gaze.

From the moment I had seen them approach the front yard, an uneasy

feeling had gripped me.

Now the uneasiness in my heart grew as Tom drew near. I felt shivers going down my spine and my brain seemed to shut down. I couldn't think.

Jesus loves me, this I know. With great effort, I recited in my heart the words Deborah had taught me a few years ago. She told me to say it if I was in trouble. *Jesus loves me, this I know!* Suddenly the phrase burst from my lips. "Jesus loves me, this I know!" I repeated it over and over again even as Tom was speaking.

He stopped abruptly in mid-sentence. His eyes dropped, unable to meet my gaze. "Come on, Leslie," he muttered. "We need to get out of here."

The slight girl looked at me, and I saw the longing in her eyes. Impulsively, I gave her a hug. "It's okay to believe in God," I told her softly. "Jesus really does love you. He is the one who died for our sins, and He rose from the dead by His own power. That means we can serve Him today and live with Him in heaven after we die."

Leslie clung to me, her eyes full of tears. "You don't have to go with Tom," I told her. "You don't have to do what he says. God can make you free."

"Leslie! Come on!" Tom's voice called impatiently from outside the apartment.

Leslie turned her face away from me and left my apartment, walking as if she were in a trance. I knew that feeling all too well, for I could now see even more clearly the bondage I had been delivered from. The moment Tom left the apartment, my brain had cleared, and I could again think clearly and pray. "God, I thank you for protecting me. Please help Leslie come to know you too."

Two days later, Tom and Leslie showed up once more. I was sitting outside in the front yard.

"Here, I'll trade you this ruby for your van." Tom opened his hand to reveal the gem. "It's worth at least three thousand dollars."

I looked at Tom fearlessly. I saw things in his face I had not noticed before: the lines on his forehead, the red veins in his eyes, and the gray tone of his skin.

"No, thank you," I said calmly. "If the ruby is worth what you say it is, sell it, pay me two thousand for the van, and keep the remaining thousand for yourself. Better yet, if you got that ruby like you got those earrings, take

it back to its rightful owner and ask forgiveness for taking it."

Tom tried to stare into my eyes in his intimidating way, but this time, it was his gaze that dropped, and he shuffled restlessly.

I was amazed at the power inside me as I faced the man who had controlled me for the past few months. I was no longer afraid, nor did I feel helpless.

"Come on, Amalyah, take it. Your old van won't last much longer anyway." Tom's voice was no longer strong and in control. I could hear a note of desperation coming from him.

"No," I reiterated calmly. "If you'd like to buy the van, you have to pay cash. No trading."

"Come on, Tom," the girl called to him from the sidewalk. "Let's go."

Tom turned angrily toward her. "Wait, Leslie!" he snapped impatiently. Then he turned to me again. "Look, I really need the van. You are staying here. You have a job you can walk to. You are beginning a new life here, and you have a family and a home in Israel you can go back to. But I have to keep moving. I have no one in this world. I am completely alone, and you don't want to help."

"Don't try to send me on a guilt trip, Tom. My family and home have nothing to do with it. We all make our own choices, and you could choose to get a job. I don't really want to sell the van, but I'll do it to help you if it's as easy as you say to sell this ruby and bring me the cash," I said calmly but firmly.

"Wow!" Leslie spoke up as she came closer. "You aren't scared of Tom! No one else dares speak to him like that."

I looked at her and saw the same hunger in her face that I used to have. "It is only because of the power of Jesus within me," I told her. "He has changed everything for me."

"I can see something happened," Leslie said wistfully.

Tom reacted suddenly. "Okay, enough! Leslie, wait for me on the road." Leslie looked at me helplessly, and left us alone.

"You are not going to convert my new girlfriend!" Tom seethed. "You are not going to poison her head with talking about God! You ruined my life when you yelled at me so that everyone at the party could hear!"

I saw raw anger in his eyes. "I hate you!" he snarled venomously.

I was sitting at the side of the apartment building, and Tom was right in front of me, yet I was not afraid. An incredible peace came over me as I looked him straight in the eyes. "Jesus has changed me," I said. "He can change you too, Tom."

The enraged man lost control. He bent over and picked up a huge rock. I didn't move my gaze from his eyes. *Lord,* I thought, *my life is in your hands.* Tom lifted the rock, and with a snarl, he threw it at the wall to his right.

"I hate you!" he hissed again before turning on his heel and stalking away.

"God, protect me from Tom's evil intentions," I prayed. "Let no evil come to me from my past or from him. I renounce the power he once held over me. I am yours, Lord, and I serve only you."

I did not understand much about the powers of evil that Satan used against those who desired to walk in the light, but I did know that a great happiness had come into my life. Ever since that night in my apartment when I had repented from my sins, I knew I was changed. I was no longer bound by darkness. I was a child of God!

14

AND THE COOLNESS OF THE CHURCH'S air-conditioned interior felt good. I soon discovered that more impressive, however, was the warmth and sincerity of the people there. Carlos had said, "I will take you to church on Sunday," and true to his word, he had brought me here.

"O Lord my God, when I in awesome wonder, consider all the worlds thy hands have made . . ." The worshipers stood to sing the old hymn.

"Then sings my soul, my Saviour God to thee, 'How great thou art, how great thou art!' " The refrain echoed the praise I felt in my heart.

A deep feeling of peace settled over me as the song continued. I felt as though I had come home to a place I had never before known in my life. This was what I had been longing for! I looked around, awestruck not only by the words of the song, but also by the joy radiating from the faces in the congregation.

As I continued looking across the assembly, my eyes shifted to the people's attire. They were more appropriately dressed for worship than I was, and I suddenly began to feel self-conscious in my sleeveless blouse. Actually, I felt immodest.

Lord, I am sorry. I did not think about how I should dress. Right there in the church, I felt a conviction that I was to cover my body in a way that was respectful to myself and to the people around me. Most importantly, I felt that God should be respected in the way I dressed. No more miniskirts and tight,

revealing clothes. The Holy Spirit gave me deep, lasting convictions about this.

"Idols are much more than images made of stone and wood that primitive people bow down to," the pastor said quietly but sincerely. "An idol can be anything that you allow to come in and take a place in your heart that belongs to Jesus. Sometimes we think we have room for both, but Jesus will not share your heart with idols. We have to get rid of them."

I drank up the words eagerly. This was living bread!

"So, we try to rid ourselves of the idols on our own," the pastor continued. "We set out to make ourselves free from sin. We get so tired of being enslaved to sin, and we determine to do better. Sometimes we even ask God to help us. We get up in the morning and decide that today is the day when we will not give in to sin. But by evening, we are defeated again. Once more, we ended up being slaves."

How could this total stranger know what I had been experiencing? How could he know how long and how often I had tried to escape my life with Tom?

"When we come to the cross and repent of everything that God brings to our attention, a transformation begins. The Holy Spirit can then enter our hearts and give us new desires. We receive power that we didn't even know existed."

It was so amazing! That was why I had received power over the spell Tom had on my life. I had repented of the sins of my youth and young adulthood, and the Holy Spirit had come in!

From then on, I couldn't find enough church services to attend. Once, Carlos took me to Albuquerque, and we attended a Messianic congregation. I felt at home there among people with whom I could identify and who shared my background.

Two months after I began attending the church in Santa Fe, the pastor invited the new believers to prepare for baptism. I felt an immediate desire to make a public declaration of my walk with God and made plans with the pastor to be baptized.

"I believe that Jesus Christ is the Son of God." A thrill of joy shot through me as I said those words.

"Amalyah, we baptize you in the name of the Father, the Son, and the Holy Spirit."

Both the pastor from the church I usually went to and the leader of the

Messianic home fellowship were there with me. A small group of friends had also come for the memorable event. The old Amalyah had died and been buried, and the power of Jesus had brought a new person to life. I rejoiced in that reality and in the opportunity to proclaim it publicly through baptism.

<p style="text-align:center">◊ ◊ ◊</p>

God is so good,
God is so good,
God is so good,
He's so good to me.

I closed my eyes and sang with the home church group. The words welled up inside me with a freedom that I had not experienced before, a freedom that sprang from a heart clean before God.

"O Lord, we love you!" Sandy earnestly prayed. "We love you and worship you. You gave us your life, your power to overcome sin and death, and we receive it gratefully."

There was a responsive echo in my heart as she prayed. The joy I had received that night in my apartment continued to live with me and comfort me. I felt like a spiritual baby, and there were many things I did not understand, but I could always rest in the fact that God loved me.

More songs and testimonies followed as we enjoyed our fellowship in Sandy's home. There were only about fifteen of us, and even though there were many whom I knew only by first name, I still felt a connection to them spiritually.

Lunch was simple, yet so spiced with fellowship that even bread and water would have tasted delicious.

"I need to get back to my apartment to start packing up," I said, rising from my seat. "I am headed to the mountains in two days. My job at the bakery ended, and I decided I can just live out of my van until I decide what to do next. I have a little money saved. I think I can stretch it until winter comes or until God leads me to my next job."

"Oh, Amalyah, we are so sorry your job has ended! Is there anything we can do to help?" Gary asked sincerely.

I sighed deeply. "Just pray for me," I requested.

It was then that I began to see how God's family loved and cared for each other in practical ways. Angela had been leaning over and whispering to Sheila, and I saw Sheila nod.

Angela smiled encouragingly at me and said, "Amalyah, I think I might have an answer for you. I have a spare room. I could rent it to you at a reasonable price for a month. Shall we give that a try and see how it works?

There it was, love in action. Though Angela hardly knew me, she personified Jesus' words in Matthew 25:35, "I was a stranger, and you took me in."

"Thank you, God!" I breathed gratefully. Oh, how I marveled at the ways He was working in my life!

◊ ◊ ◊

Brian tossed his brown hair back and looked at me intently. "Amalyah, you are really a special girl. You are different from most girls I know. I love to see a woman who is not afraid of hard work."

I said nothing while I sipped from my steaming cup. The little coffee shop was a pleasant place to spend time with my new friend. Though I remained silent, I basked in the glow Brian's words gave me. I felt he really was sincere.

Brian and I had met at the church when Carlos first took me there, and we had quickly struck up a friendship. Together, we attended the Bible study classes on Thursday evenings, and we often sat together at Sunday services.

Brian had just graduated from college, and I found it interesting to be with him. He liked taking hikes in the mountains and sitting for hours, just discussing life. I was moved by his interest in spiritual things and felt that his devotion to God was outstanding. We ended up spending a lot of time together.

It was a new experience for me to spend time with a male friend who was a Christian. I felt safe, and if I was really honest with myself, I was quite attracted to him. Even though he was younger than I, it didn't seem to matter.

Now, at the coffee shop, I just smiled at him, enjoying the companionship.

"You know, if I ever get married, I'd like to marry someone like you." His

words broke into my reverie.

"Hey! I've got to go," I said, looking at my watch. "Angela asked me to come home early so we can have dinner together tonight."

"I'll walk you over." Brian got up. "Then we can talk some more on the way there."

All the way back to Angela's house, the words, "I'd like to marry someone like you," kept repeating themselves over and over in my mind. I wondered if this was his way of letting me know that he really did intend to pop the question.

We parted outside the house, and I went inside. Angela and I chatted lightly for a few minutes. Then her cheerful face grew sober, and she took a deep breath. "Amalyah," she said, "I wanted you to come early tonight because I felt I needed to tell you something." She took another deep breath and swallowed hard. "You and Brian are spending too much time together. You are throwing yourself at him."

I sat stunned, unable to reply. The rest of the evening was a blur. I knew that my middle-aged friend was genuinely concerned for me, but I had a hard time understanding or accepting her point of view.

"We just spend time together," I finally told her. "We don't do anything wrong."

For a while I kept on meeting with Brian as before, until one Sunday Angela asked me to stay after the service to meet with the pastor.

"I am concerned that they spend too much time together," she told him bluntly. "It is not healthy for a boy and a girl to spend so much time together, especially when Amalyah is so young in the faith. I tried to tell her, but she doesn't seem to understand." There was no doubt my friend's concern was sincere.

I was bewildered. "But we like each other," I said, not really trying to defend myself, but rather trying to make sense of it all. "Why shouldn't we spend time together?"

Angela opened her mouth to speak, but Pastor Blaine put up his hand and smiled. "May I say something?" he asked kindly.

We both nodded. The pastor's wife smiled at me understandingly, and I felt assured that all three of these people truly loved me.

"Amalyah, even though our time together has been brief, I know you well

enough to be confident that you want God's will for your life. That is the first thing that needs to be said.

"I, too, have seen your friendship with Brian grow. Really, I have no objection to that. You are both adults, and from what I can see, you both love the Lord very much. Let me give you a word of wisdom to consider, though. Don't awaken love in your heart before it is time. Let it grow slowly, and let it come from God. Let Him guide you. Your feelings must not run ahead of His leading."

Then he turned to Angela. "Sister, it is good that you are concerned about your friend. I know you are looking out for her, and that is commendable. We love the work you do in the church, and we appreciate what we have seen in your life. Thank you for caring enough to approach Amalyah and speak to her. Honesty is a great help on the road to real communication."

Pastor Blaine was so wise and gentle with both of us. The conversation turned into a blessed time of fellowship, and I left with no hard feelings toward anyone.

I pondered my situation as I was lying in bed that evening. "Lord, is this real? Is Brian the one you want me to spend my life with? You know I want to get married and have children."

There. It was out. I could admit that I really wanted a man to love me and care deeply for me. I wanted a Christian man whom I could respect and admire, and Brian seemed to have the qualities I was looking for. Then, remembering what Pastor Blaine had recommended, I added, "Lord, if this relationship is not from you, I want you to show us. If your blessing is not on it, then Lord, bring it to an end."

It hurt more than I thought it would to pray that prayer. My heart yearned after the young man who had come into my life. I liked spending time with him.

"But, Lord, I really do want it to work out." I ended my prayer on a strange note, but it was the cry of my heart, and I hoped God would understand.

God answered my prayer, but not in the way that I had hoped. Less than two weeks later, Brian informed me that he was moving to San Francisco to continue his studies. Our close friendship ended.

Yes, my heart hurt. In some ways, this friendship was too much like many of my prior ones. Though I had kept myself pure in this relationship, I

wondered if I was still too emotionally attached. Was there still something in me that was seeking admiration and attention from men when God wanted me to find it in Him?

"Help me to be secure in you," I told God. "Help me to realize that all I need is you."

<p style="text-align:center">◊ ◊ ◊</p>

"I feel God wants me to return to Israel," I told Deborah on the phone. "Almost every time I pray, I get this sense that I am to return home."

"Why?" Deborah sounded puzzled. "Look, if you continue to apply for jobs, something will come up."

I sighed. "I want to follow God's leading, and I'm not sure why He wants me to go back. Is it because our parents need to see me as a Christian? I don't even know when I am supposed to return. It all seems so uncertain, but I can't shake the idea that I am to return to our country."

"Amalyah, are you taking this religion thing too far? You don't want to become a fanatic." I could tell my sister was genuinely worried.

"No, I don't think so," I said carefully. "I think I am finally starting to allow God to control my life. I have made a mess of it on my own, haven't I? Letting God be in charge seems more wise than fanatical to me."

I hung up the phone and stared into space for awhile, trying to collect my thoughts. I liked America. I liked the big open spaces, the friendly people, and the absence of conflict. It was so different than my home country where the conflict between the Palestinians and Israelis still raged. Most of all, I valued the fellowship I was having here in America with other believers in Jesus.

"Why do you want me to go back?" I prayed out loud. "There are no believers in Israel, and my only hope of fellowship will be in a Catholic church." Little did I know that the body of Christ was alive and growing in Israel, and that I was far from the only Israeli believer. At that point in my life, I had no idea what I would find.

"Do you really want me to go back to a place like that?" I asked.

All I heard was silence. No answers.

"Well, I guess this is what it means to learn to hear your voice and be willing

to obey. Not understanding, but obeying. Will you show me why after I return?" I felt frustrated, and yet, underneath the questions, I had a sense of God's care and love for me. That meant more to me than the unknown future.

Later that day, I sat in a little office at the Happy Children's Daycare Center, filling out a job application. As I went through the lengthy form, I listed my previous addresses, my previous jobs, and how long I had worked at each one. I felt my experience working at a kindergarten in Israel would be viewed favorably. The application was several pages long. At the end there was space for any additional information I might want to provide.

I paused and looked out the window into the playground and watched the small children playing. My thoughts went back to my own childhood, and especially to the junkyard that had given so much scope to our imaginations. This play yard had no junk. It contained nice swing sets, see-saws, and a sand box.

I couldn't help remembering the emptiness my childhood had held. How I had longed to be at home with my parents! I recalled how I had looked for excuses to run home to the safety of Mom's arms.

I now understood that every child needs the love and security of living with his or her own parents. "God, if you ever give me children, teach me how to meet their needs. I don't blame my parents, because they didn't know any better. But give me your vision to know how to provide for any children you bring into my life."

Pulling my mind back to the present, I looked down at the application again. "I am a believer in Jesus Christ. I am a Messianic Jew, and choose not to work on Saturdays or Sundays," I wrote in the space provided.

I did not want to miss any of the fellowship I had with the believers who gathered on *Shabbat,* the Jewish Sabbath. I did not know if this would make a difference in the daycare superintendent considering my application, but I wanted to be honest.

"You are accepted!" The welcome words came to me through the telephone the next day. "Come in for initiation and training on Tuesday."

I thanked the caller and hung up. "Thank you, God! Oh, thank you!"

What about returning to Israel? I wondered suddenly. My elation began to fade. Yes indeed, what about returning to Israel? Was I going to be obedient to the

thoughts God was sending to me frequently about returning to my homeland?

I called my friend Sandy from the home fellowship to discuss my dilemma. "I plan to leave for Israel in six months for Passover, but somehow I feel it might turn into a permanent move," I told my friend. "I do need this job, since my money is gone and I can't sponge off Angela. I don't know if the daycare will hire me if they know I will be there for only half a year."

"Honey, I will pray with you about it." Sandy's voice was warm and caring. "I am sure you can trust God to take care of you. Have you talked to your parents about it?"

"No, I haven't," I told her.

"Why not give them a call and see what they say? You can honor your parents by including them in your plans and letting them know what you are facing."

"Good idea," I agreed, reflecting on a recent discussion our group had about honoring parents and inviting them to be a part of our lives.

"Of course you need to tell the daycare that you might not stay long," Mom said when I called and asked my parents' advice. "Being honest from the beginning is the best policy."

"Be smart, Amalyah." My dad's voice was distinct when he took the phone. "You need the job, so don't tell them about your plans. If you leave after six months, they can't do anything about it."

I was quite shocked to hear my dad's advice. I remembered him as always being very forthright about everything. I couldn't remember an occasion when he had not been completely honest. Was there a side of my father I didn't know about?

Even though I was not exactly sure what God was saying, I wanted more than anything to live totally for Him. "God, I asked Sandy and she suggested I talk to my parents. Now my dad tells me to be smart and hide the fact that I am going to leave. What do you say?"

"Just trust me," He seemed to say, and the message restored peace to my heart.

The next Tuesday I took a deep breath, got out of the van, and walked up the sidewalk to the daycare. I waved to the children in the side yard.

Mrs. O'Malley was pleasant as she ushered me into her office. She picked up my application and scanned it quickly. "We don't often make a quick decision to hire someone to work with our children," she said, "but we are in

a hurry to fill a position that opened when a family emergency called away one of our workers. I was pleased with your experience, and I especially like that you have worked with children from different ethnic backgrounds. That is a valuable asset. Of course, you will be on a probationary period for several weeks, but I don't anticipate any problems there."

I could tell Mrs. O'Malley had a full schedule, for she raced through the introductions. At the same time, I also knew she was reading my face and body language as she asked questions and studied my papers.

"Okay, that settles it then," she said finally. "You may begin immediately if you like. Had you been told you could start today if you were accepted?"

I nodded. "Mrs. O'Malley," I said, feeling now was the time. "I have to tell you something."

"Yes?" She sounded curious.

"I am planning to return to Israel in six months. I want to make sure you know that before you commit to hiring me."

"Oh, that shouldn't be a problem," Mrs. O'Malley said breezily. "We can arrange a vacation for you then."

"Well," I gulped, "it may be for good. I feel God wants me to go back home. I am not exactly sure why, but I want to listen to what God tells me. I didn't want that to be a surprise to you when it happened. I felt it was something you needed to know, in case it makes a difference in your decision to hire me." There, it was out.

Reaching out a warm hand, Mrs. O'Malley smiled. "Amalyah, thank you for telling me that," she said kindly. "I appreciate it very much. Naturally, we would love to have our caregivers stay with us for a long time, but I believe you would be a blessing to us even if you stayed for only six months." A warm smile spread across her face.

God, you work in mysterious ways, I thought as I followed her outside to meet the other caregiver and the children. The childish voices beckoned me to begin the new job God had so graciously provided.

※ ※ ※

It was nap time. All the children under my care were sweetly sleeping on

their little mattresses. As was my habit during these times, I took out my Bible and began to read.

I want to please God, I thought. *I want to know what He wants me to do. Maybe I can find instructions in the books of Moses.* I began to read in Exodus and then in Deuteronomy. Do not wear clothes made of mixed fiber, do not eat certain foods, do not light a fire on *Shabbat* . . . The more I read, the more burdened I became.

"Lord," I murmured aloud, "this is too difficult. I fail all the time. There is no way I can possibly keep the Law."

The Apostle Paul's words in Philippians 3:9 came straight to my heart: "Not having my own righteousness, which is of the law, but that which is through the faith of Christ, the righteousness which is of God by faith." A sense of peace and joy filled my heart, and I felt as though a great burden of responsibility had rolled from my back. "Thank you, Lord!" I prayed, and got up to attend to little Jimmy, who had awakened.

Spring was approaching fast, and with it the Passover. The issue of whether I should go back to Israel was not yet answered. I kept praying, but God was still silent.

One Sabbath at the Messianic congregation, I saw a young man who looked like an Israeli. *One of my people,* I thought. *I'll go talk to him after the service.* But when we were dismissed, I couldn't find him.

◊ ◊ ◊

"Hey, Amalyah." It was Deborah on the phone. "Listen, I found a great deal from New York to Israel. I'll buy the ticket for you as a gift, if you pay your way to New York. You'll have to decide soon, as they can hold the ticket for me only for a week."

"Lord," I prayed, "I really need an answer. Please give me an answer by the end of the week." I was so desperate to hear from God that I began to fast so I could devote more time and attention to seeking God's will.

The next Sabbath the man who looked like an Israeli was there again, so I went straight to him. "Shalom, I am Amalyah. I saw you last week, but didn't have a chance to talk to you," I said in Hebrew.

"Sorry, I didn't understand what you said," the young man replied.

"Oh, you're not from Israel?"

"No."

"But you are a Jew, aren't you?"

"No."

"Well, are you a Christian then?"

"No," he repeated, smiling at my bewilderment.

"Oh, so what are you doing here?" I inquired.

"I just saw the sign for the Messianic congregation and thought it sounded interesting. I came in, liked the teachings, and came back again this week."

"Well," I said, "I'm happy you are here. I hope you enjoy the teaching this time too." We shook hands, but as I walked away, a deep sense of disappointment filled my heart.

You are looking for your people in the wrong place. The thought struck me forcibly, and immediately I knew it was true.

"Lord, thank you for answering my prayer," I whispered. "I realize now that I need to go back to Israel."

As soon as I got home I called Deborah and told her I would return to Israel.

"Good," she chuckled, "because I already bought the ticket."

"What!" I exclaimed. "What date is on it?"

"The end of February," she told me.

The end of February? That was only a few weeks away, and I wasn't ready for the move to come quite so quickly.

"I don't really want to go back to Israel, Lord!"

I thought of Jonah. He didn't want to go to Nineveh either, but he ended up going. I felt as though God had grabbed me and was pushing me out of America.

Wanting to be obedient, I sold my van, packed up what I could, and began my journey back to Israel a short time later.

15

"WELL, I'M GLAD YOUR RELIGION WORKS FOR YOU," MOM SAID. "WE WERE REALLY concerned about you at first, but Hannah reminded us that Deborah went through a similar phase. She is perfectly normal now, so we need not worry too much."

Mom got up and put the teakettle on the stove. "Want some hot tea?" she asked. "The rain makes it chilly."

"Sure," I replied gratefully, "I'd love a cup." I looked around my parents' room. So many things were still the same, and the familiar objects brought back a flood of childhood memories.

My father sat silently for a moment before asking, "So what are you going to do now that you're back?"

"I don't really know," I admitted. "I feel like I need to get my Israeli feet back on. So many things have happened to me since I left, and I am praying that God will guide me to the right job and give me a place to live."

"Amalyah, you could live here on the kibbutz," Mom said. "You could find work as a kindergarten teacher or a kitchen worker. You always used to enjoy that."

"Yes, I know. But I want to do something worthwhile with my life. I mean, working here on the kibbutz could be worthwhile, but somehow, I feel God wants something else for me." I struggled to explain to my aging parents how I felt.

"Like I said, I am happy for you that your faith in the Christians' God works," my mother replied. "I don't understand how God, if He even exists, is interested in individuals. I have always had to get along on my own. No higher power ever helped me." Mom poured the hot water over the teabags in the teapot.

As much as I wanted to, I could not articulate to my parents what I was feeling. I wanted to tell them more about my new faith, but it was as though a wall stood between us, hindering any meaningful communication.

"God, how can I cross over that wall?" I asked as I walked through the kibbutz one day. "It feels as though I speak one language and my parents and all my former acquaintances speak another. I don't blame them, because at one time that was the only language I spoke too, but I don't know how to relate. I need fellowship with other believers."

I thought nostalgically about my little home fellowship back in New Mexico. How I missed them, with their encouragement and spiritual talks! Why indeed had God brought me back here? Where was I to live? What was I to do for a job?

I continued down the slope to the barn. The empty stalls and pens were a reminder of how life was changing here on the kibbutz and all across Israel. No longer was our community striving to be self-sufficient as more and more families had left to get jobs in the cities. The land was still cultivated, but some of the fields were now leased out to nearby farmers.

Although meals were still served in the huge dining hall, a small fee was charged to eat there. Many people no longer worked on the kibbutz but rather commuted to their jobs by car. Houses were being enlarged, sometimes by building additions and other times by knocking out walls between two apartments to create larger living spaces. No longer were the children housed in separate buildings, but now slept in the same houses as their parents. The school was still in operation, and after I left the empty barn, I walked into my old grade school classroom and watched as the children did their lessons.

Outside, the door leading to the underground bomb shelter stood ajar. I remembered how we used to rush through that door and scurry down the steps during practice drills, and also whenever the air raid alarm sounded

during the war in 1973. I recalled that the only television in the kibbutz had been in one of the bomb shelters, maybe so we could follow the news in case of a prolonged war, or perhaps simply because it was in a central location. We children had been allowed to go down the damp stairs to watch an occasional children's show. Now televisions were common, and almost every home had one.

It was 1997, and the world that I had come home to was very different from the one I had known as a child. Even though I did not feel old at twenty-nine, it was still amazing to me how much had changed in just a few years.

"Lord, please direct me," I prayed one day as I sat underneath the tree we had always called the far tree. "I need to know what to do, where to live, and what kind of job to get.

"But even more than that, can you please bring me into fellowship with other believers? I feel so alone. I want to talk to my parents about my faith, but I feel so tongue-tied and helpless to communicate with them. Their lives are so . . . so tied up in this world." My frustration with myself and the life on the kibbutz wanted to overwhelm me.

My mind went to Jerusalem. Should I try to find a job there? My aunt had invited me to live with her until I could get situated. Jerusalem was continually rocked by violence between Jews and Palestinians. Most of my life had consisted of living in a country that was either at war or under the threat of war. Suicide bombings, random acts of terror, and sabotage were constant threats, and Jerusalem was usually at the center of these conflicts. Did I want to live there?

It was not fear that made me hesitate. My hesitation came because I wasn't sure whether God wanted me to move to Jerusalem.

As I continued to think about it, I realized that I really needed to find Christian fellowship somewhere. I had heard before I left Santa Fe that there was a church in Jerusalem affiliated with the one in Santa Fe. I was too alone here, I decided. If there were other believers in Jerusalem, then I would go seek them out. I got up from my seat on the grass and walked toward the kibbutz.

0 0 0

"This dress is on sale today at a forty percent discount." I held up the hanger and turned the dress so the shopper could see it better.

The lady felt the fabric speculatively. "I like the fabric, but I'm not sure the color would work on me," she said, holding it against her arm.

"Yes, I can see it might be a shade light for you," I volunteered. "I have another one similar to this over here." I led her to another rack. "This background is darker and the flowers are not as bright."

"Oh, this one is much better!" she exclaimed, delighted. "Is this one on sale as well?"

I turned to see if my manager was at the front desk. "Let me go check with the manager," I said, and headed toward the front.

I was working in a clothing store on Ben Yehuda Street, a popular shopping district outside the Old City area of Jerusalem. Cafes and shops lined the pedestrian mall, and musicians often played on the corners, taking donations from the throngs of people who crowded the street.

"Tell her it is on sale today. Yes, the same forty percent discount as the other one. You need to emphasize that the sale is for today only." The manager dropped his voice as he gave me instructions.

"Yes, this dress is on sale too," I told the shopper. We computed the price, but she still hesitated.

"I need this dress for a wedding," the customer confided, "but I don't know if it will coordinate with the dresses of the other ladies in the wedding. Could I bring my friend with me tomorrow to check it out?"

"Oh, sure," I said. "That would be no problem."

"But will it still be forty percent off? The sign says the sale is today only." The shopper looked at me expectantly.

Here it was again. I knew the sale was ongoing and extended from day to day until the manager decided to end it. "The most important factor in sales is to make the sale when the customer is in the store." I could hear his voice. "The most devastating remark a customer can make is, 'I'll come back tomorrow.' You must convince the customer that the sale ends today."

I battled with myself every time someone asked me about the sale. I could not honestly say the sale would end that day, so I had developed a

technique that somewhat satisfied me. "I don't really know if the manager will decide to hold the sale over another day or not," I would tell them. "The sign might stay up, or it might be gone tomorrow."

So I told this customer my standard line, and yet, in my heart I knew that most likely the sale would continue through the next day.

"I'll take a chance," the shopper said with a smile as she left the shop.

"No sale?" the manager asked briskly.

"She needs to bring her friend in to make sure the fabric works," I told him.

"You told her the sale ends today?" my boss asked. He was short and slim and moved energetically around the shop as he spoke.

"She asked if the sale will still be on tomorrow and I told her I don't know." I hesitated, and then added, "But I told her it might be extended."

"You can't do that!" The manager said quickly. His eyes darted around the shop, and seeing no customer, he continued, "You have to make a sale when they are in here. You know the chance of her coming in here again is less than twenty-five percent? We need to make the sale while the customer is in the store!" He made no secret of his exasperation. "Surely you know that by now!"

Yes, I did indeed know that, since he had emphasized it to me numerous times every day since I had started, but I could not compromise my integrity before God and lie to the customers.

"I'm afraid I really cannot continue working here any longer," I told the manager. "This sales method goes against my conscience. Our yes should be yes, and our no should be no. I cannot work with these deceitful methods."

The manager had a hard time grasping what I was trying to tell him, but to my surprise, he respected my decision. We agreed that I would leave at the end of the month.

That evening after work I went to a Christian bookstore in the Old City. It was such a relief to enter the bookstore and just sit there among believers. I could feel the presence of God there, and I basked gratefully in that reality.

My friend Sheila had told me to inquire at the bookstore about a church in Jerusalem. "I'm sure they can help you," she had told me. But when I inquired, the clerk behind the counter became very quiet.

"Come back tomorrow, and we will give you an answer," he said. "We

need to call them first and make sure there is no problem."

I understood. The Israeli believers in Jesus have many enemies, and they are understandably cautious, so the next day when I returned to the bookstore, I was pleased to be given the address.

"They have a Bible study tomorrow evening and would love for you to come," the clerk told me. "Just ask for Anastasia. She is the pastor's wife."

As I entered the stone house in the old part of Jerusalem the next evening, a young lady was walking down the stairs.

"Are you Anastasia?" I asked.

"No, my name is Mercy," she said. As it turned out, Mercy had come from Albuquerque, New Mexico, just a few weeks before. We immediately struck up a friendship.

The Bible study that evening was like cold water to my thirsty soul. There was something family-like about the group that met in this house, and they all welcomed me warmly. It was a wonderful experience to feel that I was a member of this family, the family of God.

At the end of the week, I sat outside in the sunshine during my break and scanned *The Grapevine,* a small Christian newsletter I had found. It contained all sorts of information such as apartments for rent and items for sale, along with announcements from the different Christian churches in the city.

Then an announcement bordered by black lines caught my eye. "The Messianic Student Association Welcomes You," it said. There was a telephone number, so I called as soon as I had an opportunity.

"Come on over to my apartment, and we will talk," Sivan invited.

I found her apartment, and she welcomed me inside. "Let me get you some juice," she said after we had introduced ourselves. "Make yourself comfortable on the sofa," she added hospitably.

I glanced idly at an envelope on the end table beside the sofa. It was addressed to Sivan Rosenberg. The name sounded familiar to me. Could it be . . . ?

"Do you know the Goldsteins from Santa Fe?" I asked, taking the glass of juice Sivan was offering.

"Yes, I attended a Bible college with their daughter. You know them too?" Her eyes followed mine to the envelope.

"Yes! This is so incredible! I was with them in New Mexico shortly before

I came back to Israel," I told her excitedly. "When they found out I was returning home, they said, 'Oh, you must meet Sivan Rosenberg when you get to Israel.' They scribbled your name on a note, but that was the only information they had. No phone number, no address, nothing! I told them there are millions of people in Israel, but they said, 'Oh, it's a small country, the size of New Jersey, and you will meet her sometime.' I didn't want to argue, but I thought they were a little naïve. It turns out they really were right!" I could hardly believe this.

"Apparently God meant for us to meet," Sivan laughed.

My new friend settled herself on the other end of the sofa. "Where are you attending church right now?" she asked.

"I was introduced to a church by someone at the bookstore," I told her. Sivan nodded, apparently familiar with the place.

"I like the fellowship and the teaching there a lot," I continued. "There are so many new things, at least to me, that I didn't even think about before. And then there are lots of teachings that confirm what I believe God was already teaching me."

"Like what?" Sivan encouraged.

"Well, for instance, when I returned to the kibbutz, I tried to connect with the people there, but it seemed as though I was an alien. None of the people on the kibbutz are believers, and I felt so alone. I began sensing more than ever my need for fellowship. The teaching at this church is the same. The pastor really encouraged us to stay in close contact with other believers and to be strengthened together in God."

"That is so true," Sivan agreed. "One of the hardest times in my life was when I was out on my own. I know the Bible encourages us to gather together to worship and pray."

I sipped at my juice. "Ah, it's so good to have pomegranate juice again," I sighed gratefully. "That was something I missed in America. I found it harder to get fresh juices."

"So, what made you decide to call me?" Sivan asked.

"Well, I wanted to meet Israeli believers, and even though I'm not a student, I'm the age of many graduate students. At the church I attend, services are held in Russian and English instead of Hebrew. Although I

appreciate the teaching there, I feel like a foreigner in my own country."

"I can relate to that feeling," Sivan said. "People from every tribe and nation seem to find their way to Jerusalem since it is supposedly holy to Jews, Muslims, and Christians. I just pray the Prince of Peace will come into the hearts of people and change them so they can get along in peace and harmony."

"Were you ever afraid of living in Jerusalem?" I asked her. "I mean, with all the violence and suicide bombings?" Jerusalem was in the middle of a period of violence just then. Palestinians upset about the lack of progress in resolving the conflict were carrying out many bombings, and the Israeli government was retaliating with a vengeance.

"No, I have not been afraid," Sivan said with a decisive shake of her head. "Not any more afraid than I would be living in any other city. The news media always create a lot of hype whenever there are fatalities and bombings. But I imagine if we would tally the deaths on the roads due to traffic accidents, the toll would outnumber the deaths caused by bombings. In spite of that, we aren't afraid to get in our cars and travel down the highways at high speeds. I think Satan wants people to dwell on the evil and deaths so they won't carry out what Jesus clearly commanded, and that is to take the Gospel to all peoples and nations."

I looked at Sivan with new admiration. "So many Americans used to ask me if I wasn't afraid all the time because of the violence. I told them I was used to it. I do remember as a child that I was terrified of the military jets, but eventually I got used to them."

"I would rather be in the center of God's will in a dangerous situation than out of His will in a so-called safe location," Sivan said.

My new friend soon introduced me to a Hebrew-speaking church that eventually became my home church. I learned there were quite a few congregations in Jerusalem, and as I visited them, I was blessed to learn that there were various Christian communities in my land.

16

"MY LIFE USED TO GO IN ENDLESS CIRCLES," I TOLD SHLOMIT. "FROM THE outside, it appeared I had everything I wanted. I had a boyfriend and enough money to explore America for a while. Besides, I was young! But inside, I was not happy. I was seeking for something, and I did not know what it was."

All the children at the daycare school were sleeping. I had been thankful to get another job here after I quit working at the store where I was expected to be dishonest with the customers.

"I would love to visit America," Shlomit said wistfully. "It sounds so exciting."

"It has some awesome scenery," I told her, remembering the redwoods and the rugged western coastline. "Many of the people are very friendly and made me feel very welcome.

"Sounds like fun," Shlomit said. "Well, I think I am going to see a movie tonight. What are you going to do?"

"I am going to a Bible study at my church," I told her. "Do you want to go with me? The studies are really good. They teach clearly about sin and the need to be born again. You know, how you can go to heaven after you die. Don't you want to know about it?"

Shlomit got up from her chair abruptly. "Amalyah, you have to realize that not everyone is as concerned about God and heaven and hell as you are." She stalked out of the small break room.

I heard the children begin to wake up, so I slowly got up and went to look after them. I loved to see the sleeping toddlers awaken, their cheeks rosy from their naps. As I helped them get their shoes on, the normal hum of the kindergarten picked up quickly.

I loved it here. The children came from many ethnic backgrounds, but they accepted each other regardless of skin, hair, and eye color. More than once I thought they provided a beautiful picture of what God wanted His church to be. They displayed innocent acceptance and love for each other, so unlike our adult tendency to examine each other critically under magnifying glasses.

◊ ◊ ◊

"Well, you see, it's this way," the director of the daycare said a little uncomfortably, "we have had our budget cut, and so we will have to let some of the staff go."

I looked at her in amazement. "Budget cuts? Why, we don't have enough workers the way it is. You know there are times when I am the only one on duty, and I know Shlomit is by herself at times as well."

The director shifted some papers on her desk and glanced out the window.

I followed her gaze and saw a cluster of children around Shlomit.

"Well, it is what it is. We will not need you after the summer break," she stated with finality. "And there is also the issue of your faith. It contradicts what we believe here."

I stood up and left the office. My mind was spinning in circles, but for the moment I had no time to digest what the director was saying. The demands of the children occupied me for the rest of the day.

"I think I am too outspoken," I told Mercy that evening as we waited for Bible study to begin. "I think Shlomit must have complained about me trying to convert her or something."

"Well, did you?" Mercy was very practical.

"I told her about my own experience. I asked her more than once if she was ready to die. I explained the consequences of dying without Jesus, so yes, I suppose I did try to convert her."

"How much longer until the summer break?" Mercy wondered.

"About three weeks," I said, and weariness settled over my spirit. "I guess being fired for your faith in Jesus is something to rejoice in, but I have no clue what I'll do after that."

Mercy frowned quizzically. "Are they actually firing you? It doesn't sound like they are. Didn't the director tell you they are downsizing staff due to budget cuts?"

I shook my head. "There is no way they can downsize the staff. What will they do? Have Shlomit work ten hours? No. They will let me go, and then they'll hire someone else who fits in and doesn't upset the workers who don't want to hear about Jesus."

Mercy said nothing, but I could tell by her slightly bowed head that she was silently praying for me.

I felt so tired during the next few weeks. I still loved my job, but I found myself getting impatient with the children, and I became moody and dissatisfied with life.

"Lord, I need to rest," I told God one evening during my private devotions. "When this job ends, I think I'll just stay at home for several weeks. I don't have the energy to hunt for another job right now." I put my head against the side of my chair and closed my eyes. I felt glued to the seat cushion, and my legs and arms were like dead weights.

That night at the Bible study I tried to concentrate on the lesson, and I kept praying that God would speak to me about my situation. He did indeed encourage me as I listened to different testimonies that were shared of how God was answering prayers. "Lord, help my unbelief," I prayed as we knelt in a circle. My heart was warmed again, and even though I felt drained, I was encouraged.

"Hey, everyone," Mishka announced with his jolly voice and heavy Russian accent later that evening, "I heard that Hope for Mankind is looking to hire an English-speaking floor manager!"

"Amalyah, you should apply for that!" Mercy said excitedly

I laughed. "No, thanks. I don't have the qualifications to be a manager. I never have been one, nor have I worked at a job that would teach such skills."

Several other people were listening to our conversation, and more than

one said, "Amalyah, go for an interview. Maybe God is providing this for you. Go in faith, and if the doors don't open, you will know it is not for you. But you won't know unless you try. When God sees us walk through open doors, He opens even more doors for us."

I shook my head, "This is too bizarre, applying for a job that I have no credentials for or experience in. I might as well apply to be an airline pilot!"

This drew a laugh from the group; however, they did not give up. "Try it! Go for an interview," they encouraged. "It can't hurt to try."

0 0 0

"You're hired. When can you start?"

I held my left hand over my rapidly beating heart, my right hand holding the telephone receiver.

"Why . . . when do you want me?" I inquired.

"Can you come in on Monday?"

"Monday? Yes, that should be fine. I can come Monday," I responded.

"Good. We will expect you then."

I replaced the receiver and took a deep breath. I was hired! I had a job at Hope for Mankind!

The interview had been rather uneventful. I had filled out the forms and spoken with the lady doing the interviews. Even though she notably didn't say anything about my lack of experience as a manager, she did seem favorably impressed with my command of English, and she was also very interested in my journey with God. I had left with no idea what to expect. When the telephone rang that very evening, and I heard that I was accepted for the position, I was overwhelmed with gratitude.

"How amazing you are, Lord. You really did speak through my prayer group at church! They must have sensed your guidance. Even though I didn't think it would work, they had faith for me. Isn't that amazing! I can't wait to tell them."

0 0 0

My job at Hope for Mankind was pivotal in my life. Every morning the staff got together for Bible reading and prayer. We shared our hearts with each other and prayed for peace in the region. Volunteers arrived, worked alongside us in our projects, and brought inspiration and encouragement to the people of Israel. Hope for Mankind provided material assistance to the needy, regardless of their beliefs, and we were able to witness to many of the recipients.

"We need to be very careful about our activities even when we are off duty," one of our directors told us one morning. "Because we operate with the approval of the Israeli government, we cannot make radical or overt statements about our faith in Jesus. Since we are giving material aid, we can easily be accused of trying to bribe someone to change their religion using this humanitarian aid. This is against the law, and could be devastating to the organization."

There it was again. Although all of us knew that Jesus is indeed the Messiah for the Jews and all people, we were in a country where believers in Jesus were a mistrusted minority, and we could not be very open about our faith. More than once I felt hemmed in by the constant need to watch what we said and to whom we said it.

☙ ☙ ☙

It was my day off, and I was feeling a little bored. My back was stiff and sore this morning, and I decided I needed a new mattress for relief. It had been five years now since I had begun working at Hope for Mankind, and things had settled into a familiar pattern. Feelings of discontent settled over me.

Maybe it's time to buy a house, I thought. *I could use a place to call my own. I could entertain guests and host Bible studies there.* My job was paying well, and I thought investing my money in a house might be a wise move. *This place is nice, but it gets too hot in the summer and too cold in the winter. My own house would be well insulated and easier to maintain. I . . .*

"Spend time with me." My dreaming stopped abruptly as I sensed God speaking to me.

I had been having my regular devotions, but I opened my Bible obediently

and began reading. I read in Revelation how the mark of the beast will be forced on people in order to buy or sell. The future looked dark and forbidding as I continued reading through the last book in the Bible.

I looked up and sighed. What future was there here on earth? Was it even safe to consider marrying and raising a family? I thought of my desire to buy a house. Why was I seeking something more? Wasn't I content with God? What was driving me to seek more here on earth? A wave of darkness wanted to overwhelm me.

I began to pray earnestly. "I quiet myself before you, God. I ask you to show me just what you want for me. I want to make a difference here on earth. Am I really supposed to keep working at Hope for Mankind? I've been with them for five years now. Is this really where you want me?"

I looked around my nice apartment. It was light and spacious, with lots of windows and a wooden cathedral ceiling. I did like this place.

"Is this really my calling? I know the work we do is commendable, and we are blessing many people in the name of Jesus, but I don't know why I feel like there must be something more you want for me.

"You know how I feel frustrated by not being able to freely go out and witness that Jesus is our Messiah. I don't like being muzzled, not in the least." I replayed in my mind some of my experiences since I had begun to work with Hope for Mankind. It had not been difficult for me to learn the skills I needed to run my department. I had enjoyed the challenge of organizing and managing the busy center. I had liked being one of the wheels that was important to keep our organization functioning smoothly.

"Lord, if you don't direct me to another place, that's fine. I want to be content in your will and be useful wherever you want me. Please, just let me know."

Once more I read from Revelation. The epic battle between good and evil, God and Satan, grew into an enormous struggle that filled the pages.

I became so gripped by the gigantic battle of Satan and his minions against the armies of God that I began to pray, "God, what is this world coming to? People are getting more wicked all the time. Your people are working to spread the Gospel, and many are hearing and repenting, but I see the waves of evil trying to sweep the church away! You know how I have wanted to get married and have children, but Lord, what now? What

are you telling me about the end times that are coming? I know you are speaking to me through your Word, and I want to listen. I want to know."

Earlier I had felt the weight of time pressing in on me. I was in my thirties, unmarried and with no prospects of getting married in the near future.

Suddenly it dawned on me. I wanted children of my own, but there were already many children on earth who needed mothers. I stopped praying and waited, pondering.

"Orphans, God?" That moment was so moving for me that I got excited. I rose from my place on the chair where I had been reading and rushed to the bathroom. I don't know why I ran in there, but I did. I shut the door and knelt down to pray.

"God, are you telling me that I will work with orphans? What are you telling me?"

I didn't get a specific answer right then, but I was excited! I wondered what God was leading me to now.

"Lord, I am willing to give up marriage. I am willing to throw myself into any work you want for me. Help me to serve. Help me be a mother to the motherless."

17

I RIPPED OPEN THE ENVELOPE, MY EXCITEMENT MOUNTING AS I UNFOLDED THE pages inside and scanned them. It was an application to apply as a volunteer at Luz de Cristo orphanage in Mexico! Eagerly I read the accompanying note from Mercy.

> *Dear Amalyah,*
>
> *Here is the application form you requested. I am so excited for you! If you get accepted, I'll pick you up at the airport when you come. When I lived in San Diego, my church visited this orphanage several times, and it is a great place! You are going to be so blessed, working with homeless children who have lost their parents. This is wonderful! May the Spirit of the Lord guide you through this important step.*
>
> *Your friend,*
> *Mercy*

Mercy had gone back to America, where she lived in San Diego for a time. Since the cost of living was extremely high, she eventually moved to Tijuana, Mexico, and commuted to work every day. We kept in regular contact, and when I told her what I sensed God was leading me to, she had excitedly informed me that she knew of a wonderful orphanage and would send me an application.

"I received an application to work at an orphanage," I excitedly told my co-workers at Hope for Mankind. "I applied and expect to be leaving soon if I get accepted."

"My son went into the jungles to work at an orphanage, and he got into some thrilling adventures," one of the volunteers from America told me. "Wow, Mexico! That sounds so exciting!"

My heart raced. I pictured all the little brown-skinned, dark-haired Mexican children longing for love and huddled around me. I could hardly wait to gather them into my arms. "I will give them the love they never knew," I told my co-workers. "I grew up with a loving family, and yet, because of the way kibbutz life was structured, I constantly craved personal attention and love."

The conversation turned to the need for children to have loving and accepting parents, and how so many children in the world were growing up without that. My heart yearned for the children at the orphanage.

"Thank you, God!" A new excitement swept over me.

For the next few weeks, I waited impatiently, eagerly searching the mail each day for word from the orphanage. But there was nothing.

Finally I called Mercy. "I've heard nothing!" I told her. "Absolutely nothing! Do you think they have rejected me?"

"Oh, Amalyah! They are busy at the orphanage, and I'm sure they have not rejected you. They will answer eventually," she assured me.

I waited some more. Nothing. I sent an inquiring email to see if they had received my application. Still nothing.

By this time, I had made plans to leave Israel. I had told my parents, and of course my superiors at work, that I would be leaving soon. I was getting frustrated.

"Come on over," Mercy finally told me. "I called Mindy at the orphanage, and she said you should just come."

So I went, having heard nothing directly from Luz de Cristo at all. Mercy picked me up at the airport, and I was delighted to spend a few days reconnecting with my dear friend. I marveled at her complete faith and trust, living in the suburbs of Tijuana, crossing the border every day before dawn. But at the same time, I became more and more eager to get on with

the work I felt God had called me to.

Finally on Saturday, Mercy's day off, we drove the picturesque road along the Pacific Ocean to the town of San Luis where the Luz de Cristo orphanage was located.

◊ ◊ ◊

"Oh, hi! You're the new volunteer, aren't you? I'm Mindy," the woman greeted me hurriedly. She turned and addressed the crowd of girls in Spanish, but they barely stopped their chatter long enough to look at me. A squabble in the corner took Mindy from my side as she went to try to settle the dispute.

I stood stock still and stared at my surroundings. From the moment I had set foot on the orphanage grounds, I had been amazed how totally different this was from what I had imagined. Even though I had seen pictures of the orphanage, it was different in reality. Pictures had not been able to convey the hot afternoon breeze, the incessant Spanish chatter, or the endless flurry of activity all around me. It was a beautiful, colorful place. The bare dirt yard was covered with pebbles to deal with the mud, and half-buried tires painted in bright colors lined the sidewalks around the playground. The buildings were well maintained and painted with beautiful murals. Inside it was more of the same.

"This will be your room," Mindy told me, opening a door off the short-term volunteers' dormitory. "I thought you might need sheets and towels, so I prepared some for you."

Her manner was quick and direct, but I was so thankful to her for thinking about those little details. It made me feel welcome. I marveled at how quickly she could switch from explaining something to me to addressing some girl's rapid complaint or request, then abruptly switching her attention back to me.

"There are approximately fifty children here," she informed me. "The boys' dorm is across the yard, and the dining hall and kitchen are in the middle. You will learn the schedule more by joining in than by receiving a formal introduction. Look around you, and if you see a need, take care of it."

A bell sounded, and the children immediately began forming lines. "Supper," Mindy explained to me. "Come along."

" 'The thief cometh not, but for to steal, and to kill, and to destroy: I am come that they might have life, and that they might have it more abundantly.' " The children joyfully recited John 10:10 in a singsong rhythm. After they recited several more passages, one of the caregivers prayed, and the youngsters all rushed to eat.

The dining hall resounded with children's voices, of course all speaking Spanish. Several adults sat among the children at long tables. When Mindy left my side, I gingerly smiled at several girls and sat down at an empty place.

A sweet-faced little girl looked at me, and I smiled at her. She said something to me in Spanish. I told her, "I don't speak Spanish. Do you speak any English?"

A frown creased her forehead and she turned to take her plate to the counter. I followed her, and the lady on the other side of the kitchen counter dished some rice and beans onto my plate and then added a piece of corn tortilla.

I usually don't think of myself as finicky when it comes to eating, but this dish was not like anything I had ever eaten. The beans were all mashed and tasted bland to me, but, oh, the chunks of chili pepper that were in them! My mouth burned, my nose ran, and my eyes watered, but I was hungry, so I kept on eating. The tortilla was slightly stale and a bit burned from being toasted on the fire, but it mellowed the spice in the beans a little bit.

Some girls who noticed what was happening started giggling and handed me a cup of tea. The tea was lukewarm and sweet and helped wash away the fire in my mouth.

That evening went by rapidly. Occasionally Mindy came and talked with me and answered some of my questions.

"How did you learn Spanish?" I asked her, feeling overwhelmed with my complete inability to communicate and wondering if I would ever make sense of the chatter around me.

"Oh, I just picked it up. I knew a little bit when I came, and then I learned by osmosis," she laughed easily. I guessed she was probably in her mid-thirties, but she was energetic and youthful. Even though I noticed

tired lines around her eyes, I could tell she was genuinely interested in helping the children.

"This is Gabriela," Mindy told me, indicating a pleasant-faced young woman. "She is from Panama, and she is the girls' dormitory caregiver. I have to go now, as it is my turn to watch the boys. Their caregiver has the night off."

Mindy bustled away, and I was immensely relieved to find that Gabriela spoke good English. "I am so happy you came," she told me as we walked to the girls' dormitory.

As the girls prepared for bed with much talking and jostling, I realized to my relief that a few of the faces were starting to look familiar. They were all ages and sizes, and seemed generally happy as they went about their bedtime routine.

Some girls were very affectionate and welcoming, and they indicated by gestures that they wanted me to tuck them in. Many weekend groups of volunteers came to help at the orphanage, and the girls had grown accustomed to having visitors help the caregiver with the evening duties.

At the same time, some girls were different. I could see suspicion and hurt in the eyes of several, and outright hostility in others. Naturally, it didn't help that I knew no Spanish.

"They are newcomers," said Gabriela of those girls. "It takes them some time to feel secure here and realize we don't intend to hurt them." After what seemed like an hour of hubbub as Gabriela struggled to get the girls to stay in their beds, the lights were turned off, and Gabriela led the girls in quiet praise and prayer.

I went to my little room and eased myself onto my cot. I was exhausted from the journey, and my mind was overwhelmed by all the noise and the unfamiliar Spanish chatter. Suddenly I felt profoundly alone and far from home.

18

"DONDE ESTÁ MI DESARMADOR?" DANIEL, THE DIRECTOR OF THE ORPHANAGE, raised his voice from the front of the bus as he glared rather fiercely at the children.

There was a babble of answers in Spanish; then the fifty children continued to bounce up and down on the seats. They exchanged places with dizzying speed, and since the bus was designed to hold only thirty people, many were double-stacked. I was holding a girl of about six on my lap. Using the one question I knew in Spanish, I asked her name. She merely stared at me and stuck her thumb in her mouth.

"Donde está mi desarmador?" It was obvious even to me that Daniel was asking a question, and that he was not very happy.

"Maria," I said to a girl of fourteen who knew some English, "what is he saying?"

"He needs tool," she said, turning her hand in a corkscrew manner. "To start bus."

"A screwdriver?" I hazarded.

Maria nodded, "Yes, need the screwdriver."

"To start a bus?" This was a new one for me.

"Yes, boys not bring back tool. Now Papa Dani angry."

Then Papa Dani, as the children called him, quieted the crowd and talked seriously to the children. His tone was still authoritative, but he no longer

looked upset.

While he was talking, I looked out the bus window. Rain streamed down the sides of the bus, making everything outside look watery and out of focus.

My second day at Luz de Cristo was rapidly shattering more of my dreams of life in an orphanage. The morning had been chaotic in the dormitory while the girls dressed, and even more so in the dining hall where the girls and boys were together eating their Sunday morning breakfast.

"We go to church on the bus," Mindy had told me just before we all ran through the pouring rain to board it.

I don't know if Daniel eventually found the screwdriver, or if he improvised another way, but soon we made our way out of the compound and drove onto the road.

The children stared out the window at the rain and swollen drainage ditches on either side of the road, chattering rapidly all the while.

At one place where the road dipped, we drove through several feet of water. Papa Dani inserted a CD, and all the children joined in singing a lively tune. As we entered town, they started shouting *"La bajada! La bajada!"* (The creek!)

I looked at Gabriela with a question in my eye. She just laughed and gestured like something exciting was going to happen. We rounded a curve, passed two lights, and then Papa Dani stepped on the gas and raced down across a stream so fast it felt as if we were flying! The children yelled with excitement as water splashed higher than the roof.

When we arrived at the church, the orphanage children and staff swelled the congregation to the building's full capacity. The time of singing was accompanied by much clapping and hearty singing, all in Spanish. Other than *Jesucristo* (Jesus Christ), I hardly caught a word of it.

Learn Spanish, I told myself mentally. *Pronto,* I added as I pulled from some dusty recess of my brain another word in Spanish. *I must learn Spanish quickly.*

After the sermon we boarded the bus again. Even though the rain had slacked off, it was still sodden and wet outside. It was February, and the weather was actually very similar to Israel at this time of year.

Maybe if the sun had been shining it would have helped to brighten my outlook on what I was experiencing. Never in my life—not in my wildest

dreams—had I experienced culture shock on this scale.

The rest of Sunday passed in a blur. We ate another meal of rice and beans. This time the food tasted rather bland without the chilies, but I managed to get it down.

After lunch it was playtime, and because of the rain, everyone had to spend their free time indoors. Games of skipping rope and clapping rhythms occupied the energetic girls, while the boys began holding contests to see who could jump the highest.

As evening came, the usual disputes sprang up. More than once, two or more girls came up to me, talking loudly and very fast, obviously complaining about an offence committed by the other child. I kept shaking my head and saying, *"No comprendo"* (I don't understand).

This upset the girls. They would frown deeply, and although I couldn't understand what they were saying, I could tell by their tone of voice that they were disappointed. Then the call went around, "Those who have privileges can go have ice cream and games at the mission house!" I learned that during the week a rewards system was applied to help discipline the children. Those who accumulated too many black marks were not permitted to join in the Sunday afternoon ice cream and entertainment.

After supper there were stories and singing, and Daniel spoke to the children, obviously teaching them Bible lessons. He spoke well, holding their attention, and I marveled at the change from the man who had lost his cool just that morning. Now he spoke lovingly and smiled benignly at the children. He and his wife had no biological children, but they truly treated these children as if they were their own.

"Luchas, luchas!" begged a little boy with big brown eyes, climbing on Daniel's lap.

"Okay," Daniel agreed amiably, "we'll have a *lucha,* (wrestling match) just for a few minutes. It's almost time for bed."

We all went upstairs, where Daniel took mattresses off the bunks and spread them out to create a large, soft area on the floor. The boys took turns engaging in wild and joyful wrestling matches against Daniel, with the accompanying noise level being just what you would expect.

At last it was bedtime. When I finally got to my room, the dam burst. I

was so homesick and lonely that I cried for a long time.

"I don't know the language," I told God through my tears. "The food doesn't agree with me. It rained all day. I am chilly and damp. I can't communicate with the children. They are mostly happy-go-lucky, often disobedient, and they don't seem to need me at all. God, what am I doing here?"

That was the question. Just why was I here?

"I truly thought you were calling me to come here," I continued. "So why do I feel so unfulfilled now?"

I thought back to how eager I had been to leave Israel and come to Mexico to Luz de Cristo orphanage. I had pictured myself sitting on the floor, the children gathered around me, pressing in against me and leaning against my shoulders as I showered them with love. To be sure, I had realized I would need to learn Spanish, but I had not envisioned anything like this!

A tap on the door made me dash away my tears. "Come in," I called weakly.

Mindy came in and shut the door quietly behind her. "Feeling overwhelmed?" she asked sympathetically.

I nodded, and the tears came again. Mindy gently began massaging my shoulders. "I cried every night for three weeks when I first came," she said soothingly. "I wanted to leave after the first week."

"I want to run away," I said when at last I could speak. "I just want to get out of here. Where are the children who need love? Where are the hugs and cuddles? They are orphans, and they don't even seem to care! They are either angry and arguing with each other or so withdrawn that they don't let anyone else into their worlds. I grew up in a community style of living. I've worked in several kindergartens, so I thought I would know how to cope, but I feel totally lost!"

Mindy gave a dry chuckle. "I think it would be hard to have anything sufficient to prepare a person to come and volunteer here. I have worked with the children for three years now, and believe me, it can get even worse! We often don't have enough workers, and you end up feeling like some kind of general guardian, herding the mob from day to night and back to day again. During the day when most of the older ones are in school, it can be a little more relaxing, but believe me, even then there is more than enough work to be done."

"I don't even know why I am here," I cried. "But God hasn't told me I can leave, either."

"I know why you are here," Mindy informed me matter-of-factly. "It's because I'm leaving."

I jerked my head up. "You are leaving?" I exclaimed.

She nodded. "Next August. And they need you."

"But no one told me," I wailed. "I have no idea what my work is even going to be. I came here and was thrown into the middle of things with hardly any orientation or job description."

"Why don't you let God handle that for you?" Mindy suggested serenely. "You can worry yourself ill trying to figure out what you are supposed to be doing, or you can strengthen your faith by allowing God to direct you from one day to the next. You are a Christian, aren't you?"

"Yes," I replied, chagrined. "I am. But I don't think I have been acting like one."

"Being a Christian doesn't require acting," Mindy said with quiet assurance. "When your relationship with God is strong, your actions will of course reflect it, but you can't build the relationship by performance. Your strength comes from spending time with God and simply obeying Him. Hard as that is to grasp sometimes, it is the truth that has helped me through many times when I felt I had failed Him. But I do have to tell you one thing: here at Luz de Cristo you must fight to be consistent with your quiet time. If you start neglecting that time of daily nourishment from God, you will burn out fast."

◊ ◊ ◊

"Daniel," I said as I approached the director the next morning, "what do you want me to do? What is my job here?"

Daniel brushed the hair back from his forehead. "Why, why . . . what is your name again?"

"Amalyah," I told him.

"Well, Amalyah, just look around. If you see something that needs to be done, do it. That is the best way to learn what your responsibilities are.

That is also the best way to find out what you are most drawn to among the many responsibilities here."

He smiled at me, but I was aghast. "I don't know what to do! I have time on my hands, and no one tells me what to do. And what about the daily routine? How will I fit in?"

Daniel laughed. "There will come a time when you'll wonder how you can keep up with yourself. Just enjoy this time of getting acquainted. The only thing I ask is that you learn all the children's names in the next two weeks."

"The names of all the children in two weeks! How can I possibly learn to tell them apart when they all look so similar?" I felt more overwhelmed than ever. None of my previous experiences, where I had worked with perhaps a dozen children at the most, had prepared me for this sea of small humanity that swirled around me constantly.

"You have to look for distinguishing features," Daniel said. He called out to a young boy. "Like Tito," he said as the boy approached in answer to his call. "See Tito's scar? You will remember him now," he assured me with a confidence I did not share.

A Mexican worker came up and addressed Daniel in Spanish. Immediately Daniel became engrossed in the obviously urgent need, and I was forgotten.

I looked around and saw the usual beehive of activity. The children were getting ready for school. I had still not figured out what time they were supposed to leave. I was embarrassed to keep asking the other busy workers questions as they scurried about, handing out instructions, settling disputes, and working in tune with some interior schedule they knew intuitively.

I saw one of the girls drop her sweater and rush on, oblivious of her loss.

"Wait!" I called out, and went to pick it up. A flurry of voices interrupted the departing girl. She stopped to look back, and as I caught up and handed her the garment, she flashed a smile at me and said, *"Gracias!"*

Well, that was a start. I did as Daniel had suggested and looked around. Where I saw a need, I tried to fix it. I even grabbed a hammer and pounded in a few nails to tighten a loose board on the front porch. There was trash blown up against the fence, so I grabbed a waste can and began picking up wet trash.

"You'll learn," Mindy told me with confidence when I asked her how in the world I was to learn the children's names. "Ask them their names. Just

say, '*Cómo te llamas?*' "

That is what I did. I kept walking up to each child and asking his or her name. As they told me, I tried to keep them straight in my mind. Gradually I came to recognize Alfredo and Carlos and Norbeto and Isaías and Teresa and Maria and another Maria and Susana.

Gabriela tried to help me by printing a page full of passport-sized pictures of the children, each labeled with his or her name. "But don't worry" she assured me breezily, "you will learn in no time."

More than once, I got a puzzled look with a rather indignant, "Carlos!" shouted at me when I forgot and asked the same child what his name was for the second or third time.

I learned to laugh at my mistakes, continuing on my wild quest not only to learn Spanish, but also to figure out the schedule and how I could be most useful.

I asked the sympathetic but overworked staff endless questions, and my mind kept repeating a few Spanish words. But after some time, I learned to take my questions to God. He was the one who could help me to learn Spanish. He knew why I was here.

19

"OKAY, WHO CAN TELL ME WHAT IS THE NUMBER ONE RULE HERE AT LUZ DE Cristo orphanage?" I asked, looking at the faces around the room. They were mostly teenagers from the United States on a short-term mission trip. Many of them were here for the first time, while a few were returning volunteers.

"Don't throw toilet paper in the toilet!" a chorus of voices replied.

"Right on!" I said. "And the second one is . . . ?"

"Don't drink the tap water!"

I caught a glimpse of Mindy's approving smile as I continued briefing the group about the orphanage's rules and the dress code.

"Grupo! Grupo!" The children were all excited that another group of volunteers had arrived. The teenage boys had cleaned the area at the back of the orphanage's campus, preparing the ground to pitch tents to accommodate the coming group. The younger ones were running around in excitement, helping with whatever they could. Every weekend we had a group from a different church in the United States come to help us, but now it was summer, and the groups came and stayed a whole week at a time.

"There are going to be lots of volunteers this week from three churches," Mindy had told me.

"Amalyah," said Daniel as he approached us, "I want you to work with Mindy on coordinating this group. You will assist her and the paint teams so you will be prepared to help us with the other groups after she leaves."

It was my first summer at Luz de Cristo, just six months after I arrived. Until then we'd had groups every weekend, and Mindy did most of the work coordination. But this group was huge, and it was a good opportunity for Mindy to train me.

"Okay, Miss, tell us what to do," said someone behind me. I took a deep breath and looked at the group of teens crowding the doorway. I smiled at them and wondered if I looked as overwhelmed and out of place as I felt. This time I was on my own, without Mindy to help.

"Are you fellows the water- or oil-based paint team?" I asked them.

"We're the water-based," they answered eagerly.

"Good," I said. "We have five locations for water-based painting. We will split you into two teams and tackle one job at a time. Does anyone here know anything about preparing an area for painting?"

"I painted some with my dad . . ." someone volunteered hesitantly.

"Well, Daniel is very particular about how things should be done," I told them. "A good prepping saves a lot of fixing in the long run." I explained the process of washing the walls, scraping loose paint, filling holes, priming, and then finally painting.

"Richard, you'll be the team leader," I instructed.

"Yes, ma'am!" the young man replied promptly. I chuckled at myself. Daniel had taught me well, and I managed to sound very confident and competent, but in reality I had zero practical experience in painting.

"Sister Amalyah," he had said, "your job is to supervise the teams, so resist the temptation to join in on the painting. I need your attention all over, not just in one place." As a result, I hardly ever held a paintbrush.

"Where do we put the chairs?" a boy with curly hair asked me.

"Um, let's put them out in the hall while we paint," I told him.

I spent the morning getting the teams to sand down the rough spots on the drywall. Others were sanding the trim around the windows, while one diligent girl kept vacuuming the floor, making such a racket and stirring up so much dust that I finally tapped her on the shoulder.

"Let's wait until we are done with the sanding, and then we will do a good vacuuming of the whole room," I told her.

"Oh, okay," she replied, looking a little crestfallen.

"At last we can hear ourselves think," a lanky boy quipped, and everyone laughed.

"You can gather the trash and take it to the dumpster," I instructed the girl who had now relinquished the vacuum cleaner.

"Okay, everybody, let's take a water break." Anna came into the room with a jug of ice-cold water and a handful of popsicles. She was the water girl, a very important role in the heat of the summer. Everyone was happy to see her approach.

"Where are you from?" I asked the group as we took a few moments to relax.

"Minnesota."

"We're from Canada," a few others chorused.

"Northern California," inserted a few more.

"All places that get a lot of snow in the winter," I said. "I remember as a young girl how excited I got whenever it snowed in Israel since it hardly ever did. But we had to drive all the way up to Jerusalem to see the snow."

"You are from Israel?" exclaimed several voices. "How neat! How did you get here?"

"By airplane," I joked, and then began telling them my story when I had their full attention. Questions came quick and fast as I told them about my life.

As I shared about my spiritual journey, there were some sympathetic and understanding looks from the volunteers, and I was peppered with more questions.

"The most wonderful thing that happened to me was that I found total freedom from the bondage I had been living in. The condemnation and guilt left, and finally I was free. My sins were forgiven by the blood of Jesus."

There was silence in the room. I could tell the young people were thinking about the things I had told them. "Well, it's great to chat and share about God's goodness, but I guess we need to get back to work and get these rooms painted," I finally said.

That afternoon as we tried to finish our project, we heard startled cries from outside where a group of young men had been digging a drainage ditch.

The water pipe! I remembered Mindy's prophetic words when she heard about the latest project. "Every time we get a group digging outside, someone will hit the water main. Just you wait and see."

Now we rushed outside together, and sure enough, there were drenched men standing beside a small geyser shooting out of the ditch.

"It happens without fail." Mindy shook her head, laughing.

Before our maintenance man could be found to shut off the valve, the water had run into the excavated area and formed a muddy swimming hole.

The children, who were always fascinated with any projects, splashed joyfully in the mud, and soon a water fight began.

❄ ❄ ❄

"May we go to the grass patch and get all wet with a hose?" It was several days since the water fight in the mud hole, and the girls were crowded around me speaking rapidly.

"Wait," I laughed. "You must speak slowly and only one at a time so I can understand."

This was hard for them to do, but finally they picked a spokesperson. Maria, the girl who spoke some English, repeated the request.

"I will see if I can get permission." I went off to speak to Daniel.

"Sure," he agreed readily. Then looking at me keenly, he asked, "Do you like it here by now?"

I smiled and nodded. "Yes, I really do. At first I thought I couldn't take it . . ."

Daniel raised his hand and stopped me. "Yes, we all knew how you were feeling," he said. "But we are glad you chose to stay. You are good with the children. We watch the new staff to see what they are suited for. Some are most comfortable in the kitchen or other parts of the home, but I see that you handle the children very well."

"Telephone," the secretary yelled from the open door of the office, and Daniel hurried off.

It was always like this. There never was adequate time to really discuss anything. It seemed we were always interrupted by something. I was learning to communicate in abrupt, short conversations and to cut out the filler material.

❄ ❄ ❄

The babble of Spanish words broke around my ears as three of the girls poured their tale of woe into my uncomprehending ears.

"Wait. Please speak slowly!" I said in Spanish, holding up my hand. "I don't know what you are saying."

"No comprendes?" The girls looked at me with obvious disgust. "Why do you not understand?"

I forced myself to smile. "I am trying to learn Spanish," I said slowly, "but if you speak so fast, I cannot understand what you are saying. Please, only speak one at a time, and speak very slowly."

Maria drew her eyebrows together and said distinctly in Spanish, "You are *estúpida*. You do not understand what we are saying. You must not be *inteligente.*"

I knew very well what she was saying. I easily recognized the words for stupid and intelligent. Clearly, they thought I was dumb.

A feeling of weariness swept over me. When would I ever learn this language? I was surrounded by Spanish every day, and yet I floundered and flapped about in these foreign waters like a gasping fish. Only occasionally did I really understand what was happening around me, and now once again, the girls were getting agitated with me because of my lack of understanding.

Seizing on a sudden inspiration, I said, "Girls, I have a request." This much I could say.

They stopped their babbling and looked at me.

"I want you to pray and ask God to help me learn Spanish so we can talk better." It took me a while to formulate this sentence in my head, and then it was no small matter for me to get my message across to the bewildered girls.

Eventually they understood me, and Maria spoke rapidly to the others. They nodded. "You want us to pray for you?"

I nodded, closed my eyes, and bowed my head.

"Right now?" They were surprised.

"Yes, right now!" I encouraged them.

They laughed self-consciously, but when I once more bowed my head, they prayed for me one by one. Furthermore, they kept praying for me every night before they went to bed.

That marked the turning point in my remarkable journey of learning Spanish. Eventually I actually became fluent in it, and I firmly believe God

answered those little girls' prayers. Afterward, words and phrases started flooding my mind. Sometimes I even had to look up someone and ask what certain phrases meant, because I could not get them out of my head. In a very short time I could hold a simple conversation. By the end of my first year, God had allowed me to teach His Word in Spanish to those precious little girls.

<p style="text-align:center">◊ ◊ ◊</p>

"I would love to be a dorm mother," I told Mindy after I had been at the orphanage for several months.

"It will never happen," was her honest opinion. "You are a foreigner, and the Mexican welfare office won't allow you to serve in that position."

That had been before my brief conversation with Daniel in which he praised my skills with the children. Even though that talk got my hopes up, it was still a surprise when my wish was suddenly granted.

"Gabriela is returning to her home in February. We would like you to become the dorm mother when she leaves. Do you think you can handle that?" Daniel's wife, Angelina, asked me in her sweet, caring manner.

"Oh, Lord," I prayed that night, "thank you for this opportunity, but please let me use it to please you. I feel so busy sometimes that I am afraid I am missing my connection with you."

My mind traveled back to the first three months I spent at Luz de Cristo. I remembered those first horrible days when I had questioned whether I was going to make it or if I was going to flee back to Israel in disgrace. I remembered with a smile how I had cried every night for several weeks and had felt so out of place.

"Then, every morning, you would give me fresh hope and strength to begin another day," I told the Lord gratefully. "I thank you, and I want to give myself totally into your hands to use me however you can."

"Please let me help the girls who will be under my care. Help me to see them as you see them, and God, let them feel your love through me."

20

THE STARS IN THE MEXICAN SKY SPARKLED OVERHEAD. IT WAS LATE, AND THE children were all in bed, so the staff had gathered outside for our weekly devotions.

"As the deer panteth for the water, so my soul longeth after thee." Anthony, the song leader, led us in a chorus, and our voices echoed his words.

Anthony was a gifted young man, and I enjoyed his leadership qualities. His love for people was reflected in his daily living, and I watched him admiringly as he sang in the dim light.

After our devotional time was over, the staff left one by one, but the two of us remained behind and talked a while.

"I lived in Arizona all my life," he told me. "Then when I became a Christian, I wanted to do something worthwhile. When my uncle came back from his visit to Luz de Cristo, my interest was piqued enough to want to come as a volunteer."

"I lived in Arizona for a little while myself." I told him about my adventures on the farm.

He laughed. That was one of the things I liked about this friendly young man. He laughed a lot.

"Tell me more," he urged, and I told him about my spiritual journey.

That evening was the first of frequent opportunities we took to sit together for a short time and talk.

"She took my neck scarf right out of my drawer and wore it," Estela shouted. "It is mine and she stole it!"

By this time, I knew enough Spanish to understand almost everything, but I struggled at times to formulate a quick answer when I was under pressure.

"She took it from me!" Hilda insisted. "It was my Christmas gift from the American visitors! I couldn't find it, and I saw it in Estela's drawer. It's mine!"

"Wait a minute!" I raised my voice over the hubbub. "Calm down, and let's see what this is all about. Shouting about it doesn't help."

The two girls quieted down but continued glowering at each other.

"You know it is almost time to go to school," I told them. "Do we have to talk about this now, or can I go and help the little ones get ready? I don't know how we can solve this right now anyway. The breakfast bell will ring soon. Why don't we talk about it this afternoon?"

My suggestion fell on deaf ears. "No," Estela said stubbornly. "If someone takes something out of your drawer, she is a thief. Hilda is a thief!"

"It's not yours! You are the thief!" Hilda retorted.

"If you want to wear it, you can ask to borrow it. Don't steal it like a street dog!" Estela said in a bitter tone.

"Estela," I gasped, "you should never speak that way to anyone." I tried again. "Please, girls, can we settle this later? I feel so rushed to get everything done."

"I want to wear it for school today! Give it back!"

A great feeling of sadness swept over me. True to Daniel's predictions, my days now were packed full from morning until evening. Many times I felt like a hamster running in endless circles inside its exercise wheels. It seemed I was always on the go but hardly ever getting anything done. There were many times I wondered if I was even ministering spiritually to the orphans. We gave them food and a place to stay, but they needed so much more.

The girls continued their argument. I felt burdened and helpless. I had thought I was ready to be the dorm mother, but now I felt far from adequate.

"Oh, God." I closed my eyes. "I need you. I need your help. Please give me wisdom."

As I sat there, I slowly realized that the scarf was not the issue. The scarf was merely the thing that brought out the inner hurts of these girls. The quarrel was just an echo from the lack of love they felt. My heart leaped as that truth came to me. How could I show love to both of these girls? I waited quietly.

Strangely, the quarrel was lessening. I opened my eyes to see if the girls had left. Estela and Hilda were both staring at me.

"Are you praying?" Estela asked.

I nodded my head. "I am learning to ask God to help me with every problem."

"Does it help?" Hilda asked.

I nodded again. "It does help."

"How?" Hilda wondered. "How does it help?"

"God speaks to me. He gives me answers. Not always clearly, but when I ask, I feel calmer and more focused." My voice trembled slightly with emotion.

"I wish I knew God that way," Estela said softly.

"You can," I assured her.

"What did God tell you?" Hilda wondered, coming to the point. "What did He say about my scarf?"

Estela bristled immediately, but then I guess her curiosity overcame her. "Yes, who is going to get it?" she inquired.

"Estela," I began. "You say it's your scarf. Hilda, you say it's yours. You both want it. But you know, girls, Jesus gave us something much greater than a scarf. He gave us His life. I don't know who this scarf belongs to. God did not reveal that to me, but I do know that He is very sad when two of His little princesses fight like that. It hurts Him. He loves us, and He wants us to love each other."

To my complete surprise, Hilda burst into tears. "Oh, Estela, I'm sorry I took your scarf," she sobbed.

"You are my friend, Hilda," Estela responded. "I'm sorry I called you names. You can have the scarf anytime you want." The two girls hugged, and both of them wept.

"Lord, you are truly amazing!" I whispered.

"After you come home from school, I am going to ask permission to take you both downtown to a shop," I told the girls. "I want to buy a scarf for each of you, to remind you how much God loves you."

"Are you serious?" Estela's eyes sparkled. "You would use your own money to buy us each a scarf?"

I nodded.

"Thank you!" Hilda was ecstatic. "That is so kind of you."

"Hilda," I said, "God is the one who is kind. And now I think you two should pray and ask forgiveness for how you treated each other."

Tears threatened to spill from my eyes as the girls held hands and quietly thanked God for His love and forgiveness. "Help us love others like you love us," Hilda concluded.

The breakfast bell rang and we had to rush away. The children went off to school, and I was swept into the day's activities.

◊ ◊ ◊

"Amalyah," Daniel began rather hesitantly after I had answered the summons to his office. "I want to talk to you about your relationship with Anthony. It seems to me that you go out of your way to spend time with him. Am I right about how you're feeling?"

"Well, we are serious about our friendship," I responded. "I don't see anything wrong with it."

"Are you sure?" Daniel probed. "Does Anthony feel the same way about you?"

I nodded confidently. "I am sure he does. We spend time singing together and discussing our views of the Bible. I know we are more than just friends."

Daniel raised one eyebrow skeptically but said nothing. "Well, just remember that all the children are watching you," he said finally. "They are very observant of anything going on."

I nodded. I wanted to tell my director that Anthony had been showing me how he felt about me. He had given me a small book of devotionals, and more than once he had brought me a small gift of candy after one of his trips to town. I felt sure our hearts were being drawn together.

◊ ◊ ◊

"Amalyah, I'm very sorry to have to tell you this, but Anthony says there

162

is nothing going on between you two. He told me that you are just friends." It was the very next day, and Daniel had asked to speak to me again.

Every word piled on top of the previous one as Daniel kindly spoke. The very floor beneath me seemed to tilt.

"But," I stammered. "But . . ." Then I could say nothing more.

For once, Daniel seemed to have time for me. He waited until I composed myself before continuing. "Anthony says he is sorry for leading you on in this relationship. Like fellows often do, he failed to consider how a girl's heart interprets every look of kindness and every gift, however small. That's what happened with Anthony. He likes you and enjoys spending time with you, but he was never considering a relationship. Even though he did not declare any feelings for you, you began to read the signs. Apparently you felt the signals you were getting meant he felt the same way you did."

The constriction in my throat would not let me speak. All I could do was nod mutely.

"I have some books here that I would like you to read," Daniel told me kindly. "Here is *Passion and Purity* by Elizabeth Elliot. I also have *I Kissed Dating Goodbye* by Joshua Harris. I think you will find them enlightening and helpful for you. There are so many girls who fall into the same situation, simply because no one ever took the time to teach them about healthy relationships."

I took the books, nodded, and fled. Thankfully, it was just after lunch, and even though there were hundreds of things that could be done, I went into my little room and closed the door.

My cot felt hard and unforgiving as I lay face down, shame and regret flooding my heart. Oh, what a fool I had been! How could I ever face Anthony again? I knew he had been around that morning, but then he had disappeared. I was sure Daniel had understandingly found something for him to do for a day or two while I digested what was happening.

At first, my thoughts swirled in despairing circles. *God, how could this happen again? How could I allow myself to get entangled in a relationship I thought was a gift from you?*

I had a flashback to the relationship that had developed between Brian and me soon after I had become a Christian. I recalled how I had prayed for God to make His will clear, and how Brian had left for San Francisco

soon afterward.

"I feel as though I'm stuck," I told God. "I'm stuck in a vicious cycle of letting my heart get involved with men, and then nothing comes of it."

I tried hard to keep myself from thinking about Anthony, but I kept seeing his humorous blue eyes and his dark brown hair. I could hear his voice as he would drawl, "Amalyah," and then laugh.

"Why am I so dependent on having a relationship with a man, Lord? Why do I fall so easily? What is it I am looking for?" I tried to be ruthlessly honest with myself, but there seemed to be no answers.

When I heard the children coming home from school, I jumped up and ran to wash my face. I would not have time to ruminate over what had happened. I was the dorm mother, and my duties would consume me for the rest of the day.

<center>✿ ✿ ✿</center>

"Pick up your clothes. Now!" I turned in exasperation to face fourteen-year-old Lucia. "Your carelessness almost made Tina fall on her face. I have told you and told you to stop leaving your clothes all over the floor where people will trip over them."

Lucia frowned at me. "I did not throw my clothes on the floor!" she snapped. "I put them on the bed, and they fell off."

"No you didn't put them on your bed!" Tina yelled. "You dropped them right there on the floor. I saw you do it!"

"Liar!" another girl chimed in. "I saw her put them on the bed."

The voices shrilled around me. I felt angry. "Stop it!" I screamed. "You all stop it! Lucia, pick up those clothes, and Tina, you stop yelling!" The tension in me was mounting.

"You always yell at me!" Lucia screamed. "You yell at me every day."

"You get yelled at because you are such a sloppy person," Tina sneered at Lucia. "Everybody yells at you, not just Amalyah."

With a cry of rage, Lucia lunged at her antagonist. I jumped between them, and grabbing them firmly, I pushed them apart.

"I hate it here! I want to go home!" Lucia burst into angry tears.

Before Tina could open her mouth to retort, I clamped a hand over her lips. "No." I shook my head firmly. "Don't say anything."

With a morning like that behind us, it was not surprising when later in the evening someone reported, "Lucia ran away."

"She'll be back," Daniel said calmly. "I know her situation. She'll go to her aunt's house where she will have to be the drudge, working from morning until night. She will soon decide that life here is better and will want to come back."

"How do you know?" I questioned.

"Because it happens all the time," replied Daniel. "They face so much abuse in their environment that the only way they know how to function is by fighting and fuming. When we intervene, they don't know how to handle correction either."

"I didn't help," I confessed. "I lost my temper with them. I'm sorry."

"Don't blame yourself," Daniel said kindly. "You are under a lot of pressure. We understand."

"But I am to blame," I said. "I can't stoop to their level to try to control them. I know God can give me grace not to lose my temper."

"Lucia's back already!" A girl stuck her head in the door to make the announcement, and then disappeared.

I hurried back to the dorm. Sure enough, Lucia lay in her bed, the covers pulled up over her head. I stood beside the troubled girl and began praying silently. Finally I reached out and gently touched her. "I am glad you are back," I said softly, and left the room.

In spite of all the drama of the evening, I was facing my own inner struggles. I still had not forgotten Anthony.

No matter that it was late, and I was tired. No matter that I knew I had to be up early the next morning to make sure the girls got ready for school. I could not sleep.

I began to read Joshua Harris' book on dating. I was enthralled, blessed beyond measure, and deeply convicted all at the same time. The words leaped off the pages and imprinted themselves on my heart as I read testimony after testimony that echoed my experiences. I was starting to realize that my whole concept of love and relationships was wrong.

Finally I switched my light off and lay in the darkness, reflecting on all I had been reading.

"My child, I know your heart. I love you, and I don't condemn you." The comforting words of God brought peace to me. "You have gone through bad relationships, and your heart has been broken over and over again as you were seeking for love and acceptance. But my child, I accept you, and I love you. You have my approval now."

I knew it was true. Even though I had repented of my previous sinful life, I realized God was doing a deeper work in my life. There were still issues that I needed to face honestly with His help.

"I want to get married," I told God. There, it was out. I was honest with my own feelings. "I want to be a mother. I want to have my own children." Even though in Israel I had decided I could forego my desire to have a family in order to come to Mexico and love the children here, I realized I still had not given up hope of having my own husband and family.

"I know my desires are not wrong, God, because you created me with them. But why did this happen?" I groaned. "If I am normal, why am I not finding a husband the way most women do? Where is my husband?" I could not refrain from asking these questions.

"Thy Maker is thine husband." The words from Isaiah 54:5 flashed into my mind. I remembered now that when I had read that verse, it had seemed peculiar to me. Now it suddenly began to take on a new meaning.

"God, are you saying that you will be my husband?" I asked somewhat dubiously.

"If you allow me, I will be," came the reassuring answer.

I burrowed my head in my pillow. "I give myself totally to you," I prayed. "Once again I surrender. I will let you work in me what you want through this. I am beginning to see how you want to purge me of everything else so that I can find my complete security in you."

I imagined myself as a beloved bride of Jesus, and basking in His love, I finally fell asleep.

Yes, it was awkward afterward to see Anthony and even more awkward to receive his clumsy apology. I certainly didn't enjoy offering my even clumsier apology to him, but painful as it was, I hoped I had learned a

lesson through it all. I felt much more secure in Jesus' love and acceptance for me. I no longer had that same driving need to be affirmed by people. I didn't always remember, but the Spirit was faithful in reminding me where my true joy and strength lies. Many times since that turning point, I came back to receive acceptance and affirmation from my husband, my Saviour.

21

"LOOK, LILY!" *BOOM!* TERESA BANGED THE CABINET DOOR SHUT, AND LILY'S eyes lit as she smiled.

"Look, Lily! Lights on, lights off." Tina flipped the switch up and down, much to the delight of the tiny creature in the baby stroller.

I laughed as the girls all tried to get seven-year-old Lily to respond to them. It was always like this. Lily was as tiny as a one-year-old, her head large and her body crooked. Someone had found her in a nightclub restroom, drenched in blood and her birth water and just barely alive. The doctors said she was a victim of a failed abortion attempt, and they did not expect her to live more than a few months.

A Christian couple who heard about Lily got permission to adopt her, and she survived well beyond the doctors' predictions. Lily's parents later joined the staff at Luz de Cristo, so here she was. Whenever Lily was around, the girls flocked about her. She was everyone's pet, popular and loved.

One evening we were gathering for Bible reading and prayer. Lily was staring at the lights on the ceiling, while several girls leaned on her stroller and blew kisses at her.

"I have a question for you," I told the girls as things gradually quieted down. "What does Lily do that makes you love her so much?"

There was no immediate answer. Puzzled looks were exchanged. "She doesn't do anything to make us love her," someone finally said. "She's just

. . . she's just Lily."

"She's sweet, and she likes it when we give her attention. She loves us back too, even though she doesn't talk," another girl added.

I nodded my head in agreement. "Do you know who that reminds me of?"

"Someone you knew back in Israel?" ventured Tina.

I shook my head. "No, not someone who reminds me of Lily. It's you girls who make me think of someone. You love Lily, and she doesn't have to do anything to get your love. She doesn't give you money or food, she doesn't talk, and she doesn't play with you. She just receives your love. Does she deserve your love?"

"Yes, because she needs someone to take care of her," Lucia replied thoughtfully. "She can't dress or bathe or feed herself. Because we can do all that for her, she needs us."

"I see a picture of how Jesus loves us," I told them. "We don't need to do anything to earn His love. His love for us has nothing to do with how well we talk or how strong or how pretty we are. He loves us just because He is love. In a way we are like Lily, because we, too, need help. We don't know how to live our lives in a way that is good and satisfying. We cannot take care of ourselves without Jesus' help."

The girls sat quietly, listening intently.

"You play with her and help her because you love her," I continued. "Remember how sometimes she doesn't want to eat or drink? At those times you just wait until she is ready again, because if you try to force her, she resists, and it makes it worse."

"That's just how God does to us," Tina said, a light dawning on her face. "When I resist Him, He waits. Then when I am sorry for the mess I made, He comes right back and helps me."

"Lily just takes our love," Teresa added eagerly. "She doesn't have to do anything except receive it."

I nodded. "Sometimes we think we have to do something to make God love us. We might try hard to be really good, but the Bible says God loved us while we were yet sinners. He doesn't wait to love us until we are good. It's when we let Him into our hearts and accept His love that we receive power to become like Him. Without that power, we can't do it. We need His help.

And you know what? Just as it makes you happy when Lily responds to your attention, so God is pleased when we respond to Him."

The girls were silent as they thought about this. Then one of them asked, "So even if we know we are bad, God still loves us?"

I nodded.

"You mean He doesn't care whether we do good things or bad things? He loves us just the same?" Teresa asked.

"His love does not end when we do wrong," I told her carefully. "But He does care. He cares very much, and He wants to change us so we are not slaves to sin any longer. Many people try on their own to improve themselves, and many times they succeed in making at least some changes by their own effort. However, it is so completely different when God does it. He changes even our desires so that we actually want Him to take away our sins and make us clean and new. We want Him to be in charge of our life. We want to obey His Word. He changes us from within, and we become more and more like Him."

I kept praying this lesson would stick with the girls. I frequently dealt with issues in our dormitory that showed how insecure they were. How I wanted them to find security in Jesus' love and acceptance!

At that moment Hilda began spontaneously singing, "Jesus loves me, this I know," and as we joined in singing the familiar words, I thought about how appropriate it was. Once again, the simple yet profound message of that song reminded us just how much our Saviour loves us.

◊ ◊ ◊

"Why do I have to?" I overheard a little girl's voice say sullenly.

"Because it's your turn," nine-year-old Stephanie said bluntly. "When it's my turn, I clean the bathroom. Now it's your turn, so go clean it."

Gabby drew her lips into a thin line and shook her head. "I'm not going to," she said defiantly. "Nobody can make me do it."

Both girls turned to me as I came to see what was happening. Their voices tried to drown each other out as they both presented their case.

"Gabby," I told the eight-year-old newcomer, "here we take turns at jobs

assigned to us. You will have to take your turn like everyone else."

"No! No! I won't do it!" Gabby jumped toward Stephanie with an angry cry and slapped her viciously on the cheek.

The attack was so swift and unexpected, I was caught completely unaware. Before I could gather my wits, the two girls were fighting in earnest.

"No! No!" I echoed Gabby's earlier cry. By now each girl had a grip on the other's hair, and both were yanking as hard as they could. I sprang into the middle of their tangle and tried to separate them.

Gabby's response was not unexpected for a newcomer, but I was aghast at Stephanie. An outgoing child, she was usually happy and easy to get along with.

"God, what is going on?" I asked under my breath. Like a flash, it dawned on me. Yolanda, the laundry worker, had left the day before. No doubt Stephanie was missing the security of the woman who had been a big part of her life for so long. Mild-mannered and easy to love, Yolanda had loved interacting with the children. I now remembered how Stephanie had clung to her, weeping as they said goodbye.

Now I looked at the dejected girl, sitting on her bed and crying. My heart went out to her. "I am so sorry," I whispered. "I know it is hard for you to see Yolanda leave."

There was no answer except a deep, heartbroken sob that confirmed I had identified her pain.

I turned to the matter at hand. "But you need to forgive Gabby. She is new here, and I am sure she misses the people she used to live with. It was wrong for her to slap you, but can you please forgive her?"

"Never!" Stephanie whispered fiercely. I could not miss the hatred in her voice. Her little world had come crashing down around her.

I vividly remembered the lonely and forsaken feeling I had as a child when I had to leave my parents' house and return to the children's house on the kibbutz.

Gabby was sitting on her own bed, and she, too, was crying.

I sank down on the floor with a groan, the sadness of these two precious girls hanging over me like a heavy cloud. I was frustrated with the cruelty they had to experience at such a young age, and frustrated with my inability to fix their lives. Tears began to cascade down my face.

I thought about the loneliness and insecurity of the girls' lives. Many of them stayed here at the orphanage for years, and the little security they did feel was uprooted as workers continually came and went. Also, their friends among the residents of Luz de Cristo either left to live with family members or in rare cases were adopted, and then more new children came and the cycle continued. Change swirled constantly through their young lives, and it was deeply unsettling.

My own frustration at not being able to provide more for them overwhelmed me at that moment. How could I be more to the girls than just an arbitrator for their quarrels and a maid who looked after their physical needs?

So there we were, all three of us crying together.

"Why are you crying?" Gabby asked when she noticed my weeping. She stared at me in astonishment, her cheeks wet with her own tears.

"I am crying, Gabby, because I feel your pain and it hurts me too," I told her. "It is not easy to go through so many changes at such a young age. It was hard for me every time I had to leave my mom, and I even saw her every day. I know how you feel."

"You had to leave your mother?" Gabby was surprised. "Why?"

I explained to her how we lived on the kibbutz, and both girls listened intently. When they realized that I really could relate to them, a bond formed among the three of us. The session ended with Gabby apologizing and Stephanie offering her forgiveness. I felt healing coming into their hearts. Actually, into *our* hearts, because something seemed to have happened in my own heart as well. I felt lighter afterward.

Soon the rest of the girls came in and got ready for bed. I began my evening rounds. At first when I had started tucking in each girl at bedtime, some of the older ones had not responded, but now it had become a ritual that everyone seemed to enjoy.

"I have a letter," I began, standing at the first cot. "It's a letter of love that I put into an envelope, an envelope of peace." I drew the blanket up around Teresa's neck. "I close the envelope, I close it very well, I lick it and I stick it, I stick it very well." I tapped Teresa's feet as I tucked her in. "I put stamps on the chin, nose, forehead, left cheek, and right cheek." I put a kiss on each spot as I named it. "And I send the letter to the land of sweet dreams!"

Teresa smiled up at me.

"The letter of love is you, Teresa. The envelope is God's peace. Good night, precious Teresa."

I had learned this from my dad. Whenever he would tuck me in at the children's house on the kibbutz, he would recite a similar song. This ritual of mine was actually a combination of Dad's tucking in, along with some upgrades the girls suggested, like the kisses all over the face.

I went down the row cot by cot, drawing up blankets, making up stories, and singing softly, "Take this letter to the land of sweet dreams. Fly away on clouds soft and fluffy.

"Do you want me to pray with you?" I asked Stephanie as she reached out and clung to my hand. When she nodded, I knelt beside her cot and prayed softly, resting my hand on her head. Her clinging arms around my neck said more than any words could have.

"Why do you do that?" Gabby wondered when I came to her bedside.

"I pray for God to watch over you girls," I told her. "Sometimes in the night, bad dreams want to come, but I believe God sends His angels to watch over us when we ask Him to."

Her rigid form indicated unfamiliarity with loving touches, but I kissed her anyway. Perhaps later she would begin to respond.

"My feet need a stamp too," Paula giggled. I bent over obligingly, moistened my finger, and pretended to stick a stamp on the top of her foot.

"I send you to the land of dreams," I crooned to Maria. "I seal the envelope with a kiss." I kissed her round brown cheeks.

"More kisses," Maria giggled.

I kissed a row of kisses over her forehead.

"This cheek; don't forget this cheek!" Maria could not get enough.

"I send you to the land of dreams with the angels watching over you," I sang, pulling up her blanket.

When I reached the last bed, Elena pulled me close. "When I close my eyes, I see bad things," she whispered.

I sat on the floor beside her bed, holding her hand in mine.

"I see dark shapes of men coming toward me," she whimpered, her seven-year-old body trembling beneath the blanket. "I have to keep my eyes open

so they don't come closer."

My eyes stung with tears as I slowly began brushing the hair out of her face. "Let's talk to God about what you see," I suggested. I held her close as we prayed.

"Jesus always cares for you," I told her afterward. "We read in the Bible how some children came to Him one time. His disciples thought He was too busy for children, but Jesus told them, 'No, let them come to me.' I believe He held them in His arms and hugged them."

Elena nodded and her rigid little body relaxed. When I stood up, she no longer clung to me in fear.

More than once, children had opened up to me and spilled out horrific stories. "Drugs, drinking, immorality, fights . . . most of them have seen it all," Daniel had told me when I talked to him about it. "Knowing what they've been through in their short lives will help you understand many of the reasons for anger, rebellion, and distrust. Some we can help; we can't seem to get through to others."

I began then to see something I hadn't understood when I had first arrived. Back then I had thought the staff was calloused and uncaring. But now I realized they all cared and were concerned, but they had seen so many abused children and had heard so many horror stories, they were not as easily shaken anymore. I did not blame them, but the stories always hurt me deeply. I was frustrated at feeling powerless to do anything about it.

"Lord, help me!" I prayed. "I want to show them how you love and care for them. Oh, I want to be a mother to all of them, but sometimes it is so very hard. I can't do it without you."

22

"LOOK, AMALYAH! WHERE CAN I PUT THEM?" TERESA HELD UP A PLASTIC BAG filled with water and a few tiny fish.

"Oh, my! Where did you get the little fish?" I asked. "They're so cute!"

"There was a lady selling them outside the school. It was five pesos for five fish. She said I could pay her tomorrow. Can you give me some of my Christmas gift money to take to her?" Teresa requested.

"Sure," I said. "Why don't you look for a bowl or something to put them in, and I'll ask Lorena to get some fish food when she goes to town today."

Throughout the next week, little bags with fish kept showing up after school. "She dropped the price to three pesos for five fish!" the girls exulted. All around on the windowsills and on the shelves were odd shaped containers with the squirmy creatures swimming in circles.

"Your girls too?" Anthony asked with a smile when he saw them. "Our dormitory looks like the national aquarium! Tonito even got a goldfish."

It was winter, and the unfinished ditch that had been dug in the summer was now a pond full of rain water. "Let's put all the fish in the pond," suggested Lucia, who had a keen interest in all living things. "They are growing and need more space."

All the girls agreed and dumped their fish into the unfinished ditch. The boys soon followed suit, and we must have had at least a hundred fish in the little pond.

As the days got warmer and the rain less frequent, the children would often pull a hose to the pond and add a few inches of water for their pets. The fish were soon joined by tadpoles that journeyed home with us from a trip to the mountains. Before long, a turtle and Tonito's goldfish could also be seen happily swimming among the other creatures. The walls of the ditch were porous, however, and the water kept seeping away. As the water level went down, the fish began to disappear.

"We must save them," Lucia declared, kicking into action again. Taking her shoes off, she stepped into the pond. Carlos and Tonito jumped in to help her and they quickly transferred the stranded fish into a large plastic tote box. I'm not sure where the fish ended up, but Tonito's pet goldfish was the only one that ever made it back to the dormitories.

<center>◊ ◊ ◊</center>

The door to Daniel's office opened and a young mother, her baby in her arms, came out. Turning back toward him, she said, *"Gracias."* When she saw me, she smiled hesitantly, and I saw traces of tears in her eyes. I smiled back at her, watching curiously as she left the building.

"That's Cassandra," Daniel said when he saw me watching the departing woman. "She used to live here."

"Really?" I said with interest.

"Yes," he continued, "she left when she was sixteen. We didn't hear anything about her for three years. Then one day she came to see me." He nodded his head slowly, lost in his reflections.

I sensed a story. "What made her come back?"

He smiled and said ruefully, "She didn't have anywhere else to go. Her man had abandoned her, and she was expecting a baby. Desolate and forlorn, she came here."

A question that had been swirling inside me for a long time bolted out. "What good are we accomplishing for these children? I mean, I know we provide food and clothes and shelter for them and teach them the Word of God. A few are adopted into good homes, but many of them go back into their former environment and, like Cassandra, end up nowhere. I feel

frustrated, going through these motions day after day."

Daniel turned and looked at me thoughtfully. "Another one of those, I see," he said with a smile. "Thank God for people like you, workers with a tender and caring heart who want to see real change come into the children's lives."

I was puzzled. "But does it ever happen? Don't many of them end up like Cassandra? Having babies, no place to live and just . . ." I shrugged my shoulders.

"Like Cassandra? You see her as a single mother, down on her luck, not turning out any better than her own mother. You see her as a young woman who had lots of exposure to the Gospel of Jesus, but who left and did her own thing. Is that what you see?" The director looked at me with a piercing gaze.

I nodded, "Yes, I guess so. Maybe a little variation on what you said, but yes, that is what I see."

"Let me tell you what I see," Daniel continued. "I see a girl who came here to the orphanage at the age of seven. Already she had been exposed to so much pain and trauma and abuse that she had been forced to skip her childhood. Her innocence was gone, her ability to laugh and play was gone, and her life was in shambles.

"When she first came here, anyone touching her would make her jump and cower in fear. All we did was feed her, clothe her, and let her sleep undisturbed. That was all we could do."

I nodded understandingly. I had girls just like that in my care.

"Then the day came when Cassandra laughed. She actually laughed out loud! Never mind that she still wet the bed, refused to go outside in the dark, and fought like a wildcat whenever someone didn't let her have her own way. When I heard her laugh, I knew we were giving her back a small portion of what had been stolen from her." Daniel rubbed his hand over his hair and shook his head.

"In spite of her seeming inability to adjust, Cassandra eventually grew up and learned to function somewhat normally," Daniel continued. "Of course, we were saddened when she left with her boyfriend. Yes, it may have seemed to us then that we had not been able to do anything for her except feed, clothe, and shelter her. Even though we had tried to give her childhood back, we weren't sure we had." He sighed, and I knew how he had felt.

Then he turned to me. "But she came back!" His face lit up with joy as

he beamed at me. "Amalyah, she came back when she ran up against it. She remembered us!"

It didn't sink in. "Yes?"

"She wanted me to pray with her the first time she showed up, pregnant and abandoned. She remembered the countless Bible stories she had heard, she remembered the testimonies of the staff who knew what it was to pray and have a relationship with God, she remembered the songs she had learned, and suddenly, Amalyah, it all began to register! She wanted that relationship with God too!"

The veil that I had been trying to see through was being pushed away in my mind. I was beginning to see a larger picture. "Oh," I breathed, "I . . . I think I know what you are talking about."

Daniel didn't stop. "We want perfect little children to grow up, remember all the teaching we gave them, respond to life's situations properly and live happily ever after. That is marvelous, and when it happens, I am as happy as anyone else.

"But the father in Jesus' parable was just as happy over the prodigal son's return as he was in his older son's faithfulness. He didn't seem to waste a lot of time going over what the son had done wrong. He just rejoiced over his return. 'This is my son, who was dead, and is alive again.' Then he prepared a big feast.

"Don't you think, Amalyah, that is what God is still doing? Yes, I am sure His heart was heavy when Cassandra left and took her own way. But I know He is rejoicing that the seeds we sowed back then are now bearing fruit. The seeds will bear fruit! I claim that promise. Some may not remember until they are sixty years old, but if they eventually respond at the eleventh hour, God can still save them."

Then, in his characteristically abrupt way, he was off down the hall, leaving me open-mouthed at the door he had opened in my mind. Yes, what we were doing did not seem like much right now, but we were providing the basic needs and sowing seeds. Rightly did the Apostle Paul say, "I have planted, Apollos has watered, but God gives the increase."

I had a different perspective on caring for the children from then on. No longer was I just caring for their immediate needs. Now I saw more clearly that I was also sowing seeds for their futures.

Lucia drew the washcloth away from her swollen lip. The gash was not big, but the blood continued to ooze.

"Hold it firmly against the cut," I told her. "I think it will stop bleeding soon. The cut isn't that big, and I think it will heal okay."

The bathroom sink was splattered with blood, and I could hear the indignant voices of the girls in the dorm. As always when there was a fight, they were all taking sides.

As I helped Lucia, I wondered what Isabella was doing. Probably she was sitting on her bed, sullen and withdrawn.

I sighed. When Isabella had arrived, it had seemed she was going to fit in well with the other girls. We soon realized, however, that this teenager had a major temper. Though she didn't get angry very often, when it did happen, she would completely lose control.

I didn't even know what had started the quarrel this evening between Lucia and Isabella, but by the time I realized how bad it had become, Isabella had burst Lucia's lip.

Probably the sight of the blood had shocked her enough to cool her down for a bit, because after that she had backed away.

Apparently while I was tending to the gashed lip in the bathroom, word of the fight had gone out to Daniel. When I stepped outside to answer his call, his face was stern.

"Tell Isabella to come here," he told me.

I went back into the dorm, and a sullen Isabella followed me outside.

"Pack your suitcase," Daniel told her without preamble. "This is the third fight this week. I told you after the last fight that one more would mean you are out."

I had not known about this ultimatum. Even as I listened, my heart grew heavy.

I knew Daniel well enough by now that I did not question his authority. He was a kind, compassionate, and overworked man, but he was also a strict disciplinarian. He had to be in order to run Luz de Cristo. And with

twenty years of experience behind him, I knew I could trust that he knew what he was doing.

After Daniel left, Isabella looked at me and I could see she was scared. "Do I have to leave tonight?" she asked in a trembling voice.

At that moment I saw Daniel and Angelina's vehicle pull out of the drive. I had forgotten they were leaving for vacation that very evening, so I turned to Isabella. "Pack your suitcase for now," I told her. "Go to sleep, and we will decide tomorrow." Although I was also upset with her for getting into another fight, my heart went out to the young girl.

That evening, I made my usual rounds of tucking the girls in one by one. I saved Isabella's bed for last. She was lying on her side with her back to me. I tucked the blanket around her and prayed over her. When I bent over to kiss her cheek, there was no response.

I went to my room and reached for my Bible. Wordless prayers rose from my heart in intercession for Isabella and the other children.

The knock on my door was soft, yet insistent. "Yes?" I answered, getting up and opening the door.

Isabella stood outside. I drew her in and shut the door.

"I'm scared," she whimpered. I guided her over to my bed, and we sat down.

"I can't sleep," Isabella continued. "I keep seeing my dad going into a black house down the street from our home." She was shaking, and I put a comforting arm around her.

"Do you know what happens inside that house?" I asked.

She nodded, "He goes there for drugs. I know there are other men there too."

I prayed in my spirit before continuing. "Has anything bad happened to you in that house?"

I was relieved when she shook her head. "No, but I'm afraid."

"Has anyone done anything bad to you somewhere else?"

"No, but I'm still afraid," she repeated. "I'm also afraid because of what I did to Lucia."

"Oh, Lord," I groaned. "What do I do? What do I tell her?"

"Don't tell her anything right now," God seemed to say. "Let her contemplate this for a while. If you give her the medicine too soon, it will not be effective."

"You should go back to bed and talk to God about it, Isabella," I told her. "Just talk to God about it."

It may have sounded harsh, but I was convinced I was merely passing on God's own instructions. Isabella walked quietly back to her bed, and I closed the door behind her.

Daniel and Angelina were gone for a week. During this time, Isabella lived out of her suitcase. I did not have the authority to allow her to stay, nor had I been told when she should leave.

The change in Isabella during that week was remarkable. It seemed to be more than a way to keep from leaving since she fully expected to be expelled when Daniel returned. The change in her was so dramatic that I was amazed. She was mellow, she smiled a lot, and not once did she lose her temper. The other girls all noticed the difference, and after she voluntarily offered a heartfelt apology to Lucia, we all knew this change was for real.

"He said I could stay!" the jubilant Isabella told me after her meeting with Daniel. "He said I deserved another chance!"

I grabbed her and squeezed her tightly. "God gave you special favor, Isabella! He answered your prayers!"

When something like this happened, it made the whole world brighter! We were assured that God was showing Isabella that He was genuinely interested in her life.

23

"DEAR GOD, PLEASE GIVE MY GRANDMA A ROOF. SHE REALLY NEEDS A NEW roof," six-year-old Blanca prayed earnestly. "When she gets a roof, I can go to live with her. She needs me."

I knew Blanca's story. Her grandmother had found that the young girl was being left in a hovel by herself each day. At night, a steady stream of unsavory characters visited the house. Indignant, the kindhearted old woman had taken her granddaughter to live with her.

However, the grandmother's extreme poverty made it impossible for her to keep Blanca. After the roof on her house collapsed, she had brought the traumatized girl to the Child and Family Protection office, and she was subsequently placed at Luz de Cristo. Blanca loved her grandmother and missed her dreadfully. Her daily, heartfelt prayer was for a roof on her grandmother's house so she could return to live with her.

My mind flashed back to an evening when we were having the girls' devotions in the dorm. I had read from Psalm 140:1 ". . . protect me from violent men . . ." when Blanca had suddenly volunteered, "I know what that means. Violent men used to come to see my mother."

Knowing looks had been exchanged among the older girls. One of the younger ones had asked innocently, "What does that mean? What are violent men?"

"Oh, Lord, give me wisdom," I had pled in a silent prayer.

"I will talk about that later with you," I had finally told the young questioner. "You are safe to tell me anything, but it is better for us to talk privately about some of these things. If any of you ever need to tell me something, you may come to my room so we can talk privately."

That evening there had been a stream of girls at my door, each telling some heartrending tale of abuse.

"Lord, it is too much!" I had cried at the end of it all. "I am so helpless, and they are so young! How can there be such evil in the world?"

Feeling oppressed with the weight of their pain, I had cried out for healing and cleansing both for myself and for these dear girls.

Now I reached out and took Blanca's hand. "God is answering your prayers!" I told her. "A group of volunteers is coming to rebuild your grandmother's roof, and you will be able to live with her again."

Blanca's gasp of wonder and delight brought tears to my eyes. "Oh, thank you, Jesus!" she whispered, and snuggled against me. I was starting to notice that many times when these girls prayed fervently for something, the prayer would soon be answered. I had especially seen it when they prayed to go back home or be reunited with a family member. God did not fail these little ones.

I always loved the Sunday evening sharing times. The staff and all the children gathered together for a time of singing and Bible lessons. Even though I had long ago abandoned the idea of orderly children sitting in perfect rows as they listened to the devotions and sang in perfect harmony, I had gained a different perspective of life in a children's home.

So what if not all the children sat quietly? What if squabbles broke out now and again? They were being taught about Jesus and were being taught things they would never forget. I prayed there would be a fruitful harvest among them from the seed that was being sown.

"There is no more important issue in your entire life," Daniel was telling the older ones now, "than to know that you have been born again. To repent from your sins, believe in Jesus Christ as your Saviour, and have His power in your life is of the utmost importance. Not only will your life here on earth have meaning, you will have the blessing of knowing that you will spend eternity with God in heaven."

Whenever someone spoke about death, dying, and eternity, the children

became very sober. Perhaps because they had seen so much suffering and death in their young lives, they were keenly aware of the hereafter.

"How many of you know that when you die, you will go to heaven because you have repented and are following Jesus?"

I raised my hand, and there were others who followed suit.

"Juanita, you raised your hand," Daniel said with a smile. "That is good. When did you give your life to Jesus?"

"One night while I was talking with Amalyah," she said simply. "I knew I needed Jesus, and when I asked Him, He saved me."

"That was the wisest thing you could have done," Daniel encouraged her.

There were other testimonies that night, and as we continued to sing and worship, I once more thought back to Daniel's words about sowing the seed and not knowing when or where those seeds would sprout.

I remembered how I had wanted to come to Mexico as a missionary to be a mother to the orphans. I smiled ruefully at the memory of the rude awakening I had gotten when the situation had turned out so differently than I had imagined. It was only after I had become disheartened and turned to God for answers that He had graciously shown me that the work was His, and He had given me joy in following His direction. Through my experience here, I could see more clearly the importance of living for Him daily, trusting His Spirit to work in me and through me.

<p style="text-align:center">◊ ◊ ◊</p>

I struggled unsuccessfully against the dark waves of despair and regret that overwhelmed my spirit. "I should have known better!" I wailed despairingly on Monica's comforting shoulders. "What was I thinking? How could I have been so careless?"

"Amalyah." Monica took me by both shoulders and raised my chin so she could look into my eyes. "Are you still grieving because of what happened? Are you seeing your mistake over and over again whenever you close your eyes? Do you keep endlessly rehearsing what happened?"

"Yes," I gulped, "that's exactly what I'm doing."

Monica led me to an armchair in her room while she took a seat on her bed.

"I've been here for three years now," she began. "I like my work here, but as we both know, there is a steady stream of children coming and going, a constant change of staff and volunteers. In all this commotion, we cannot plug all the cracks and keep everything undesirable outside our compound.

"We try. God knows we try, and we should. Something I have learned—at least I hope I have learned it—is that when we are placed in a position of trust such as here at Luz de Cristo, we still cannot do everything. We must do what God expects us to do." She paused and looked searchingly into my eyes. "But then we must allow God to take care of the rest."

"What do you mean?" I asked. "Why can't we make sure nothing bad happens? If I had only been more careful, I would not have left Roberto alone in the conference hall while the two girls were cleaning. I would have made the girls come with me, or I would have sent Roberto back to his dorm. This is what keeps haunting me. I know I was negligent." My voice trembled as I reiterated my mistake.

Monica shook her head gently but firmly. "Amalyah, there are thousands of parents and caregivers who have been through the same scenario you are going through. They could always think they should have been more careful, raised higher barriers, laid down more rules, or in some way kept these bad things from occurring.

"None of us can be everywhere, constantly guarding all of our charges against every possible danger. Of course we try. We are supposed to try. But most importantly, we must turn the children in our care over to God. We must give these children into the hands of One who never sleeps or slumbers."

I was puzzled. "What does that have to do with my negligence?"

"Everything," Monica smiled. "Once we realize we can't keep all the evil away from our children, we begin to teach them about the constant presence of God. We teach them that we can't be with them all the time, but we help them understand that God can. We make them aware that we want to guard them from evil, but that we are human and even our best efforts may fall short. We show them that God wants to do what we can't do. That is where the difference lies."

"You mean," I interrupted, "if I had instructed Cynthia and Maria that God wants to watch over them even when no adult is with them, they

would have not gone along with what Roberto wanted to do?" I knew Roberto was primarily to blame, even though he had persuaded the girls to play a "game" rather than simply forcing them to go along with his perversion. At thirteen, he was older than they and knew that what he was doing was wrong.

"But I can't just be careless and assume that God is going to cover for me," I persisted. Even though what my friend was saying made sense, it seemed as though her reasoning ended at a certain point.

"Oh my, I could talk for hours on this subject!" Monica chuckled. "We hold ourselves up to such a high standard that if we had our way, there would never be a need for grace and mercy from God. If we could handle everything, we wouldn't even need God to redeem difficult situations. We would make sure there is no need for redemption. But God knows people. After all, He made us!"

We both laughed. It felt good to laugh again.

"When you found out that Roberto had come into the bathroom where the girls were cleaning, you began blaming yourself for leaving them alone, unsupervised. I think you will be careful never to do that again. However, because this happened, you began to doubt your fitness to be a caregiver, right?"

I nodded. "I still wonder about that," I admitted.

"Satan wants you to throw up your hands, to say it's not working, and to give up. If you abandon the work and run off to a safer environment where you don't need to take risks with people, and if you simply live a nice life in a secure box, the devil will have scored a point with you. He wants you out of commission," Monica continued. "God wants you to accept His forgiveness and stand back up, wiser than before, and continue fighting battles in His kingdom. Do you believe He can redeem this situation?"

I knew I should say yes. My theological intellect told me I should trust that God could redeem the situation and make something good come from it, but deep inside, I doubted.

"But won't all three of these children be scarred for life?" The question burst from my mouth.

"Is that what is stopping you from accepting forgiveness and moving on?" Monica asked gently. "Are you wrestling with whether God has ever completely

forgiven you for your own sins of immorality?" Monica knew of my past.

"Sometimes we believe God forgives sin only up to a certain point, but God looks at the confessed sin as completely done away with. The Bible says He remembers them no more. They are washed away by the blood Jesus shed for us. Gone, just like that!" With a snap of her fingers, Monica emphasized the point.

"It's true that in some ways we have to reap what we sow," she added. "But God is the only one who understands how that reaping takes place, and He wants us to commit it to Him. Man says all kinds of repair work will be needed to get rid of the sin. Did God ever say He would set up a twelve-step program to redeem those He has forgiven? I think that is more man's idea, perhaps borrowed from the secular world. Jesus simply says, 'Come unto me, and I will give you rest.' "

"I think I see what you mean," I told her. "Even though I have asked God to forgive my negligence for allowing the three to be together unsupervised, God is saying He can actually redeem that situation in addition to forgiving me. Now that takes some faith!"

Though God did forgive, there were still consequences to be paid. The girls, being so young, received special counseling. Roberto was sent to a juvenile detention center. "God can redeem the situation," I told myself over and over again. Monica's kind talk really had given me a different perspective, and I clung to it with stubborn faith.

"So our son Roberto is in juvenile detention. As we see it, that's all the more reason to move on with the adoption process," Mr. and Mrs. Davis said, surprising Daniel with their response when he told them what had been done by the bright, cheerful boy they were planning to adopt. "We realized from the beginning that he has been exposed to a great deal of evil in his young life, but we also know God wants us to love him. We intend to help him understand God's love, and we believe we will see him become a new boy in Jesus Christ."

So Roberto was given a chance, a second opportunity to be completely redeemed and transformed by Jesus! I began to understand more deeply the great and powerful gift of mercy and forgiveness. My formerly heavy heart felt light and free once more!

24

"FOUR AND A HALF HOURS," I SAID TO MYSELF, LOOKING AT MY WATCH. "IT'S FIVE o'clock in the morning, so I'll finish the march around 9:30."

It was a stunning morning in Israel in 2008. After spending the last four years in an arid part of Mexico, the fields around my old kibbutz looked especially verdant with life.

I continued around the perimeter of the kibbutz, praying aloud as I walked. "Lord, I believe you brought me back here to be with my mother. Thank you for speaking to me at that women's retreat. But Lord, there is not even one believer on this kibbutz. Please make the walls of unbelief fall down."

My feet knew the path I was walking very well. After all, this was the seventh day of my morning walks. Before returning to Israel, I had been reading the book of Joshua when an idea occurred to me. Perhaps God was taking me back to Israel for more reasons than just to help my mother. Maybe, I thought, God wanted to do something through me to bring His light to the kibbutz. I had decided then that just like the Israelites marched around Jericho, I would march around the kibbutz. I had already walked around it once every day for six days, and now on the seventh day I was marching around seven times.

Dad had passed away in 2002. On my visits back to Israel from Mexico, I had seen Mom begin to age. But it had not been until 2007, when at age eighty-three she had made a courageous trip to the United States to see her

family, that I had realized just how feeble she was getting. She traveled to America with my sister, and I accompanied her back to Israel. It was then that I knew I had to return. I had decided I would make one more trip back to Mexico to pack my belongings and say goodbye, and then I would return to be with Mom.

Now as I continued my prayer march, I watched two tractors leave the kibbutz and blaze their way across the fields, exhaust smoke trailing them. Much had changed in my old home, but the agricultural life of the kibbutz still continued as in years past.

I reflected on the recent series of changes in my life. The events leading up to my return to Israel had helped me realize more than ever my need for God's clear guidance. As I was preparing to leave the orphanage for good, doubts began to sweep over me. Everywhere I turned I saw familiar faces of people I loved.

"Here, these are for you." I handed some books to Aaron, one of the workers at the orphanage.

"I'll keep them for you until you come back," he said simply, "if the Lord wills." I had begun weeping. Day and night I had wept. I was no longer sure if it was indeed God's will for me to return to Israel. I wondered if maybe I should wait until the end of the summer. It was such a busy time at Luz de Cristo. Maybe I should stay just six more months . . .

But then I attended a ladies' retreat in California. Some of the women there were acquainted with my dilemma. I sat by myself, unable to concentrate on what the speaker was saying. *There is so much noise in my mind, I can't concentrate,* I was thinking. "Are you all right?" a kind voice asked. A lady in her forties was smiling down at me as she laid a hand on my shoulder.

I began to share with her the situation I was facing, and she smiled understandingly. "Let's pray right now," she said, and without hesitation bowed her head and began to speak. "Lord, you are sovereign. Our lives are in your hands. You promised that you will guide us and lead us and show us the way . . ."

I couldn't hear her anymore. I broke down in tears, and the noise in my mind intensified. "Lord," I cried in my heart, trying to make myself heard over the raging sound, "I can't hear you. I don't know what to do. Please

silence this noise and speak to me."

As I waited, the noise subsided and a new question popped into my mind. *What if your mother is no longer alive six months from now?* Then just as suddenly as the confusing noise in my head had been silenced, it resumed.

I turned to the lady still praying for me and shared with her what had happened. "You know," she said, "That message about your mother is exactly what I had on my heart to tell you, but I refrained because I didn't want to interfere with God's direction to you."

Before the conference ended, conversations with two more women seemed to confirm that this was the way God was leading me.

There was no way around it any longer. I knew I needed to go back home to be with Mom.

"God, I was sure you called me to be a missionary," I reminded Him, still puzzled. My mind backtracked through the four years of working at Luz de Cristo. I remembered the first weeks of loneliness and discouragement, followed by the heady rush of throwing myself into the work and the challenges of learning a new language. More recently I had enjoyed the feeling of knowing where I was going and what I was doing. I was a missionary to Mexico. That was my identity.

"Your identity is in me, Amalyah. I am all you need," God reminded me gently. "You don't have to be a foreign missionary to earn my love and acceptance."

The tender tones sank deeply into my heart. As I surrendered to the comforting message, I found myself beginning to cry, "Oh, Lord, yes! I want only you!"

The dam of tears burst again as I realized that God was not as interested in my performance as a missionary as He was in my relationship with Him. I had begun to find my identity in my work rather than in my position in Him. My tears increased, and I surrendered anew to His love.

Now here I was, back in Israel and walking around the kibbutz. I lifted my hands toward heaven and began singing, "I love you, Lord, and I lift my voice to worship you. Oh, my soul, rejoice!"

As I sang, I remembered how the loving women at the retreat had encouraged me to listen to God's voice, and then later how God had

confirmed His will to me by a dream He gave to my sister Deborah. She shared it with me immediately after I returned from the retreat, and it was the final confirmation I needed in my heart.

In my sister's dream, she had been wandering around the kibbutz looking for Mom. She had met a man who lifted a finger to his lips to indicate she should be silent. She asked him if Mom had died, and he shook his head, but pointed to his head to indicate something was wrong with her head.

When I asked my sister if she thought Mom was going to lose her mind, she said, "No, I don't think so. It was as if the man was telling me she was sleeping, but that something was wrong with her head."

So far I had not seen the dream fulfilled in detail, but I was confident that I belonged back in Israel with Mom. Today was my seventh day of marching around the kibbutz. I had put seven small stones in my pocket, and to keep track of my laps, I dropped one after each round. As I came around to the starting point and bent over to put the fifth stone on the pile, I felt a sudden pain in my chest, and my arm got distinctly cold. I dropped the stone and cried out in surprise.

"God, what is happening?" I began to feel faint and strangely lightheaded as though I could suddenly defy gravity and float away.

A verse from Psalm 143 came into focus and I found myself repeating the prayer David had prayed. "Teach me to do thy will: for thou art my God: thy spirit is good; lead me into the land of uprightness."

"God, are you telling me to quit the intercession march against the darkness here in this place?" I asked, baffled. "Am I doing this in my own strength? Or was it not even your will that I should do it in the first place?"

Somewhat confused, I returned to the little guest apartment where I was staying and took out my Bible. It dropped open to John 4, and I read verse 34: "My meat is to do the will of him that sent me."

I read and reread the verse. Jesus had only one desire—to do the will of the Father. A noise outside interrupted my thoughts. Mom came by on her battery operated mobility scooter.

"You didn't come to my room, so I came to see if you were okay," she told me.

"Oh, Mommy, but I told you I would come a little later today, and you need not come looking for me," I said reproachfully.

"Let's go to breakfast together," she said eagerly.

"Mommy," I said, "I think I will just stay here. I need to read my Bible and spend some time praying. I had a strange experience just now, and I want to ask God what He is trying to tell me."

Mom dropped her eyes and said nothing for a moment. "Well, I guess I'll go then," she said tonelessly and turned the switch on her scooter.

"Yes, you go ahead, Mommy. I'll come later," I told her and picked up my Bible. This time I read Hebrews 10:9: "Lo, I come to do thy will, O God."

I still was not getting it. So consumed with seeking the hidden meaning of it all, I ignored the obvious. God had brought me back to be with my mom, and yet, time after time I neglected to spend time with her.

Two more weeks passed. My body was in Israel on the kibbutz with Mom. But my heart was not there. I kept seeking God's will, trying to decipher His message.

And then one day it finally dawned on me: I was not available for Mom. I had failed a very basic part of God's will, to honor my father and mother.

"Lord, please help me to spend meaningful time with her," I prayed. "I'm afraid I have not been a good daughter. Just today Mom asked me to go with her to the holiday meal at the community hall, but I declined. How could I have been so blind? But I will change that. I will start to make time for her and honor her."

"How was the holiday meal?" I asked Mom when she returned.

"It was very good," she replied. "Dalia sent you some fruit salad and a cake, and Roni was asking about you."

"He was? It seems so strange to come back and see some of my classmates married and having children," I reflected. Roni now lived with his wife and family in the same house his parents had lived in many years ago. Our parents had been neighbors as long as I could remember. We had moved to the new buildings together, and now the wall between the two apartments had been removed so his house was much bigger than before. Only the last apartment in the row was left intact as a guesthouse. That was where I was now staying.

"Mommy, Jesus died for your sins," I said as my mother settled herself in her favorite chair. "He wants you to repent and believe in Him."

Mom nodded slightly and shrugged her shoulders. "You keep saying that,

dear," she said patiently. "I think that even if there is a God, He is not interested in our daily lives."

I sighed. Why was she so set against seeing what God had done for her?

"You know, Amalyah," she continued, "when you first talked about God, I thought it was just a passing phase. But I see now that it isn't. For you, it works. But for me, I don't need that. I'm okay the way I am."

"No, Mommy," I tried to remonstrate gently, "we all need Him. We won't always live here on earth. We must prepare for the time when we face God in judgment for the way we have lived here on earth and what we have believed. We must prepare!" I could not keep the urgency out of my voice.

"What do you think about this house?" Mom pointedly changed the subject. "Should I put an extra bathroom onto the back of the house? You know the kibbutz is paying for the addition they are going to build for me, but they are not paying for the bathroom. If I decide to add one, I will have to pay for it myself."

I sighed. "Mommy, I really don't know. I think it's probably a good idea. Maybe one day you will need a caregiver, or maybe I could even live here with you and help. But it's your decision. Do you really want the bathroom or not? It is your money." I tried to be helpful.

"I just don't know," she sighed, and again I realized how old and worn out she looked. She no longer had that sparkle about her that I had always remembered.

"I want to build that bathroom," Mom said as I was getting ready to leave for the night. "Tell Shimon I have decided, and they can start whenever they are ready." She got up and shuffled to the kitchen. "That is, if I don't die before they finish the renovations," she added.

"The question is not so much if you die, as it is when you die," I corrected.

Mom managed a weary smile. For years, whenever someone said, "If I die . . ." my sister would interrupt with, "Not if I die, but when I die," and it had become a humorous family expression. I guess we did it to remind ourselves we would all someday die. But now, it wasn't said lightheartedly. Death was lurking closer than we could have imagined.

That next morning I was in the guest room, praying and reading my Bible. "I will go to Mom early today and see if she needs anything," I murmured as I gazed out the window at the breaking dawn. "I haven't really

been there for her like I should have since I arrived three weeks ago. I really want to make this day all about loving and caring for her."

"Amalyah!" I heard my name being called, and I got up. There was a knock on the door and another shout, "Amalyah!"

I opened the door quickly. "What is it, Roni?" I gasped when I saw my old friend's ashen face. "Is it . . .?"

"Your mother is not well," Roni told me quickly. "My mom called and told me to find you."

Without a moment's delay, I raced to her door. "Mommy," I called as I hurried to her bedside, "I am here. It's Amalyah."

Mom smiled feebly and closed her eyes.

"I found her on the floor," a neighbor told me. "I heard a man calling her on the emergency speakerphone, so I figured she had pressed the emergency button, and I came in to check on her."

I motioned with my head toward a bucket, raising my eyebrows questioningly, and the neighbor nodded. "Your mother threw up right after I came in," she whispered.

The nurse from the kibbutz arrived a moment later and quickly checked Mom's vital signs. "We need to take her to the hospital," she decided.

"We are going to take you to the hospital," I said to the frail, still form on the bed. "I will go with you."

"Okay." Mom slurred as she tried to speak. One side of her face remained rigidly immobile.

I had a hundred questions, but I didn't want to ask them there in Mom's hearing. I motioned for the nurse to step outside with me.

"I think she had a stroke." The nurse quietly confirmed my fear. "The sooner we get medical care, the better. Time is crucial in getting her over this."

Even though my eyes filled with tears, I managed to whisper, "She has always said she doesn't want life support."

The nurse shrugged and called for an ambulance which arrived quickly.

Riding in the back of the ambulance, I held my mother's hand tightly. "Oh, Mommy," I whispered in her ear, "please give your heart to Jesus. Let Him come into your life, and repent from your sins."

Urgency put everything else out of my mind. I didn't know if she was

going to die or become unconscious, but one thing I did know—I wanted my mother to believe in Jesus.

As she tried to speak, managing only a mumble from her distorted mouth, I dashed away my tears and leaned closer.

"Mommy, if you hear and understand me, squeeze my hand," I begged.

A firm squeeze let me know she heard what I said. I also believed that she was well aware of having had a stroke. She had told me once that when my uncle had a stroke, my aunt communicated with him by hand squeezes, and no doubt she remembered that now.

As we reached the emergency room twenty minutes later, she fell into a coma.

"Mommy, if you ask God to forgive your sins and trust Jesus to save you, He will. He wants to save your soul so you can live with Him in heaven."

I wasn't sure if she could hear me, but I begged her to say yes to Him who could bring everlasting life to her soul.

"Lord Jesus, please save my mom," I prayed softly. "Please don't let her die without you."

Mom was soon transferred to another hospital and placed in a bed by the window. "The only thing we can do," the doctor said, "is to make her as comfortable as possible. There is a lot of blood on her brain, and surgery is not an option in her condition."

I sat by her bed, took her hand in mine, and explained to her what the doctor had said. I had heard that sometimes people in a coma were still able to hear and be aware of their surroundings. I don't know if Mom could hear me, but I knew she would have wanted to know exactly what was going on, so I explained it all carefully.

Weariness spread over me. I tried to pray, but my heart was empty and dry.

I sat continually by Mom's silent form for the next three days. Some of my Christian friends took turns staying with me, making sure there was always someone there with me. I was deeply thankful for their love and support.

"Ann, would you please pray for my mom?" I asked one of those friends. "I feel so empty and dry, like I'm out of touch with God. It seems my words are going no farther than the ceiling."

"I certainly will," Ann agreed readily. "And one more thing; I live close by. Come to my apartment, and get a good night's sleep. Your strength is

ebbing away."

The doctor had given no hope for recovery, but told me it could be weeks or even months before my mother passed away. I could not imagine her lasting that long. She was eighty-three years old, and what she had always dreaded most was to be helpless. She had never wanted to be a silent lump in a bed or on a wheelchair, unable to speak or take care of herself. I feared the end might be very near, but I was indescribably weary.

Reluctantly, I decided to leave Mom's side to go to Ann's apartment.

"You need to get some rest," the doctor agreed. "I'll call you if there is any change. Just relax and catch up on some rest tonight."

"Mommy, I'm going to Ann's apartment for the night," I said, kissing her on the forehead. "Please hold on a little longer. Hannah and Deborah are both flying in, and Rafael is on his way too. They'll be here tomorrow, okay? I love you, Mommy."

I don't know how long I slept at Ann's apartment before the phone rang. It was the doctor. "You need to come to the hospital," she told me gently.

Ann rushed me back to the hospital, and we hurried to my mother's bedside. I glanced at Mom's still face, and then looked at the heart monitor. The red line blipped slowly and rhythmically, but I could see there were no longer any peaks. The line was flat.

Dropping to my knees, I took my mother's hand. "Oh, God, be with me now!" I pled. "Hear my prayer!" In the pain of the hour, I felt utterly alone.

As I continued praying, I felt God's presence in the room. A song bubbled up from deep inside my heart, and I began to sing softly, "Swing low, sweet chariot, coming for to carry me home . . ."

Another song came to my mind, one of Mom's favorites. It was commonly sung by Jews at Friday evening's meal to welcome the arrival of the Sabbath. I began to sing it:

> *You are welcome, angels of peace;*
> *Angels of the most high, who come from the King of Kings*
> *The Holy One is He. Your presence is for peace, angels of peace . . .*

As I sang the words of the last verse, I felt a tap on my shoulder. It was the doctor, asking me to step outside.

"Goodbye, Mommy. I love you." I kissed her forehead and stepped out of the room at the doctor's request. As I waited in the hall, I still felt the presence of Jesus.

"Your mother has died," the doctor told me when she came out. "I have finished my examination, and you can go back in now."

"I believe in God!" I said. "I believe in Jesus, and He came and ministered to me while my mother was dying. He is so real!"

She looked at me strangely, and without responding, began telling me where they would take Mom's body.

I went back into the room for the last time. I wanted to see the empty bed by the window so that I would not always picture it with Mom's body. I wanted to remember her at her best—strong and alive.

On my way out of the room, I saw a young man in the room across the hall, looking out at me. He was connected to a breathing machine, and he had all sorts of needles and tubes attached to his body.

I had seen him there before and heard part of his story, but had never talked to him. But now, as though compelled, I went into his room. "Oh, sir," I said, "do you know that God loves you? He really, really does!"

The man looked straight into my eyes, but he did not reply.

"Yes!" I continued, "Jesus came to earth to show us what God is like and to teach us how to love Him. We will all have to face Him after we die, and He will judge us according to what we have done. We have all sinned. Look, I know it sounds impolite to talk about death, but this is reality. I know you can hear me, so please listen."

Even though he didn't answer, the man was intently looking into my eyes. I had been told that he had been in a car accident. He had been improving at the rehab center, but then he got an infection in the lungs. Now his life was hanging by a thread, and he was losing the desire to live. It was as though God was pushing me to talk to him even though I couldn't really tell how he felt about it.

"We have all sinned. If you are honest with yourself, you know that," I told him. "When we face God in judgment, we will all know we deserve to go to hell, but He doesn't want us to. He sent His Son, Jesus Christ, to the earth as a human to redeem us from our sins. His death on the cross was an

offering for our sin so that we can be free from sin and its penalty. He was buried, but on the third day He rose back to life! By this He proved His victory over death and sin. Now we can live forever with Him in heaven, instead of suffering forever in hell. He loves you. I know you have a family, a wife, and two little girls. Choose life for their sake.

"I want to pray for you," I concluded. "I will pray for your healing. Okay?"

The man turned his head toward me silently as I knelt and began to pray. I prayed for his salvation, and then I prayed for his healing. Like fountains of water, the words gushed out of me. God's loving presence was so strong I could have gone on praying for a long time, but finally the stream of words turned into a sweet silence. After a few more minutes, I knew it was time to go.

"I must leave now," I told him, getting up. "But I want you to remember what I told you. Be strong. What I told you about Jesus is the truth. The salvation I told you about is a gift from God, and it is available for you today. If you want His salvation, just ask Him for it."

"Lord, we thank you for what this man has heard," Ann prayed as I came out of the room and rejoined her. "Thank you for giving Amalyah an opportunity to share the good news of eternal life. We place him in your loving hands, and we trust you for whatever happens to him."

God's love was so real that night. It was somewhat odd that He came to me so powerfully at the very time my mother died, and yet it really wasn't strange after all. God used that experience to show me again how our purpose as Christians is to take God's message of salvation wherever we go. He expects us to seize each opportunity, no matter how difficult the circumstances, to reach a lost soul. This is God's heart, and He will give us strength for the task even in our moments of greatest desperation.

25

THE FUNERAL WAS OVER. IN THE CEMETERY JUST A SHORT DISTANCE FROM THE community houses and buildings, Mom's worn-out body had been buried beside Dad's grave. Numerous friends had walked back to Mom's house with me, where we went to "sit *shiva*" (seven). After a funeral, it is a Jewish tradition to spend seven days with the family of the deceased. During these days, people come and go from morning to night, mourning together and remembering the departed loved one.

Both of my sisters had come from the United States, and my brother Rafael had come from the north. There had been the expected group of people from the kibbutz, including Mom's friends from the rapidly passing older generation. Family members and friends of all generations came from other parts of the country, and my friends from church were there too.

But now the seven days were over and everyone was gone. It had been a sultry day, and I was grateful for the cooler evening air as I went back to my little guest apartment.

Even though I had been staying alone in these small quarters before Mom died, the room seemed somehow emptier and quieter than usual. I looked at my reflection in the mirror and saw a middle-aged woman looking back at me. I sighed and turned away. There wasn't much to see there.

I sank down on the bed, and sadness settled over me like a dark cloak.

"I am an orphan," I said to the silence in the room. "I have no father

and no mother. Why?" I suddenly began to pound my fists on the bed. "Why, God? Why is she gone? Mommy, Mommy!" I wailed, "I'm so sorry, Mommy!" Anger and frustration filled my heart.

"Why?" I repeated. "Oh, Mommy, I failed to love you as I should have!" I thought about her house that would no longer feel like home to me. "I feel so alone, God, without a husband or children. I rarely see my siblings. God, where do I belong?"

I reflected on my father's death. I had been with him before I went to Mexico, and I had sat at his bedside as his strength had ebbed away.

As I thought about my parents, I remembered the times in my childhood when we had family outings and how my parents tried to make sure I was well cared for. Even though at the time I thought my parents were not as modern and understanding as they should be, I now realized they had really wanted what was best for me.

I remembered the painful scene when I had arrived at a Purim celebration so scantily clad that my dad had ordered me to go and change. I wept as I remembered how in my rebellion I had ruined their evening, and they had left early.

"Daddy, I am so sorry for that evening," I had told my dying father. "I was so thoughtless, and I ruined your evening. I am sorry. Will you please forgive me? I know now that you were actually trying to protect me."

"Amalyah, it is no problem," Dad had told me. "You didn't actually ruin my evening. I wasn't really all that keen about going on the stage anyway."

"But you never dressed up on other occasions," I had protested, "and that year you and Mom were to be honored as king and queen. I ruined it for you!"

"No, no, child," he had said. "I don't want you to beat yourself up about that. It is forgiven."

My dad had never been one to show affection, but this time he had patted my hand reassuringly. Even though it was hard for me to let the incident go, I did.

Many times after his death, I had asked God why my father never responded to the Gospel. I had witnessed to him over and over again, and like Mom, he never wanted to talk about spiritual things. This had broken my heart.

Now I relived my last moments with Mom, and even as I cried out to

God for answers, it felt as though the heavens were sealed.

"I want some assurance that my mother believed in you, God!" I cried. "How can I live without the assurance that my parents accepted your salvation in their last moments here on earth? How can I bear coming to heaven and perhaps not finding them there?"

Gently, lovingly, the Spirit of God began showing me that He was my comfort. He was the one in whom I was to trust. He was sufficient for my every need. Yes, it was good to pray and intercede for others, but when I allowed the state of other people's salvation to block out who He was, I began losing the relationship I needed with Him.

I began breathing more easily as I reflected on these thoughts. "Come, Holy Spirit," I prayed. "I need your presence in my life."

Without words, I poured out my loneliness, my frustrations and my grief about missed opportunities to love Mom properly, opportunities that would never return. I poured out the pain about not finding a companion to share my life with, and the worry about direction for the future. Even though I did not form my thoughts into sentences, I kept on letting God know how I felt with wordless cries from my heart.

"I am the good shepherd: the good shepherd giveth his life for the sheep." The words of Jesus from John 10 came as a balm to my aching heart.

In my mind, I pictured the shepherd out on a hillside, intent on the good of the flock. I saw the many sheep, each pursuing its own way, and yet I knew the shepherd would want the best for every one of them.

"I am very interested in you, Amalyah," I could hear the Shepherd say. "I see the ache in your heart, but I am the Father of orphans, the Companion of the lonely, and the Comforter for the hurting. I know about the loneliness. I have made you. I understand you. Come to me, and let me heal your broken heart. I will send healing oil and wine into all your wounds and bind them up with my love."

"Thank you, Jesus!" I exclaimed with heartfelt gratitude. "Thank you for being my Comforter, my Father, and my Shepherd. I love you, Lord Jesus. I surrender my loneliness to you, and I want to let you be my all in all. I want to be at perfect rest in my singlehood. I want to be at peace in knowing that even if I were married, I would still need to find this place of perfect rest in

you. Nothing can fill the space in my heart except you, Lord!"

Even though I had gone through similar times of loneliness and heartache and had cried out to God for healing, I did not sense any condemnation for not having learned this lesson thoroughly by now. I just leaned on the loving arms of Jesus and rested.

If I learn everything and become self-sufficient in my knowledge of Christ, why would I still need Him? Why would I need to come to the end of myself and find the answer in His love? God wants me to be needy and desperate for Him. That is what He longs for. Blessed are those who hunger and thirst; blessed are the poor in spirit.

I sat up in bed as the revolutionary thoughts raced through me. How true! If I found a way where I could always know the answers, know just how to deal with my emotions, and know how to map everything out, when would I find myself lying helpless at His feet? When would I seek His presence so overwhelming that I found myself weeping with joy? My heart leaped within me, and I stretched my hands toward heaven in gratitude and rest.

0 0 0

"I would like to keep this if you don't mind." I lifted a small pottery jug from the shelf in my mother's bedroom.

"I don't want much," Deborah said. "Anything I choose will have to go back to Arizona in my suitcase. But there is one thing that I would like. For me it really represents Mom. It is this cat-shaped nail clipper with the missing eye. I will always remember her when I see it."

"It used to belong to Mom's mother," Hannah said. "Sure, take it, Deborah. I don't mind; do you, Amalyah?"

I didn't mind. We had decided to let each one choose what they wanted of Mom's possessions, and to find a solution together should a disagreement arise. That was Mom's wish too. We had found a little note saying, "When I die, I want the four of you to sit together lovingly and divide what I have among yourselves."

Thankfully, there were no disputes. Even though my siblings are far apart geographically, and we really didn't keep in close touch, when we did get

together, we got along very well.

Mom's house was small, but we still needed to empty it. As difficult as it was to disperse of everything, I knew I did not want to clutter up my life with lots of keepsakes. I was more thankful than ever that my parents had never wanted a lot of possessions, because now it made it easier for us to settle everything.

"I want this jacket that Mom used to wear around the house," I said, lifting up the faded gray and purple jacket. I held it up against my face and closed my eyes. I could smell the familiar scent of my mom.

"Do you still have Dad's jacket?" Hannah asked. "That maroon and black one?"

"I do," I laughed. "I have it in my suitcase. Now I will put Mom's jacket beside his, and I'll have something familiar from each one of them. Maybe I am more sentimental than I knew."

"It is sad to realize that our parents' home is going to be emptied," I reflected. "Do we inherit the house, or how does that work?"

"I'm not sure if anyone knows," Hannah said. "The kibbutz has been going through a long process of privatizing everything, and many policies aren't clear yet."

I wasn't interested in the house. I wasn't planning to stay on the kibbutz, since I hadn't felt God wanted me to stay there. Instead, I wanted to leave and move back to Jerusalem. I felt I needed to fellowship with the believers there. I craved worship and interaction with those who loved the Lord.

Before I left, I made another trek around the kibbutz. I knew an era of my life had ended. Once more, the old questions wanted to assault me. I wondered anew whether I had done everything I could have to witness to my parents.

I recalled how my mother had wanted me to go with her to breakfast just several weeks before and I had been too busy having my devotions. Now I realized with regret that she had indeed wanted to connect with me, and all I had wanted was to convert her.

"Forgive me, God," I said, but this time it was not in despair. "I want to take this as a lesson and see how you want me to be your feet, your hands, and your voice. I want to minister as Jesus did. I see now that service and friendships are the direct connections to peoples' hearts."

So I left the kibbutz in peace. Passing the cemetery on the way out, I once again left the condition of my parents' souls in the hands of the Creator of the universe. I found a great rest in simply admitting that God could carry that burden. I could not.

26

"SHALOM!" THE MALE VOICE ON THE OTHER END OF THE TELEPHONE LINE
sounded young and distinctly Israeli.

"Shalom," I replied, cradling the receiver on my shoulder.

"Uh, I saw this telephone number on a small pamphlet I picked up on
the street. It talks about Isaiah 53 and the fulfillment of that prophecy."

"Do you know where you will go after you die?" I asked, bypassing his
remark for the time being.

"No one can be sure," the voice on the other side said.

"Well, do you know the Ten Commandments?" I asked.

"Sure," he replied.

"So when you stand before God, and He judges you according to the Ten
Commandments, will you be innocent or guilty?"

"Guilty for sure," the young man said promptly.

"And if you are guilty, where will you go?" I probed.

"I guess I'll go to hell," the voice said more somberly.

"Well then, don't say that no one can be sure where they go, because we can
be sure. You just told me where you're going. God is not hiding the truth from
us," I continued. "But God doesn't want you to go to hell. He came here in the
form of a human being to deliver you from sin and eternal damnation.

"He came in the person of Jesus. He is our Messiah, the promised one,
the fulfillment of the prophets' visions and dreams. He came to earth to

teach us how to live, He died on the cross for the redemption of sin, and He rose from the dead three days later. Now He is alive and wants to live in us as our Saviour and Redeemer. Someday we can live with Him in heaven instead of suffering in everlasting hell."

I know my hasty words might seem to have been premature, but I had learned that many callers tried to sidetrack me, and we would discuss many other topics. I had become determined that every caller would get to hear the Gospel in a nutshell.

"Wow," the caller said. "That was a mouthful."

"Yes," I laughed. "You just heard the Gospel. My name is Amalyah, by the way. What is your name?"

"Amalyah," he repeated thoughtfully. "That means 'labor of God.' That is good, since you labor for God."

"And your name? You have a name, right?" I inquired.

"Um, my name is . . ." he hesitated. "My name is Isaac," he laughed a little nervously.

"Isaac. That means laughter. Okay, I will call you Isaac," I told him, though we both knew that was not his real name.

"Isaac, what do you think, having read the tract and now having heard it again from me? Have the Scriptures been fulfilled in Jesus Christ?"

"Well," he said, "I am not really sure what I believe. I mean, I know we Jews are not supposed to believe in Him. The rabbis say He is a traitor, and that He started a false religion and made Himself God. No one can be both man and God. But I do believe He was a prophet—a very good one."

"More than a prophet," I insisted. "He Himself claimed to be the only begotten Son of God. If that is not true, then He is not a good prophet—He's a liar."

"And this thing about Jesus rising from the dead," Isaac continued, "we know that His disciples came and took the body out of the tomb. Then they said He rose. I know also that some people think angels came and took the body of Jesus to heaven."

"But He appeared alive to many people after His crucifixion and death," I told him. "There are many eyewitness accounts of people who saw Him with their physical eyes. Besides, I myself know He is alive."

"Are you married?" Isaac asked, rather irrelevantly, I thought.

"No, I am not married." I replied. "Do you want to know how I know that Jesus is alive?"

"Why are you not married? Are you too young? How old are you?" Isaac persisted.

"I am forty-three," I told him. Maybe if I answered his questions he would respond to mine.

"What? You are forty-three years old and not married!" He gasped at the idea.

"That's right. Forty-three, and not married." Even as I said the words, I felt the familiar pain want to rise up in me, but I just committed it to Jesus once more.

"Why did your father or brothers not help you find a husband? How can this be? Is this how you Christians do it? I mean, I am not even twenty yet, and I am continually under pressure to settle down and find a wife. I don't know if I am ready, though."

So the conversation was going in a different direction than I thought it should, but I had learned to mind the Spirit and not force people too hard.

"I am sure it is not easy for you to understand this," I told Isaac, "but I am not interested in getting married unless God clearly leads a man into my life. Until that happens, I do not want to marry. Even if I never marry, I am at peace with God's will for my life."

"That's what I hate about the Orthodox way," Isaac said bitterly. "Don't do this, don't do that, don't touch a girl, and stay away from women." After a pause he said, "But you Christians are free to do those things. I see boys and girls together in public, and I like that."

I breathed a prayer for wisdom. "No," I corrected him gently, "you are confusing us with people who come from so-called Christian backgrounds. You may think they are Christians, but true believers in Jesus live holy lives. We do not believe it is okay for people of any age to be promiscuous. Don't you think it is the most beautiful thing if a man and a woman come to their marriage and they are both virgins? I think it is a wonderful thing for them to save their very first kiss for their wedding day."

There was a long silence. Was he going to hang up? "Whoa!" Isaac said at last. "I have never heard anyone say something like that. You really mean

what you said?"

"That's right. They keep themselves pure for each other. I can't think of a better wedding gift to give each other than that, can you?" I wondered how he would answer that.

"But how is that possible?" he questioned, clearly aghast. "I mean, young people are young people. They have . . . needs."

"First of all, those are not needs. They are desires, and like I said earlier, if the power of the Holy Spirit comes and lives inside a person, he receives the power to live according to God's will. That power comes through believing in Jesus Christ. It is much more than just forgiveness from sin so that you can avoid hell, although it does start with forgiveness. Beyond that, it is entering into a relationship with God that will help you live as He wants while you are still in this body. That is why we publish these pamphlets and books. We want to help people understand how to have this relationship with God. Would you like some of our literature?"

"No, thank you. No, I cannot have you send anything to my address. I just wanted to call and ask you a few questions. Anyway, whew! You have given me some things to think about. Thank you."

"Isaac, I will pray for you. I will ask God to give you understanding and revelation about Jesus Christ and the wonderful loving Saviour He is for all people, including us Jews. When you receive the truth into your heart, the things I am telling you will all make sense."

"Thank you, Amalyah, thank you," he said sincerely. Then he hung up.

"Dear God, reveal your Son to this young man, whatever his real name is. Help his hunger for you to grow, and please send someone into his life who can help him understand your plan of salvation." I turned my attention back to the computer and continued entering information into the database.

I enjoyed my new job as secretary of New Life Church in Jerusalem. I liked the phone calls that came in, like this one, and I liked being surrounded by Christians. I loved our services and the regular interaction with the believers.

"Thank you, God," I breathed more than once, "for providing me not only with a job but also a place to live."

When Jenny, a friend and sister in the Lord whom I had known for

several years, had first shown me the apartment she was offering to share with me, I had gasped with pleasure.

"When I was praying for a place to live, I asked God for several things," Jenny told me. "One was that there would be plenty of natural light. The other was an extra bedroom, so I could have guests."

Jenny laughed pleasantly at my surprise as I walked over to the sliding glass doors and looked out over Jerusalem. God had answered each and every point on my own list. It was the first and last apartment I saw; I did not need to look any further.

"I love it too," I said, turning toward her. "This is wonderful!" A bar separated the small but efficient kitchen from the living room, and a dining table fit comfortably beside the entry hall.

"There are three bedrooms and two baths," Jenny said as she showed me the rest of the apartment. "You will sleep in this bedroom, and as you can see, the third bedroom is actually an office. You are welcome to use the office computer, as I do most of my writing on my laptop."

"Thank you so much!" I had been overwhelmed.

"As soon as I get a job, I will start paying you rent," I had told her.

"You don't need to pay me anything," Jenny said good-naturedly. "This is God's house, and I rented it with the intention of making it available for ministry."

"I know, and I thank you, Jenny, but I want to help as much as I can," I told her.

"Well then," Jenny smiled, "help will be accepted as long as you know that you don't have to."

Just that easily, God had provided a place for me to live. The job opening had come when my pastor had asked if I would be willing to work for the church. "We need someone who is fluent in both Hebrew and English," he told me. "Plus, your ability to speak Spanish may be useful sometimes too."

My secretarial duties kept me busy, and I was blessed with kind and godly co-workers. They all agreed that my interaction with people on the phone was as much a part of my calling as the work I had originally expected to do. Their encouragement and support blessed me tremendously, as God had been placing in my heart a burning desire to reach my own people.

"Is the tract with your phone number about Jesus?" The tone of the woman's voice on the phone clearly indicated that she thought I would say yes. I did not disappoint her.

"Then it should be torn up, just as I am going to do right now," she said bitterly. "We don't need you people coming into our country and spreading your religious views. We have our own religion which is more than twice as old as yours."

"Actually, I am also Jewish," I told her mildly. "So I didn't come to this country. I was born here, and I am free to live here and have my own views about God and His Son, Jesus Christ."

With a gasp, the woman said, "Oh, double shame! You, an Israeli, a daughter of Abraham, leaving the traditions of your fathers and falling for a false and inferior teaching! People like you should not be allowed to live here. Israel is meant for the Jews!"

"There is something more important than all that," I told her. "Jesus Christ is the Messiah for the Jews and for all who believe in Him. I know that when I die and stand for judgment before Almighty God, my sins will be cleansed and covered by the blood of Jesus. God will declare me innocent because I accepted the atonement He provided for me. What about you? How will you face the judgment?"

"I don't know what happens when someone dies," the woman replied honestly and a little less belligerently. "But I still think you are being deceived, and you should return to the synagogue. You are *meshumad*," she said with renewed venom, using the Hebrew term for destroyed, applied when someone converts to Christianity from Judaism.

"No," I corrected her. "You see, I was raised a secular Jew, so I was never part of the Orthodox Jewish religion or even a modern form of Judaism. But then I began reading the story of Jesus and came to realize that He actually fulfilled the prophecies of the Old Testament, the *Tanach*. As I opened my heart to the truth, God revealed to me many more things. Did you know that Jesus is spoken about in the *Tanach?*"

"That is preposterous!" the lady snorted disdainfully. "He is not mentioned anywhere in the Torah or the other holy writings."

I quickly asked the Lord for guidance on how to proceed and decided to be direct. "Look, I know you care about the truth since you called the number on the tract. I would like to send you a book called *Jesus in the Tanach*. After you read it, you can decide for yourself what to believe. If Jesus is indeed not mentioned in the *Tanach*, you are welcome to throw the book away. If He is, you might just want to compare the text with the book and verify it for yourself."

There was no immediate reply. "I don't know," she said dubiously. "I don't want to contaminate my house with Christian junk."

I felt led to simply remain silent for a few moments. Finally I said calmly, "Well, it is up to you. If you want to check the truth for yourself, you may want to read the book."

"If I give you my address, you will know where I live."

"Well," I replied, "and why would I be interested in that?"

"Well, you or some of your friends would come and try to convert me."

"I don't think so," I said with a smile. "We do not pursue people who do not wish to be visited. If someone is interested in what we do, they generally come to us. We would only consider coming to your home if we were invited."

"That would never work," she said. "No, you cannot possibly come here." There was another pause. "Okay then," she said at last. "Send me the book. If He really is the Messiah, I need to know."

"God, I pray for the recipient of this book," I whispered as I prepared the package. "Open her heart to understand, and let her believe in you! Reveal yourself to this woman."

"Another package?" the pastor, Yehuda, asked with a smile as he came out of his office.

"Another interesting telephone call?" Avram, the assistant pastor, called out of his office. "That conversation sounded interesting. I hope you didn't mind that we were eavesdropping."

"Oh, no," I assured them. "At least this one didn't swear like a caller this morning did. I had just come into the office when the phone rang, and the person asked me in broken Hebrew if I spoke French. When I said no, but

that I could converse in Spanish, the caller said, 'Hebrew will work, but I could curse so much better in French.' "

"Maybe you should just hang up if they begin swearing," my pastor suggested.

"That's what I did," I told him, "but then I regretted it immediately. I have been asking God about what to do when people become belligerent and use offensive language. I felt that if there was some way I could wade through all the garbage and let light shine into their lives, I would do it. What do you think about it, Yehuda?"

I looked expectantly up at my pastor, a man whom I had learned to respect deeply. He himself had been raised in a Christian home here in Israel, and I knew he had faced much persecution for his faith. He rarely talked about it, however, but continued to pursue his calling as a pastor in spite of the difficulties he faced as a Messianic believer in a Jewish nation.

"I think your idea is correct." He nodded his head thoughtfully. "Perhaps some small seed can be sown that will someday sprout into faith. We don't know how God's Spirit works to penetrate the hard shell of unbelief and ignorance about the Gospel. Just be wise, and don't let the evil words into your heart."

I looked out the window at the beautiful view of Jerusalem. We were at the top floor of a multi-level building. "Oh, by the way, I have not been successful in getting our utility bill settled for our water usage," I told the pastor. "We are still getting free water from the pipes at the front."

"How very gracious of the city," Yehuda smiled. "Well, we have contacted their office more than once. I guess if they don't want to install a meter here, there is nothing we can do about it either. When we finish the renovations, we'll try calling them again."

Avram stretched his arms above his head. "Well, I know I'm very happy with our new facilities. After everything we went through before we moved here, this seems wonderful." He returned to his desk.

"I will be gone all morning," Yehuda said, pulling his jacket from the hook. "I'm picking up my wife, and we'll be doing some visitation at the hospital."

As I returned to my work, I thought about the somewhat turbulent journey our church had gone through in finding a suitable location. Yehuda had first met with a group of believers in his home. When the assembly

outgrew his living room, he had arranged to meet in a large ecumenical center. That ended during the intifada, the Palestinian uprising, after we found out that the gardener had been wounded by a stray bullet. The group had decided it was too dangerous as a meeting place for families, and we had rented a conference room from a hotel.

That had worked out for several years until the hotel had been threatened with the revocation of their *kashrut* license if they continued to let a Messianic group meet there. This license is given to restaurants and hotels, and is normally just a certification that the food served in these establishments meets Jewish dietary requirements. At times, however, the authorities who grant these licenses will take them away if the party in question is perceived to be involved in other "non-Jewish" practices. Since a revoked *kashrut* license would mean the loss of religious Jewish customers, a major source of income, the hotel manager told us we had to move. However, he had let us use a meeting hall on a private property.

But that, too, lasted only a few years. As soon as the groups that target Christian outreach activities found out that we were still somehow connected to the hotel manager, they resumed the threats. We had to move again, this time to a church building downtown. As at the other locations, this building was a rental property that we could use for only a couple hours each week. That meant that all the church activities apart from the main service every Saturday morning were held in people's homes, including all the office work.

After more than seven years of prayer and collections from members of the congregation, the group started to share the vision for a building of their own with other believers from around the world. Nineteen years after it began in Yehuda's home, the congregation had stepped out in faith and bought this top floor of an industrial building. The church had numbered about a dozen members at its inception; now there were nearly three hundred.

It had been a step of faith, as the space needed a lot of renovations. God had blessed this venture, and now we were the owners of our own facilities. The building was paid for, and we still had money left over to start the first stage of the renovations. God is a mighty and awesome God, and there is nothing impossible with Him!

I couldn't help wondering how much longer we would be granted this freedom to distribute tracts and books and meet to worship our Lord and teach His Word. There were many signs that suggested future problems for Christian groups in this Jewish nation. But today there was work to do, and we wanted to be a light for our Messiah, Jesus Christ, as long as we could.

27

"SWEETIE, YOU MUST NOT TALK LIKE THAT. IT ISN'T THE END OF THE WORLD, YOU know." I looked into the teary eyes of the young girl sitting in my office.

"Yes, it is the end!" she cried. "There will never be anyone else for me. He was the one and only, one of a kind. I will be alone for the rest of my life!"

"Listen carefully now," I told her. "You are starting with some actual facts, but your conclusion is a lie from Satan. Yes, your friend is a special person. We all are. But if he is not part of God's will for your life, then he is not what is good for you. You must focus on God. He knows your heart, and if He took something good away from you, it is only because He has something better. We as Christians often struggle more between good and God's best than between good and evil."

"But it hurts so much!" she cried.

"I know," I said, taking her hand in mine. "But you must trust God for everything in your life, including love and romance. Pour out your heart to Him, and He will comfort you."

I thought about my own struggles with loneliness and singlehood. How often had I allowed my heart to be tied to someone who was not part of God's plan for me? And even though I had learned to better control my emotions and submit every thought to the obedience of Christ, it was not easy. I knew I was still not immune to such pain. How often I had compared myself to other women and thought that they were chosen by

their husbands because of their superior beauty.

Those thoughts were still with me the next morning as I stood in front of the mirror, brushing my frizzy hair. Nothing seemed to help that morning, not even the expensive hair lotion I had allowed myself to buy.

I scanned my image in the mirror critically. The brown skin and brown eyes had been inherited from my father, but the curly mop of hair was unmistakably from Mom. For the most part I thought I had accepted my looks, but there were times like today that I struggled.

Friends had often spoken about my sparkling eyes, and even as I looked in the mirror to see what they meant, I knew it was only because of Jesus living in me. I certainly couldn't see anything special. "Thank you, Lord, that you add some inner beauty," I said as I stared at my reflection, "but why can't my hair be beautiful too?

"You will submit, you unruly mop," I said through gritted teeth. I pulled the brush through my hair once more.

I have to get this hair under control. I don't need any more whistles and catcalls, I thought wryly. I was remembering a time when I had walked through the streets of Jerusalem, my hair displayed in an unbecoming manner, and some young men had whistled at me.

God had actually used that experience as a reminder for me to ask Him for direction on how I dressed. I had been wearing a rather short skirt that day, and even though I hadn't been intentionally dressing to attract the attention of men, I also hadn't asked God enough about how He wanted me to appear. My mind went back to the time in the States soon after I had become a Christian when I had the uncomfortable experience of feeling immodest in the middle of a church service.

Now that I was being more careful to seek God's direction for my appearance, some young men at our congregation had actually come to me to express their appreciation for my modesty.

And yet I was still single. Even though I was happy most of the time, there were still instances where I would allow self-pity to enter my heart, and with it the discontent about my looks.

"Why do I have to learn these things over and over, God? My life is a series of steps, a ladder of levels, and a slow climb upward. When will I have

learned all I need to learn? I feel as though I'm just a teenager going through painful discoveries instead of a woman in her forties." I had to laugh at myself even as I spoke.

"I made you, Amalyah." The words came lovingly into my heart. "I made your face, and yes, even your hair! To you, your hair may not be lovely, but accept it. To me, it is lovely, because I made it."

"You love this!" I lifted my hair and laughed a little incredulously. "Yes, I guess you did make me this way, so of course you like it. I never thought of it that way before. I know you don't want me to be proud and display it in an uncomely way, but I am so grateful that you delight in me!"

The presence of my Lord was so real. I basked in His love and felt once more that all was right in my world.

When will I learn all these lessons? When will I stop needing to go through one more learning experience? I wondered. I was not in despair, but I really did want to experience the fullness of God's presence all the time.

I remembered some words from a sermon my pastor had preached. "Don't despair when you think you are always going through school with God. Don't wonder when you will reach perfection. Your perfection is not measured by your performance. Your perfection is found through Jesus Christ. Let His presence live inside you, and He will take care of your imperfections. That is what the Spirit of the Lord does for all those who ask."

"I need your mercy and grace every day," I said out loud as I recalled the message. "Lord, keep me from getting to the point where I become self-sufficient and think I have learned everything so well I no longer need you! I come like Mary to sit at your feet and let you teach me. I cannot live without you!"

It was amazing how my mind was renewed as I left the apartment and went to work. I had gone from fretting about my appearance to being reminded by God that I was accepted completely by Him. More than that, He allowed me to go through these experiences to bring me to a deeper relationship with Him. Amazed by it all and feeling newly accepting of myself, hair included, I laughed with joy.

<p style="text-align:center">◊ ◊ ◊</p>

"Yehuda," I said as I entered the pastor's office, "have you seen the check that Mr. Lawrence sent us yesterday?"

"No, I haven't. Is it missing?" he inquired.

"I can't find it anywhere," I told him, my voice quivering. The check had been for a large sum. As a long time supporter of the church, Mr. Lawrence would want to know his donation had been safely received and deposited.

"I doubt it was stolen," Yehuda told me reassuringly. "It is probably just misplaced, but if you can't find it, the best plan would be to go to the bank and cancel it."

A few moments later I stood beside the road, my hand held out to indicate I needed a taxi. Most of the time I traveled by public bus, but this time I needed to hurry to the bank as quickly as possible.

Since taxis are numerous in Jerusalem, I didn't have to wait long before a car pulled up and stopped. I opened the back door, slid in quickly, and gave the driver the address. After he had pulled back out into the traffic, I saw him look at me in the rear view mirror.

"I recognize you," he said. "I've taken you somewhere before."

"Probably you have," I said briefly. I was still disturbed about the missing check and did not feel like making small talk.

"You are the one who believes in Jesus!" the taxi driver said suddenly, his face lighting up with recognition.

I looked at him more carefully. Then I laughed. "And you are Bashir, the Muslim!" I remembered.

"Yes, I am. I'm still a Muslim," he chuckled. "You did not convince me to accept your belief."

"No, I guess I didn't," I replied. "Anyway, it will not be I, but the Holy Spirit, who convinces people. We are told to share the Good News, but it is God who makes it come alive through His Spirit."

"Wait a minute," he protested. "You still believe in all that spirit stuff? That is something I can't understand. There are people who believe certain places are haunted, and that spirits speak to people. I can't accept that nonsense."

A noisy truck was rumbling past us at the moment, so I waited until the noise died away. "Sir, do you know of anything counterfeit that is not patterned after the genuine?"

"Why do you ask?" he inquired, puzzled.

"Because there are definitely people who hear noises and are bothered by evil spirits. There are also people who are being healed by all kinds of mysterious energies and spirit rituals. But they are only a poor imitation of the real Spirit of God who comes and lives in the hearts of those who believe in the Messiah.

"The Holy Spirit makes the Bible become alive to me. The work of the Spirit is to comfort me when I am in trouble and to guide me when I need help." I spoke quickly, for we were getting close to my destination.

The driver held up one hand. "Whoa! That is what you say. How can you prove it?"

"By my changed life," I said simply.

"You know," Bashir told me, "I know some people who were on drugs and alcohol and even in prison. They decided to become devout Muslims and turned their lives around as a result."

"No doubt that's true," I replied. "I also know many Jews who did the same when they became religious. There are many ways in which we can learn to behave better, but there is only one way to receive forgiveness from sin and stand clean and perfect before God. This is what it boils down to: Where will you spend eternity?"

"Well, you are very sure about your faith. I have to appreciate that, even though I don't agree," Bashir told me. He pulled the taxi to the curb, and I paid him.

"I will pray that Jesus reveals Himself to you," I said as I got out.

He shrugged and smiled as he said, "When He does reveal Himself, I will have many questions to ask Him." He drove off, and I entered the bank.

Back on the street after more than an hour of trying to hurry a lethargic bureaucracy, I flagged down another taxi to go back to work. Thankful for the cool, air-conditioned interior, I just wanted to close my eyes and relax. *I should witness to the driver.* The thought came to me suddenly.

Oh, God, I thought, *I'm so exhausted. I really don't want to speak to anyone about anything.* But then I looked at the young man behind the wheel. *What if he knew I was a believer and I didn't care about him enough to share with him the life-saving news?* I cringed at the thought.

Suddenly God filled my heart with compassion for the driver. *Lord, please give me an open door for a conversation,* I prayed silently. Just then I noticed his name plate—Ignacio.

"Are you Spanish?" I asked him.

"No, I'm Italian," he replied. "Are you from Spain?"

"No, but . . ." and God led the conversation to my time in Mexico. From there I was able to share the testimony of my salvation.

"I'm from a Christian family," Ignacio told me.

"Have you personally repented of your sins and given your life to the Lord?" I asked.

"Not really. I just grew up in a Christian home. I believe in the story of Jesus, but I'm not a fanatic or anything."

"It's not about being a fanatic," I said. "It's about knowing that you are right with God and living in relationship with Him. This is the most important thing you could ever do," I urged as we pulled into the church parking lot. "You never know when it will be your time to meet the Lord. You are welcome to join us right here for worship on Saturday morning."

As I walked back to the office, I wondered how an Italian from a Christian family ended up as a taxi driver in Jerusalem, but I couldn't ponder the issue for long.

"We found the check!" Yehuda called as soon as I walked in. "It was under a pile of papers on your desk. You should really be more organized, you know," he teased.

I had been meaning to clean up for several days, but had kept procrastinating. The check must have gotten buried in the mess. If I had cleaned up as I should have, the whole incident wouldn't have happened. But, God in His grace took my shortcomings and turned them into opportunities. He gave me the strength and compassion to be His mouthpiece. Two more people had heard the Gospel; two more souls might one day be saved.

θ θ θ

"Shalom. Would you like a copy of the book of Daniel?" I held out the

pamphlet to an Orthodox Jew. He recoiled as though I had offered him poison, looking suspiciously from me to my friend Rachel. The crowd around us pressed toward the Western Wall, a sacred place for religious Jews since it is all that remains of the Old Testament temple. Observant Jews come here to pray and mourn the destruction of the temple, and their weeping has led to another name for this spot, the Wailing Wall. The din of Hebrew prayers rose up as the Friday evening crowd came to cry out to God and welcome the *Shabbat*.

"Christians!" The angry shout of the man to whom I was offering the booklet rang out like a cry for battle. Those around us took up the cry, and the men began crowding around us, shouting and shaking their fists at us.

"It is the book of Daniel! It is from the Writings!" I explained, using the Hebrew term for the section of the Hebrew Bible that contains the book of Daniel.

"Get out! You are accursed!" yelled the angry mob of men dressed in traditional black coats and black hats. They surrounded Rachel and me, many of them shouting hostilities.

I tried to figure out what was happening. How did these men even know we were Christians?

"Wait, I am an Israeli!" I protested. "I am only distributing Hebrew copies of Daniel! It is something which your own rabbis read and teach from. This is just the Hebrew translation of the original Aramaic."

Since most of the book of Daniel was originally written in Aramaic, many Jews don't read it, but the prophecies in it are unmistakably clear. It seems that anyone who sincerely studies them cannot deny that Jesus is indeed the promised Messiah.

"We have our God, and we don't need your God! We have the teachings of our rabbis. We need no other interpretations!" The angry voices around us continued their tirade.

Rachel crowded against me, her eyes wide with fear. I held her hand tightly, trying to reassure her as well as myself. Our backpacks, crammed with pamphlets, provided some protection for our backs, but the enraged men thrust their scowling faces closer and closer to ours. I looked around for someone to help us.

"It is only the words of God," I tried again, but I quickly fell silent as I remembered the Talmudic ruling of "It is not in the heavens." It basically says that if God Himself told His people something different from the Torah, He would be ignored. For centuries now, truth in Judaism has been established by a majority opinion from the leaders who interpret the Torah. They are the final authority.

I didn't have much time to think about these things now, though. There was no stopping this crowd. More and more men joined the throng until I feared we were going to be trampled under their feet. Rough hands were clutching and shoving us back and forth.

I whipped out my phone and called the police. "Help!" I shouted. "We are being mobbed at the Western Wall!" I wasn't sure if I could be understood above the din, so I yelled again.

Rachel was fighting back tears and clinging to my arm. The voices continued to rant against us, screaming and cursing.

Within minutes, help arrived. The military maintains a strong presence everywhere in Jerusalem, and the Western Wall is no exception. Wading through the crowd with no-nonsense authority, a group of soldiers quickly came to our rescue, positioning themselves between the mob and us.

"Disperse! Leave these women alone!" The commands were given in no uncertain terms by a burly soldier.

Shouting and grumbling, the men slowly began to move away, still directing venomous glares at the two of us.

"The angel of the Lord encamps around those who fear Him," I quoted shakily to Rachel. "Even if the angels are disguised as soldiers."

Rachel drew a deep breath but made no reply.

"You ladies need to leave the plaza," one of the soldiers told us. "Come along." We walked obediently between the soldiers as they led us through the security checkpoint and to the other side of the plaza. "Sit here for a while until you are sure the mob isn't going to pursue you," the soldier instructed, motioning us toward a seat outside the Western Wall police post.

"My knees are all shaky," Rachel breathed, leaning back on her seat. "Why were they so angry with us?"

"Partly because we are women," I told her. "And somehow they also knew

we were Christians, and that infuriated them."

"Why do they hate Christians so much?" Rachel took another deep breath.

"Because we believe Jesus is the Messiah," I told her. "To them that is heresy. However, I think it's more than just that our belief challenges theirs. I think what we really see is the kingdom of darkness warring against the followers of Jesus. They act out of zeal for what they believe is true, but they don't know they are in darkness. They don't know that the devil is blinding their eyes. The enemy will do anything he can to stop them from coming to the saving knowledge of the Messiah."

"It was like one of the mobs that persecuted the apostle Paul," Rachel said. "It happened so quickly and they were so utterly unreasonable."

I looked at the Jewish women walking toward the checkpoint, headed for the wall. I knew that in a few minutes they would approach the wall in prayer. When they finished, they would back away from it, being careful not to turn their backs to the wall while praying. My heart went out to them with great compassion, for I knew the sincerity of my countrywomen.

"Let's see if we can distribute our pamphlets out here by the checkpoint," I suggested. "These people need to read and understand the redemption available in Jesus Christ."

"Please," Rachel said with a tremor in her voice, "I don't feel comfortable doing this. I thought I could be brave, but the memory of those hateful voices shouting at us . . . those clutching hands . . ." Her voice trailed away.

"I understand," I told her. In no way was I going to blame her. I knew how often I had hesitated to testify of Jesus even in far less threatening circumstances. We got up and left the area without incident.

"So some of the Jews hate us, and yet the soldiers who came to our rescue are also Jews, aren't they?" Rachel was bewildered.

"Well, in Israel there are all kinds of Jews, from the deeply religious and Orthodox all the way to the secular Jews, many of whom are atheists," I tried to explain.

"Atheists?" Rachel was stunned.

"Yes. Secular Israelis outnumber the religious. Here in Jerusalem you see large numbers of Orthodox people, but in other cities they are a much smaller minority."

Rachel shook her head. "Such a mixture of religions," she mused. "If the various religions are not fighting each other, then members of the same ones are fighting among themselves."

I nodded as we began the walk home. Evening had fallen, and public transportation had ceased to run, for the *Shabbat* was beginning.

"Well put, Rachel," I agreed. "So many times we just hear about the Jew against the Muslim and the Muslim against the Christian. What we often forget is that within each group, like you said, there are endless differences and factions."

"No wonder that Jesus is called the Prince of Peace," Rachel said. "The world desperately needs the peace that only He can bring."

"Oh, God, help us to be ambassadors for you!" I breathed. "Help us to make a difference by allowing your Light to shine in this troubled nation." Adjusting the straps of the heavy backpack across my shoulders, I braced myself for the walk home. As I walked, I reflected on our experience. No, I probably wouldn't be rash enough to risk another such mob scene at the Western Wall, but I rejoiced that my own heart belonged to the Prince of Peace, and that I could testify of Him to my countrymen.

That evening, I sat on my little balcony that overlooked the city of Jerusalem. The heat of the day gave way to a cool, refreshing breeze. Crows and swifts glided through the sky in a final performance before perching for the night. As the last golden light of day faded from the sky, my thoughts traveled to the past. Now a woman in my mid-forties, I saw a golden thread running through my life, binding together each event, whether good or bad, uniting every part of who I was and who I would yet become in Christ Jesus.

It was amazing how everything, the insecurities I had faced as a child at the kibbutz, the yearning to be accepted as a restless teenager, and the longing for love in my adult years, had all been answered in Jesus Christ. It was so clear now that God's hand of guidance and protection was involved in my life even long before I knew Him. I marveled that in spite of my bumbling and hesitant steps initially, God had been so loving and patient with me.

"Oh, God," I prayed as the evening light slowly faded from view and the first stars came out. "Thank you for opening my eyes. Thank you for letting me know you as my Father. Thank you for saving me, for taking me

through all those experiences, and for never giving up on me. Thank you for your mercy and grace that covered me and continue to bless me.

"But I still have many questions that are unanswered. I still wonder if this is where you want me to serve you for the rest of my life. Am I still supposed to be a mother to suffering children? Will I live to see many of my people turn to you and know the Messiah? Will the rest of my family be saved? Will I spend the rest of my life alone?"

An old hymn began running through my mind.

> *Whatever my lot, thou hast taught me to say,*
> *It is well, it is well, with my soul . . .*

My thoughts quieted, and a joyful peace filled my heart.

The evening star twinkled brightly against the dark sky. Just above the horizon, it bravely shone out against the encroaching darkness.

"Jesus, just as that star, you also send out eternal rays of hope, love, and above all, eternal life," I whispered. "Let your kingdom come, let your will be done on earth, as it is in heaven. May your will be done through us, your children."

I turned and reached for my Bible. Once again, I turned the pages of the Holy Word that will never stop inspiring and encouraging me. Once again, the presence of Jesus comforted me. Once again, my heart had come home.

PRONUNCIATION KEY

HEBREW WORDS

Gozalim . goh zah LEEM

Hashomer Hatzair hah shoh MER hah tsah EER

kashrut . kahsh ROOT

Katzir . kah TSEER

Mashiach . mah SHEE ach

meshumad . meh shoo MAHD

Shabbat . shah BAHT

Shalom . shah LOHM

Shavu'ot . sheh voo OHT

Shema . SHMAH

shiva . shee VAH

Tanach . tuh NAHCH

Yeshua . yeh SHOO ah

Yom Ha'atzmaut! yohm hah ahts mah OOT

SPANISH WORDS

cómo te llamas COH moh teh YAH mahs

donde está mi desarmador DOHN deh ehs TAH mee
dehs AHR mah dohr

estúpida	ehs TOOP ee dah
gracias	GRAH see ahs
grupo	GRUH poh
inteligente	in tehl ee HEHN teh
Jesucristo	HEH soo KREE stoh
la bajada	lah bah HAH dah
lucha(s)	LOO chah(s)
no comprendo	noh cohm PREHN doh
pronto	PROHN toh

ABOUT THE AUTHOR

HARVEY YODER AND HIS WIFE KAREN LIVE IN THE BEAUTIFUL MOUNTAINS OF western North Carolina. They have five children, all of whom are married, and nine grandchildren. A teacher for many years, Harvey is now a licensed real estate agent in addition to being a prolific writer. He has traveled extensively while gathering materials for his many books, most of which have been published by Christian Aid Ministries. Harvey finds it especially fulfilling to write the inspiring accounts of faithful believers whose stories would otherwise remain unknown. His greatest desire in writing is that his readers will not merely be entertained by the stories, but rather be motivated to seek God with all their hearts.

Harvey enjoys hearing from readers and can be contacted by e-mail at harveYoder@juno.com or written in care of Christian Aid Ministries, P.O. Box 360, Berlin, Ohio, 44610.

CHRISTIAN AID MINISTRIES

CHRISTIAN AID MINISTRIES WAS FOUNDED IN 1981 AS A NONPROFIT, TAX-EXEMPT 501(c)(3) organization. Its primary purpose is to provide a trustworthy and efficient channel for Amish, Mennonite, and other conservative Anabaptist groups and individuals to minister to physical and spiritual needs around the world. This is in response to the command ". . . do good unto all men, especially unto them who are of the household of faith" (Gal. 6:10).

Each year, CAM supporters provide approximately 15 million pounds of food, clothing, medicines, seeds, Bibles, Bible story books, and other Christian literature for needy people. Most of the aid goes to orphans and Christian families. Supporters' funds also help clean up and rebuild for natural disaster victims, put up Gospel billboards in the U.S., support several church-planting efforts, operate two medical clinics, and provide resources for needy families to make their own living. CAM's main purposes for providing aid are to help and encourage God's people and bring the Gospel to a lost and dying world.

CAM has staff, warehouse, and distribution networks in Romania, Moldova, Ukraine, Haiti, Nicaragua, Liberia, and Israel. Aside from management, supervisory personnel, and bookkeeping operations, volunteers do most of the work at CAM locations. Each year, volunteers at our warehouses, field bases, DRS projects, and other locations donate over 200,000 hours of work.

CAM's ultimate purpose is to glorify God and help enlarge His kingdom. ". . . whatsoever ye do, do all to the glory of God" (I Cor. 10:31).

STEPS TO SALVATION

THE BIBLE SAYS THAT WE ALL HAVE "SINNED AND COME SHORT OF THE GLORY of God" (Romans 3:23). We sin because we give heed to our sinful nature inherited from Adam's sin in the Garden of Eden, and our sin separates us from God.

God provided the way back to Himself by His only Son, Jesus Christ, who became the spotless Lamb "slain from the foundation of the world" (Revelation 13:8). "For God so loved the world that he gave his only begotten Son, that whosoever believeth in him should not perish, but have everlasting life" (John 3:16).

To be reconciled to God and experience life rather than death, and heaven rather than hell (Deuteronomy 30:19), we must repent and believe in the Son of God, the Lord Jesus Christ (Romans 6:23; 6:16).

When we sincerely repent of our sins (Acts 2:38; 3:19; 17:30) and by faith receive Jesus Christ as our Saviour and Lord, God saves us by His grace and we are born again. "That if thou shalt confess with thy mouth the Lord Jesus, and shalt believe in thine heart that God hath raised him from the dead, thou shalt be saved" (Romans 10:9). "For by grace are ye saved through faith; and that not of yourselves: it is the gift of God" (Ephesians 2:8).

When we become born again in Jesus Christ, we become new creatures (2 Corinthians 5:17). We do not continue in sin (1 John 3:9), but give testimony of our new life in Jesus Christ by baptism and obedience to Him.

"He that hath my commandments, and keepeth them, he it is that loveth me: and he that loveth me shall be loved of my Father, and I will love him, and will manifest myself to him" (John 14:21).

To grow spiritually, we need to meditate on God's Word and commune with God in prayer. Fellowship with a faithful group of believers is also important to strengthen and maintain our Christian walk (1 John 1:7).

MORE BOOKS BY HARVEY YODER
PUBLISHED BY CHRISTIAN AID MINISTRIES

RIFKA SINGS

When Rifka, a young Muslim girl from Sudan, moves to England with her parents, her world turns upside down. Everything is new, and the girl who once loved to sing is now strangely silent. With time, however, Rifka learns new songs and finds something new to sing about. And when Christmas comes, she hears a story that will change her life.

72 pages $6.99

A GOOD DIFFERENT

Only a miracle could restore the shattered lives of this Kenyan couple. Their story will cause you to marvel anew at how God heals the brokenhearted and gives beauty for ashes.

255 pages $12.99

VERA, THE KING'S DAUGHTER

In spite of her abject poverty and crippled body, Vera finds herself a treasured princess and her home a castle where Jesus lives with her.

208 pages $11.99

BREAD FOR THE WINTER

Eight-year-old Pavel learns from his godly parents what Jesus meant when he said, "Love your enemies. . ."

70 pages $4.49

A LIFE REDEEMED

The inspiring story of Ludlow Walker's journey from his childhood in Jamaica to

his current calling as a minister of the Gospel. An unforgettable testimony of God's redeeming grace and transforming power.
232 pages $11.99

INTO THEIR HANDS AT ANY COST
Bible smugglers find ingenious ways to transport Bibles into Romania and the former Soviet Union.
194 pages $11.99

MISS NANCY
The fascinating story of God's work through the life of an Amish missionary in Belize
273 pages $11.99

IN SEARCH OF HOME
The true story of a Muslim family's miraculous conversion
240 pages $11.99

THE HAPPENING
Nickel Mines school shooting—healing and forgiveness
173 pages $11.99

A GREATER CALL
What will it cost Wei to spread the Gospel in China?
195 pages $11.99

TSUNAMI!—FROM A FEW THAT SURVIVED
Survivors tell their stories, some with sorrow and heartbreak, others with joy and hope.
168 pages $11.99

A SMALL PRICE TO PAY
Mikhail Khorev's story of suffering under Soviet Union communism
247 pages $10.99

WANG PING'S SACRIFICE AND OTHER STORIES
Vividly portrays the house church in China
191 pages $10.99

WHERE LITTLE ONES CRY
The sad trials of abandoned Liberian children during civil war
168 pages plus 16-page picture section $10.99

ELENA—STRENGTHENED THROUGH TRIALS
A young Romanian girl strengthened through hardships
240 pages $10.99

GOD KNOWS MY SIZE!

How God answered Silvia Tarniceriu's specific prayer
251 pages $10.99

THEY WOULD NOT BE SILENT

Testimonies of persecuted Christians in Eastern Europe
231 pages $10.99

THEY WOULD NOT BE MOVED

More testimonies of Christians who stood strong under communism
208 pages $10.99